MAN ON THE BRIDGE

THE PHOTOS OF ARTHUR FIELDS

A uniquely crowd-sourced publication, this book is the culmination of the Man on Bridge project, a national photograph collection campaign. People from all over Ireland sent in photos taken by Arthur Fields, the man who became the unofficial photographer of a city. Before an era of smartphones, he provided a vital service, taking photographs of couples on first dates, people up in Dublin for the day, happy parents with newborn children, matchgoers and even some celebrities, including a seven-year-old George Harrison.

Arthur Fields stood on O'Connell Bridge almost every day from the 1930s until 1988 and took an estimated 182,500 photos of passers-by. The photographs bear witness to a changing cityscape, fashion, lifestyle, social habits and even camera technology. The result is a window onto a different era, a time when photographs were taken to be cherished.

Ciarán Deeney and **David Clarke** have worked together for over ten years producing documentary, drama and multi-platform projects including Man on Bridge.

WWW. MAN ON BRIDGE .IE

Facebook.com/manonbridge
Twitter: @ManOnBridgeDoc

Man on Bridge Project Partners

Comhairle Cathrach
Bhaile Átha Cliath
Dublin City Council

MAN ON THE BRIDGE

THE PHOTOS OF ARTHUR FIELDS

www. MAN ON BRIDGE .ie

COMPILED BY CIARÁN DEENEY & DAVID CLARKE

The Collins Press

INTRODUCTION

Within these pages is a collection of photographs taken on Dublin's O'Connell Bridge and O'Connell Street from the 1930s to the 1980s. Each image has been sourced from members of the public and represent just a small percentage of the photos that have been uncovered in family albums, shoeboxes and breast pockets as part of the Man on Bridge project, an ongoing photo-collection campaign. Individually these collected images are cherished family objects; collectively, they form a unique record of Dublin city, as it was lived in and as it was enjoyed.

Born in Dublin in 1901 to Jewish-Ukranian emigrants, Arthur Fields began life as Abraham Feldman. His parents had fled religious persecution in their native land and Arthur and his family changed their names to integrate better into Irish society of the time.

He began his working life as a tailor, and it was not until the 1930s that Arthur Fields tried his hand as a street photographer. He was not alone. There was a vibrant community of photographers who all provided the service of capturing special moments on camera for the masses. The main thoroughfare in Dublin was O'Connell Bridge leading onto O'Connell Street. It was the place to be seen and naturally the place to be photographed. This became Arthur's patch and he quickly excelled.

For Arthur, taking photographs was not about flair, prestige or, indeed, art. Nor did he realise the unique photographic record of social life that he was creating. For Arthur, it was a job and by all accounts it was a job he was obsessed with. At the time, cameras were beyond the reach of most and providing that service, Arthur worked day and night in all weather conditions, 365 days a year for over 50 years. This work ethic is at the heart of why Arthur became a Dublin legend and part of the fabric of the city where he became simply known as the 'The Man on the Bridge'. As a result of his constant presence at this location, it was commonly said that the statue of Daniel O'Connell guarded O'Connell Street but Arthur Fields guarded the bridge.

Behind the scenes was Arthur's wife, Doreen, who played a vital role in creating the photographs. Arthur might have taken them but it was Doreen who developed the photographs under the stairs at home. She also looked after the administration, ensuring that people received their photos, which was no mean feat. Although celebrating one Dublin street photographer, this book is also a testament to Arthur's wife and all the other street photographers who stood and photographed passers-by on O'Connell Street, including Con Keane, Danny Delahunty, Harry Cowan, Max Coleman, John Quinn and many others. Undoubtedly, some of their photos spill into this book.

By the end of Arthur Fields' career in the late 1980s, the world and, indeed, Dublin had completely changed. Arthur had adapted during the time also and had made the move to Polaroid technology, providing instant colour photographs. By this stage, however, he was the last working street photographer in the city, a relic of a different time in the story of Dublin. When Arthur retired in the late 1980s, it was not due to lack of desire on his part but ultimately for health reasons. On 11 April 1994 Arthur passed away and the 'The Man on the Bridge' finally faded from view.

Arthur's life straddled arguably the biggest social changes in Irish history. Born very much an outsider, through his camera he came to observe all strands of Irish society. His images capture how Dublin city and Irish people changed within that time, specifically in terms of fashion, architecture and social habits. Without ever knowing it himself, Arthur is one of Ireland's greatest photographic archivists of social life.

One challenge in appreciating Arthur's gift to social history is that no negatives of his images were ever kept, primarily because there were just too many (a conservative estimate is 182,500 images). The only versions of Arthur's photographs were those he gave to his customers. The purpose of the Man on Bridge project was therefore to assemble a collection of Arthur's photographs. From the very beginning of the project, we have been overwhelmed with the engagement and the thousands of photos that have been submitted. This book exists because of the people who have added their photograph to the project. Equally, it owes a huge debt of gratitude to Arthur's wife, Doreen, his family and, of course, 'The Man on the Bridge' himself.

We hope that you will find each page mirroring who we were and how we lived over 50 years. Enjoy the book but, most of all, cherish each of the photographs contained within.

This portrait of Dublin is a growing one and the process of collecting photos is ongoing. If you wish to add your photograph to the archive, visit www.manonbridge.ie

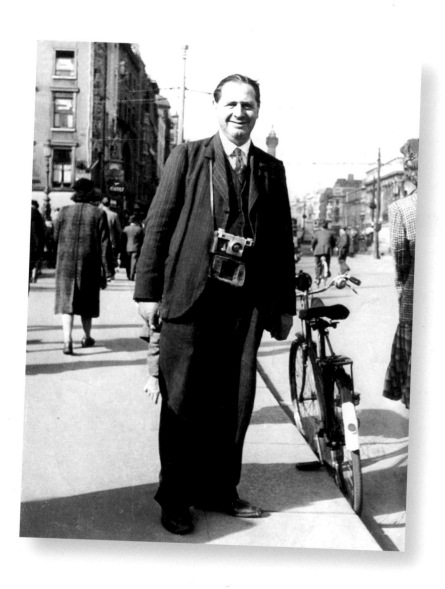

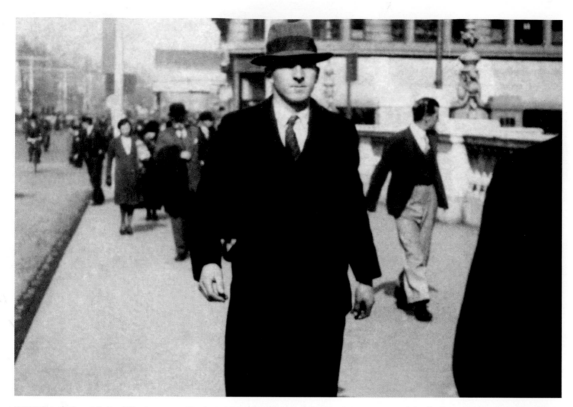

1930 'My father, Michael Brady, was a Garda stationed in Clontarf at this time. He was originally from Dromore West in Sligo and moved to Donegal a few years after this photo was taken. He retired from the Gardaí in Dundalk, County Louth, in the early 1960s.' *Kathleen Brady*

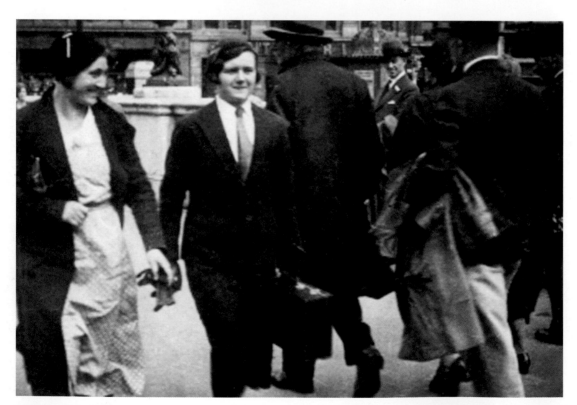

1930 'On the right is my mother, Margaret Burns (née Clifford) of Boolananave, Sneem, County Kerry, with her friend Bridie Murphy (née Devane), from Baile an Éanaigh, Ballyferriter, County Kerry. They were fast friends from the time they met in Coláiste Íde and both qualified as teachers. They made a trip to the World's Fair in New York in 1939 and arrived back in Ireland on the day the Second World War was declared.' *Margaret Burns*

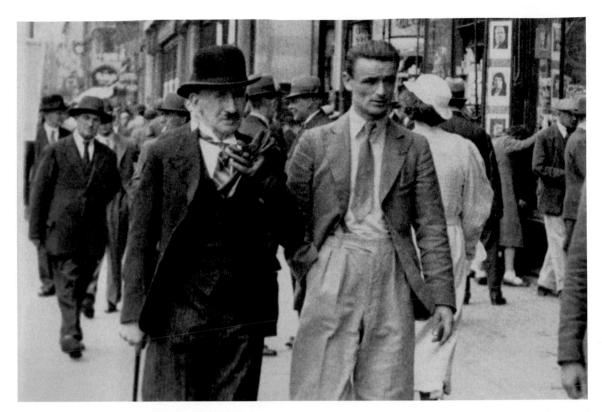

1932 'I was given this photo by distant relatives. It shows Gabriel Lee with his father James. Gabriel fought and died in the Spanish Civil War in March 1938 fighting on the National side with O'Duffy's men.' *David O'Reilly*

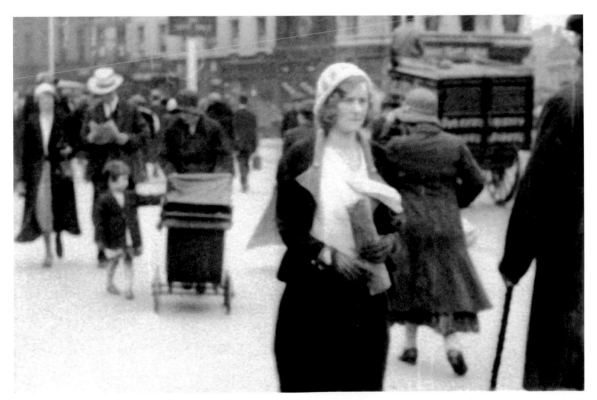

1933 'My mother, Kay Dunphy, when she was 28 years old. She was from Abbeyleix and worked in the Irish Hospital Sweepstakes. The head office was in O'Connnell Street. She was always very fashionable.' *Des Clarke*

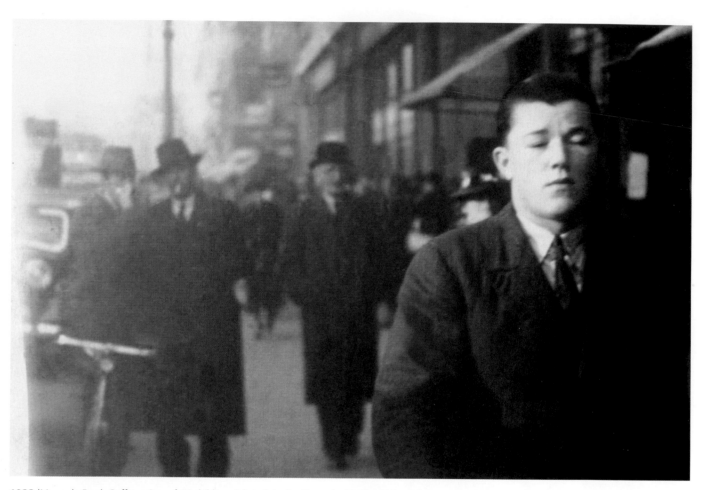

1933 'My uncle Frank Gaffney. One of 16 children. A lot of the family worked in the O'Connell Street area.' *Jackie Gaffney*

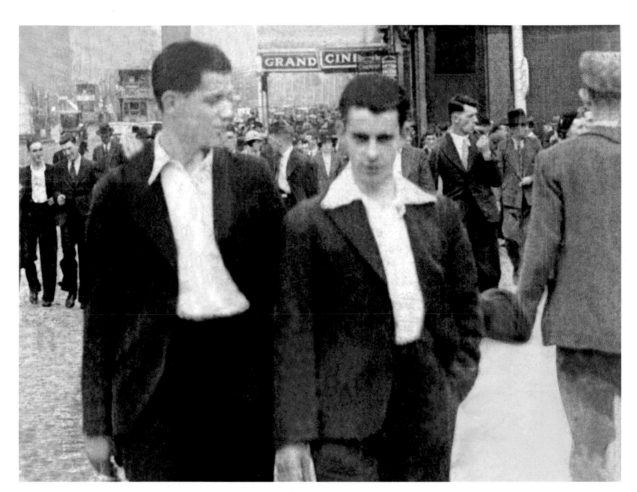

1934 'This is my dad, Tom Gaffney (right), with a friend. He was a barman in Gaffney's pub in Fairview for a while and also ran dances in Barry's Hotel. We believe he had an arrangement with Arthur Fields to take photos of couples as they left the dances.' *Jackie Gaffney*

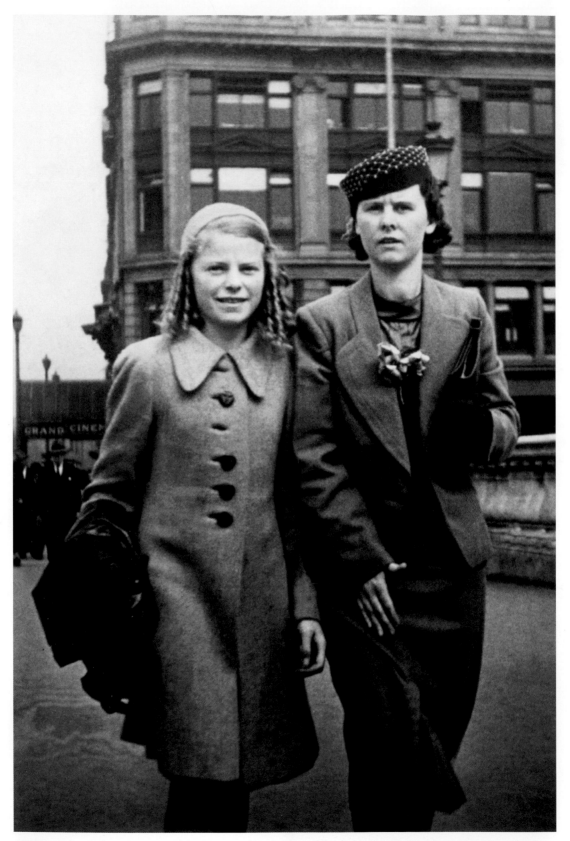

1935 'My two aunts, Nellie (right) and Esther O'Connor from Ringsend. Esther was a royalette in the Theatre Royal. The royalettes were a troupe who danced before the film. I imagine Nellie was bringing Esther to a dance lesson. They would not have had much in those days but they were always very stylish. Both of them were born in Ringsend. Nellie worked in Jacobs. Esther became Esther Nagle and always had lovely blonde hair tied up with a bow, always really glamorous.'
Angela Warren

1935 'My great grandfather Jack Gahan and his son-in-law William Connolly. Jack worked as a cinema usher and William Connolly as a compositor in the printing business. Both were from North Strand.' *Francis Melia*

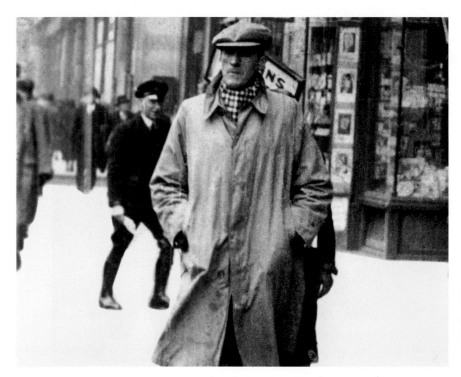

1935 'My uncle Jim Roberts when he was a Garda stationed in Roundwood. Later he moved to Greystones. When he came to Dublin he would always meet his sister (my mother) Kathleen Murphy. They met every week.' *Marie Dunne*

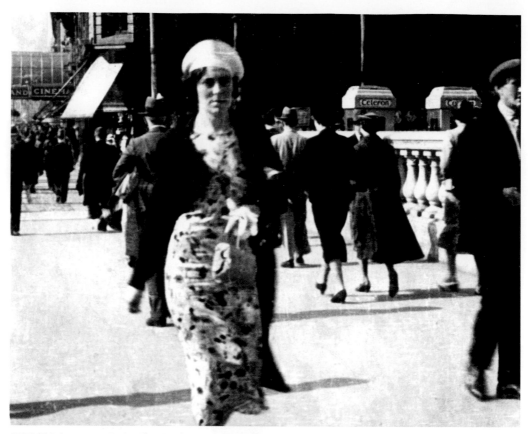

1935 'This is my aunt Doris Gillespie who was born and reared in Dublin. She was the wife of Jim Roberts (see previous page).' *Marie Dunne*

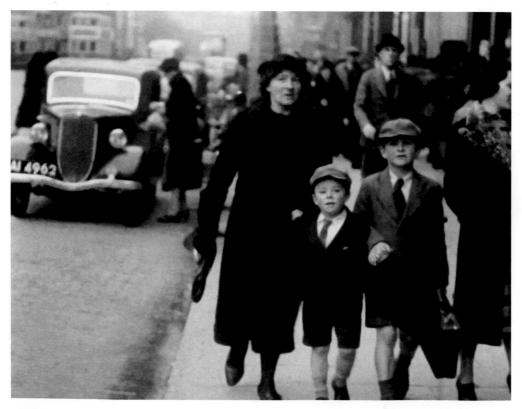

1936 'My mother, Evelyn Williams, me (Alwyn Williams) and my brother Alva up in Dublin for the day. We are all in our Sunday best. I love this photo as it shows how busy O'Connell Street is, with the old car in the background and us in our best suits – including short pants and caps!' *Alwyn Williams*

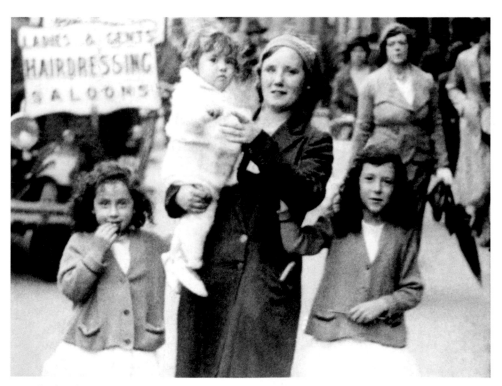

1936 'My sister Lona Moran, when she was four or five years old. Lona studied art in the National College of Art; she taught art for a while and studied in Italy for a period. She worked as a set and costume designer in The Gate and Olympia and travelled with shows to New York, Hong Kong and Finland. She joined RTÉ in 1965 and worked on *The Riordans, Strumpet City* and many others. She passed away in 2007.' *Frances Gorman*

1937 'In this photo are Ralia, Beulah and Jacqueline (my mother), three daughters of another street photographer by the name of Harry Cowan. Harry, just like Arthur Fields, was Jewish and of Russian origin. Harry arrived in Dublin when he was three and went on to study with the court photographer in London before establishing Harry Cowan Photography Studios in Dublin. Harry took both studio and street photographs, including this one. At the time, there were plenty of street photographers and I imagine Harry would have known Arthur quite well. The woman in the photo is the children's nanny.' *Hilary Abrahamson*

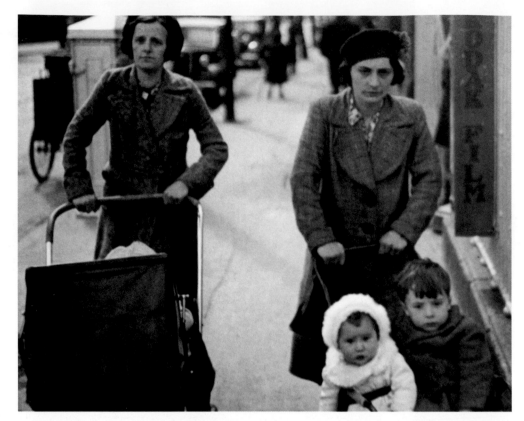

1939 'Me and my brother Frank (in buggy) pushed by our mother, Cecilia Halford, accompanied her friend Mary Fahy. This is the earliest photo I have of me as a baby.' *Cecilia Homan*

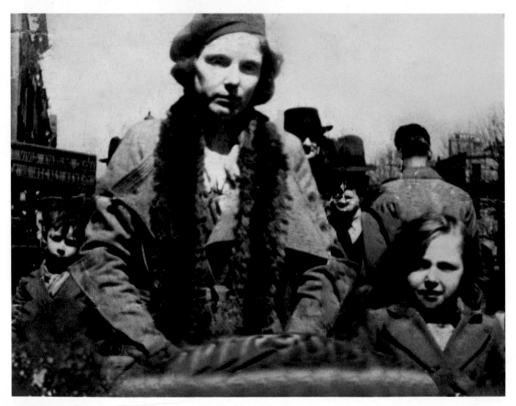

1939 'My wonderful mam Isabella Horrigan Jolley in 1939, with my sister May Jolley Wheeler, aged six. May is now 82 years young. The baby in pram was my sister Honora who passed away when she was just three years old. She was buried in a paupers' grave in Glasnevin which she shares with two other people. Last year I found her grave in St Patrick's Plot, not far from my parents Isabella and William's family grave.' *Trish Nunes*

1939 'This is my grandfather Mathew Fennell from New Ross, County Wexford. This was the first ever photo I saw of him as a young man. We think he was in Dublin that day on business for the insurance company he worked for. The most vivid memory that I have of my grandfather is that he always had a cigarette in his hand, as you can see he even has one in this picture. He died of lung cancer in 1984.' *Paul Fennell*

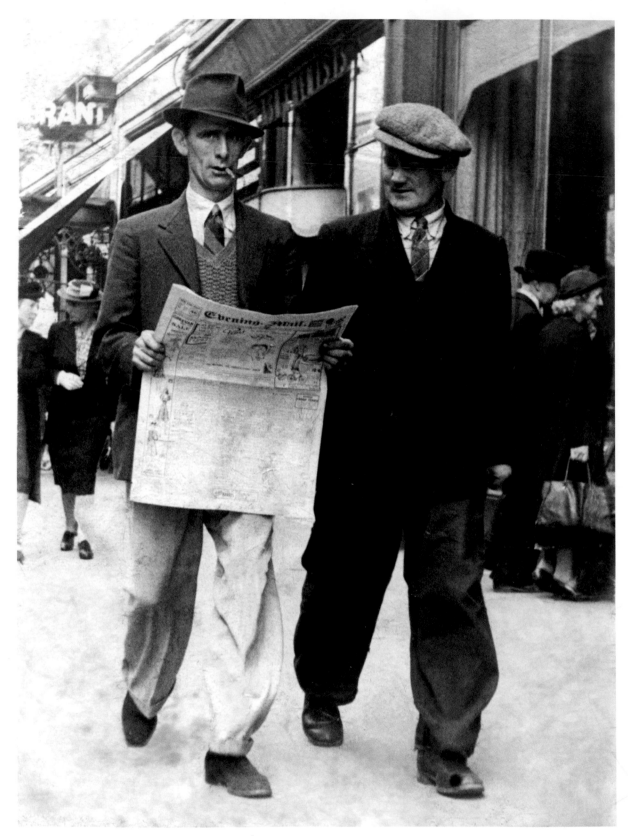

1939 'My father, Thomas (Tommy) Dalton on O'Connell street with a friend. He worked in the Clarnico Murray sweet factory in Terenure.' *Bernie Dalton*

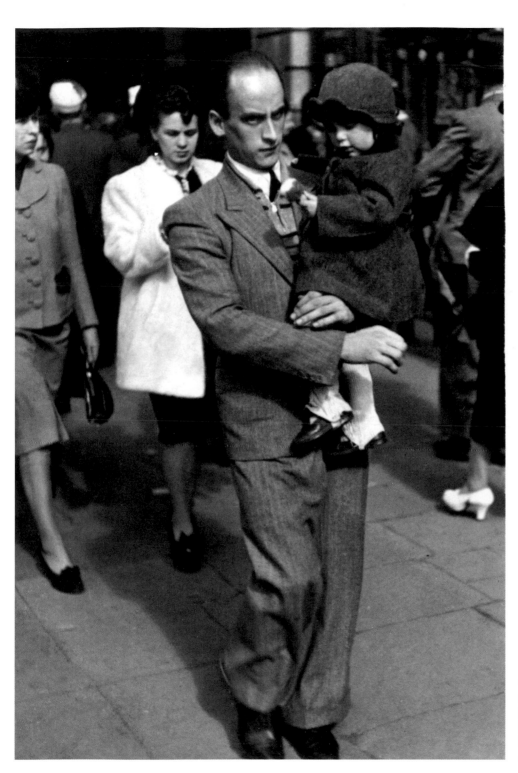

1939 'My father, George Scarry, and me (Florrie) out for the day. He used to take me out to the amusements.'
Florence McElroy

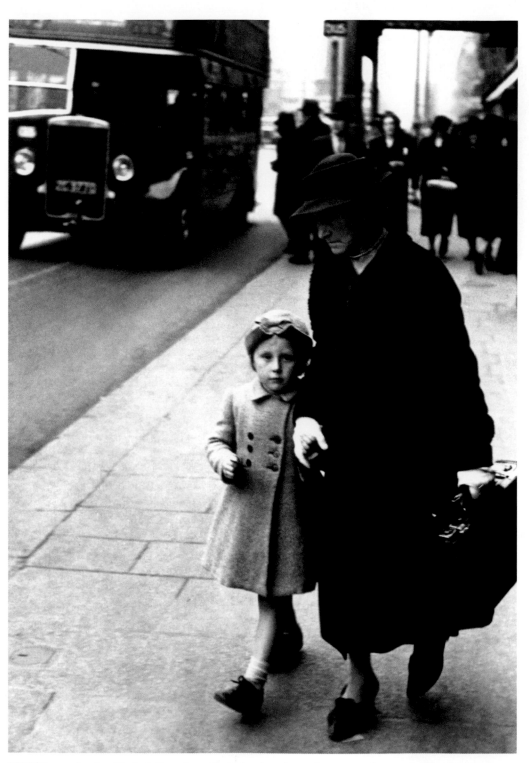

1939 'My grandmother Elizabeth Casey from Clontarf and me. I was about two or three years old at the time.'
Joan MacNeice

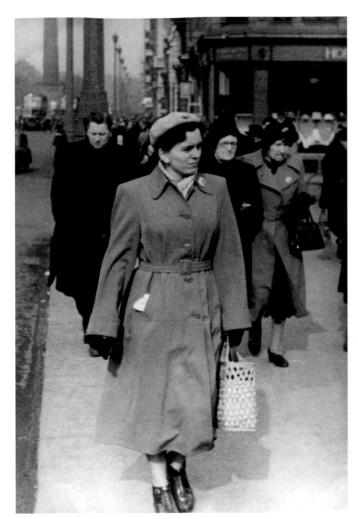

1940 'My grandmother Marie Murphy from Blackhall Place on her way to Pollycoffs where she worked as a seamstress. She used to make her own clothes and was even known to make three-piece suits from very good curtain material, à la Scarlett O'Hara in *Gone With The Wind*. Every one of us in the family wore something that she made.' *Natalie Christie*

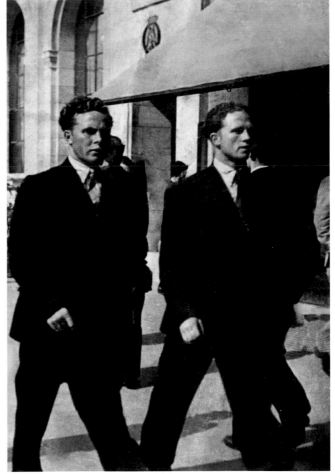

1940 'Brothers Teddy (right) and Paddy Horrigan from 13 Henrietta Street, Dublin. Teddy served in Singapore in the Second World War. He is now is a cool 88 years young. Their father, John, fought in The Battle of Loos and was taken as a prisoner of war in April 1916. He survived.' *Trish Nunes*

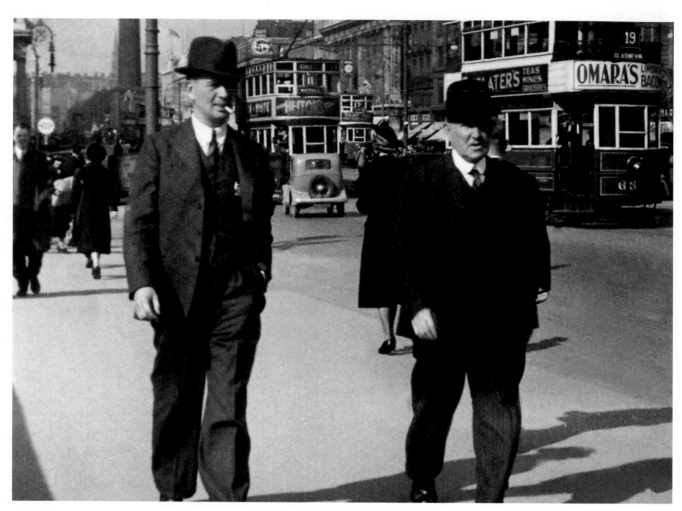

1940 'James McMurrough (right). He was an importer of materials – silks, sheets, towels, etc. – from Kobe in Japan. He supplied Arnotts and Clerys with sheets and so on. James McMurrough & Co. were located at 75 Middle Abbey Street. The photo was taken about 75 years ago. My late mother, Mai Verling, was his secretary.' *Stella O'Neill*

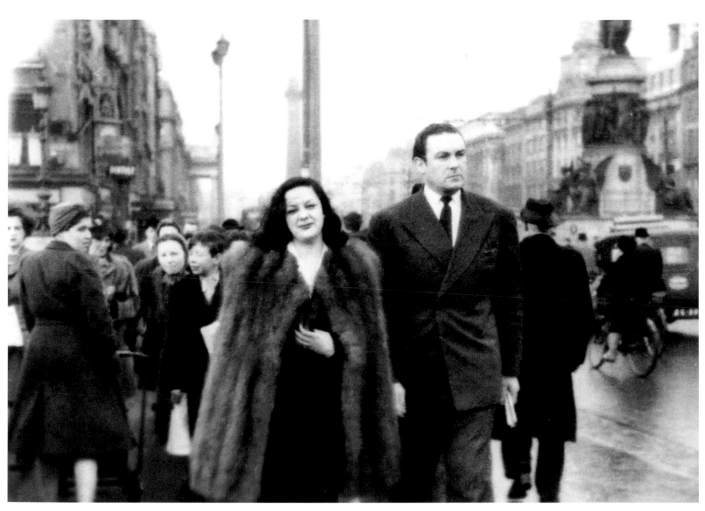

1941 Actress Movita Castaneda and boxer/singer Jack Doyle, who were married briefly. When the pair walked down O'Connell Street in the 1940s, a couple of hundred people trailed awestruck behind the glamorous couple. They went their separate ways shortly after this photograph. Movita went on to marry Marlon Brando. Jack died from cirrhosis of the liver in 1978, penniless and homeless. For a while though, they were the 'it' couple in Dublin. *Arthur Fields family collection*

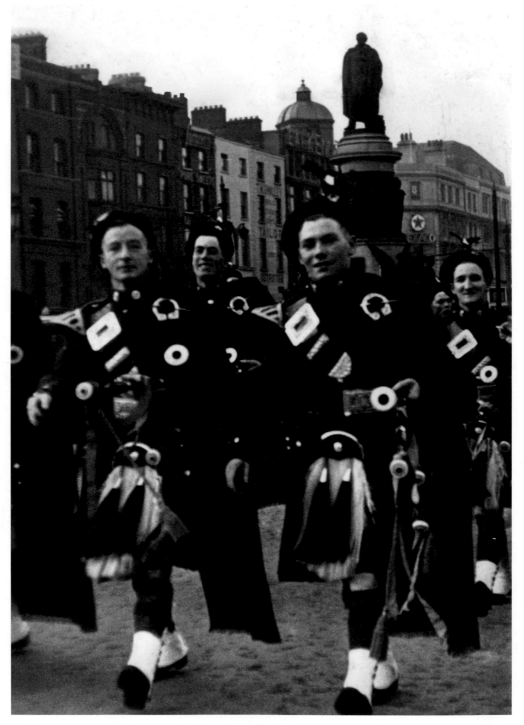

1941 'St Dominic's Pipe Band, Tallaght, returning across O'Connell Bridge from a Marching Band Parade in Croke Park in 1941 or 1942. Most members were from the Tallaght area, as well as Terenure and Clondalkin, and they were en route to their buses home (both the 51 and 77 left from Aston Quay at that time). Front row (l–r): Dan Kelly from Tallaght village and Jim Kennedy from Greenhills. In the back (l–r): John Byrne from Rialto and Paddy Kelly from Tallaght village.' *John Curran*

1941 'Rose Cosgrove (left), my second cousin and godmother. Rose was a very stylish and beautiful young woman. Beside her is the love of her life, Lieutenant Claude Bishop, a US soldier whom she met on a visit to our house in Newry. The officers of the US army were billeted at 40 Canal Street in Newry, three doors from our home. My cousin in Canada tells me her mother often spoke of the great distress in our family circle when they learned of Claude's death during the war. My other grandparents lived in a large house on Barrack Street, a short distance away, and as they were builders engaged in the construction of the army camps, their house became a home from home for many of the soldiers. With a large family it was a great ceili house. To the right of Lieutenant Bishop is Rose's sister Kathleen. He probably travelled up to Dublin on the train and spent the day being shown around the very relaxed Dublin, free from the cares of war. Rose never married – perhaps the war ended her dreams – and nor did Kathleen – she was too young at heart.' *Rosaleen Cole*

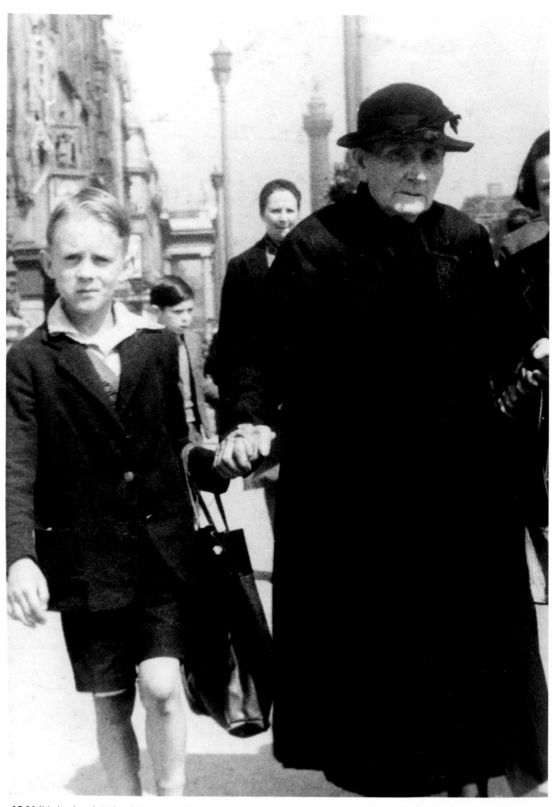

1941 'My husband, Richard Dunne, and his grandmother, Margaret Gibson. Richard's father died before he was born and the family went to live with their grandmother who lived on Oxmantown Road in Stoneybatter. Her husband was a shoemaker in the army and was stationed in the Curragh.' *Marie Dunne*

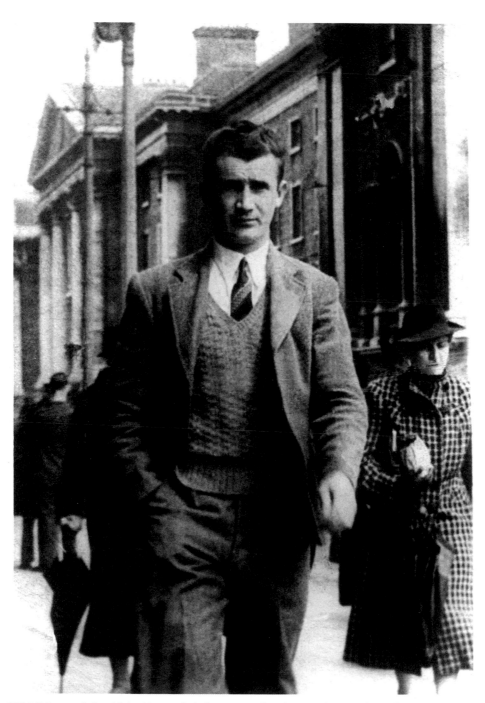

1941 'When my father, Michael Lyons, died, there were a few photographs around. I can't remember how this photograph came into my hands because I was overcome with grief. My father was involved with the Old IRA. He was interned in the Curragh for a period. Among his possessions was this photo with the name Charles Kerins on the back. Charles was, I believe, a friend of my father and was a prominent Irish Republican, who, following his killing of policeman Dennis O'Brien, was named the chief of staff of the IRA. After spending two years on the run he was captured by the Gardaí in 1944. following his trial and subsequent conviction, Kerins was hanged in Mountjoy Prison.' *Josephine Stewart*

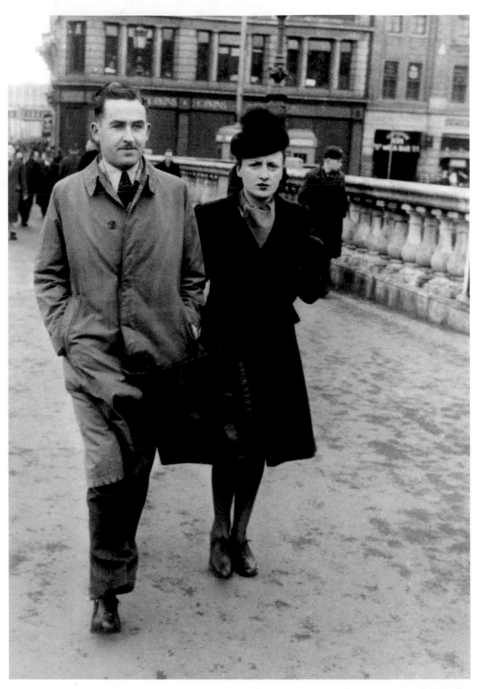

1942 'My parents, Michael Brennan and Rose (née Matthews), from Glasnevin, walking over O'Connell Bridge in March 1942. He lived in St David's Terrace, Glasnevin, and Rose in Goldsmith Street, Phibsborough. They met in the Botanic Gardens in Glasnevin. They were photographed in Dublin city a number of times between 1942 and 1945, during which time they were dating. On the backs of some of their photos are the words "with love, Michael" or "with love, Rose". It seems as if they got the photos taken to give to each other, and to keep as memories of those days. Rose had a great sense of fashion and made a lot of her own clothes. She made her own wedding dress, and made her children's clothes when they were youngsters. They lived in Glasnevin for the rest of their lives. They were married 49 years when Rose went to heaven in October 1995, and Michael followed her four years later.' *Anne Brennan*

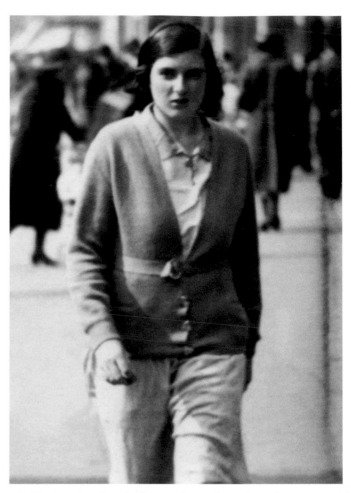

1942 'Mai Moran, whose family owned Moran's Hotel on Talbot street. Mai worked in the tourist board on O'Connell Street.' *Frances Gorman*

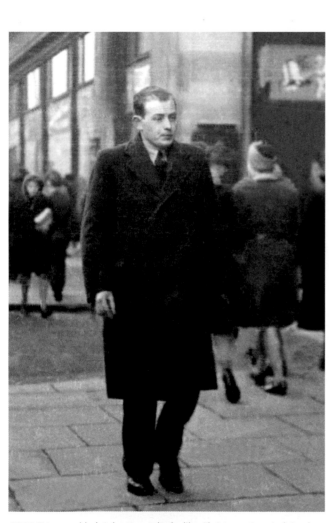

1942 'My granddad, John Kerr. It looks like Christmas time, judging by the decorations in Clerys.' *David Clarke*

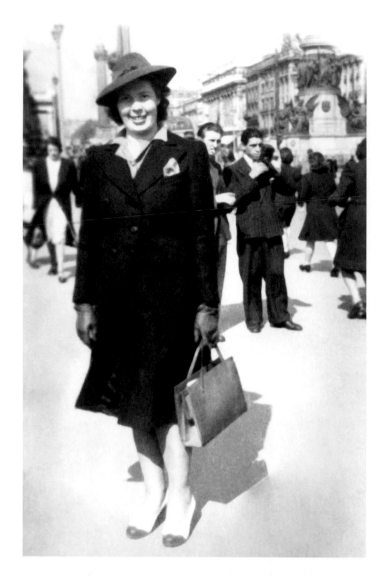

1942 Arthur's wife, Doreen, who was originally from London, is seen here photographed by her husband in the early 1940s, dressed immaculately in the fashion of the time. She would frequently go into Dublin city and visit Arthur while he was working on the bridge. Arthur would always take the opportunity to photograph his family on their trips into the city. They turned one of the rooms in their home into a darkroom where Doreen developed the photographs. There was also a writing desk where she typed out addresses for posting out the photos. *Arthur Fields family collection*

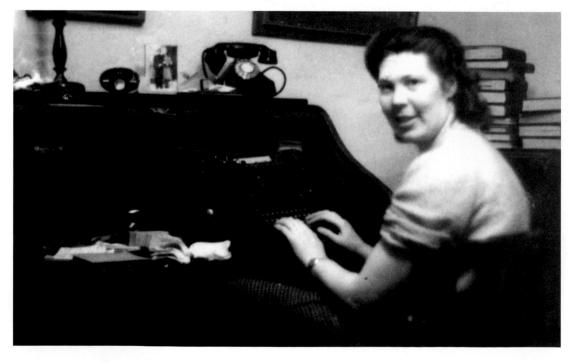

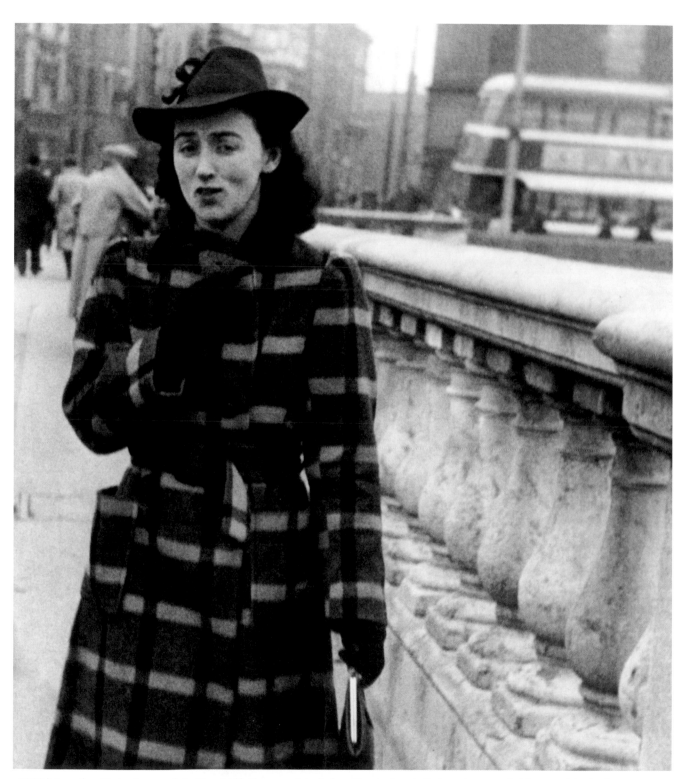

1942 'My mother, Madge Brennan (née Fitzpatrick). She was originally from Kinsale, County Cork, and came to Dublin to work in the Custom House, in the civil service.' *Maura Brennan*

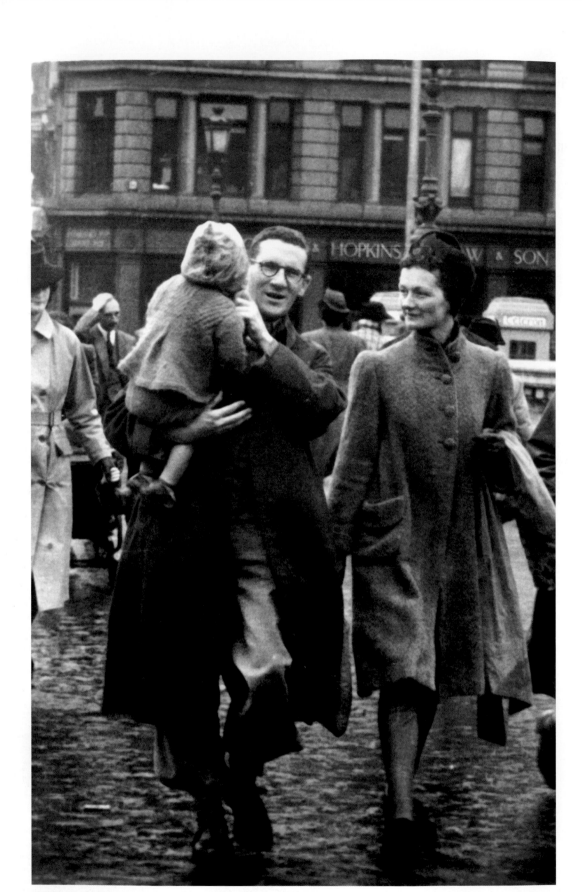

1942 'Refugees from a wet holiday: my father Bill Phelan, my aunt Molly and baby Padraig.' *Mary Phelan*

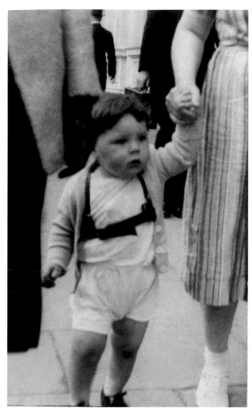

1942 'I am two and a half years old in this photo. I was born in Liverpool in 1938 and moved to Dublin in 1939. I dodged the German bombings of North Strand during the war and the big flood of 1954. I'm just waiting on the volcano.' *Dermot Molloy*

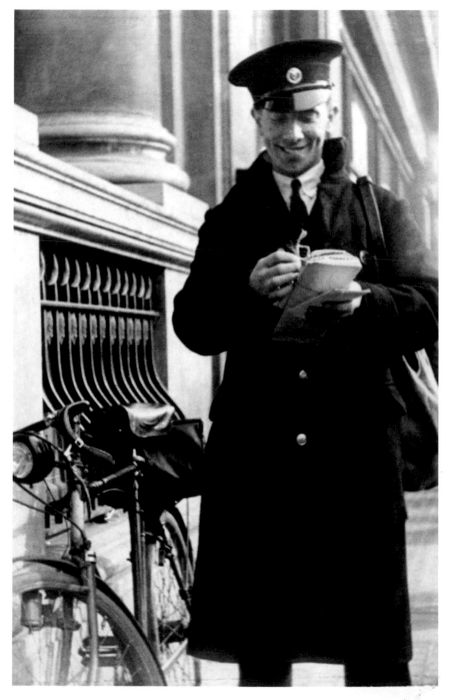

1943 'Tim Kearns from Ballyhaunis County Mayo, aged 35 years. Tim worked for Posts and Telegraphs (P&T) and served for over 56 years.' *Patrisha Lovelle*

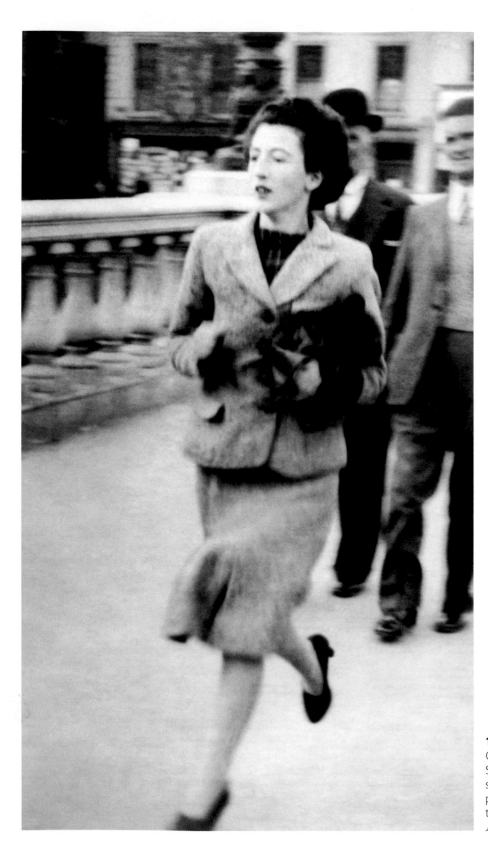

1943 'My mother, Mary (Maisie) Collins, who worked in the civil service. She was perhaps late this day and was snapped running across the bridge. This photo was taken prior to her marriage to my father Jack Walsh.'
Jeanette Darcy

1943 'Thomas Kirwan and father Christy on his communion day. My father loved his bike and was always on it.'
Tommy Kirwan

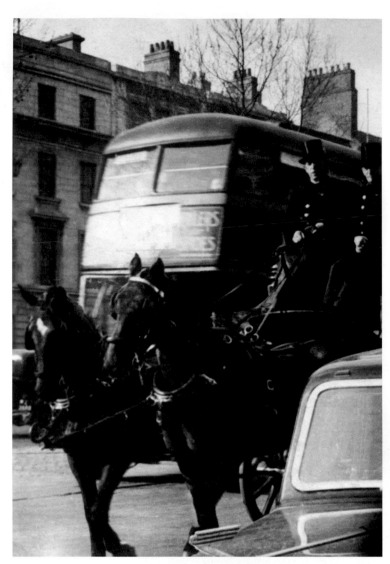

1943 '(L–r): My grandfather John Doyle and his colleague Jack Mates, who worked for Fanagan undertakers on Aungier Street, on their way back to the stables after a funeral. Mr Mates lived beside the stables with his wife and family, which was across the road from the main offices. He looked after the horses primarily so it must have been a busy day if Mr Mates was on the road.' *Marion McCarthy*

1944 'Arthur Fields' daughter Norma and son Bernard (my sister and brother). Our mother, Doreen, would regularly take us into Dublin to do shopping and buy presents. Here, Bernard has a brand-new drum and drumsticks, so no wonder there is a grin on his face. Norma has got something nice, too.' *Philip Fields*

1944 'James (Jim) and Florence (Florrie) McLoughlin, taken, I believe, on their honeymoon in Dublin in October or November 1944. Florrie's maiden name was Raymont. Jim, my dad, was born and raised in Dublin, where at one point he was a driver for the Theatre Royal. He joined the British army in the war and one of his postings was to North Devon, where he met my mother, Florrie. They married in north Devon and went to Dublin for their honeymoon. I was born the following year, but on my first birthday, in 1946, my mother was admitted to a TB sanatorium and died there in 1949. So you can see why this photo is very special to me. They were newly-weds who were happy and had no idea that their married life would be so short. Yes, there was happiness in my dad's life after losing my mum to TB. In 1950 he remarried and he and Olive had another two children, my sister, Ann, and my brother, Mike. He died quite young though (by today's standards) aged 60, while Olive died in 2011, aged 89.'
Maureen Terhune

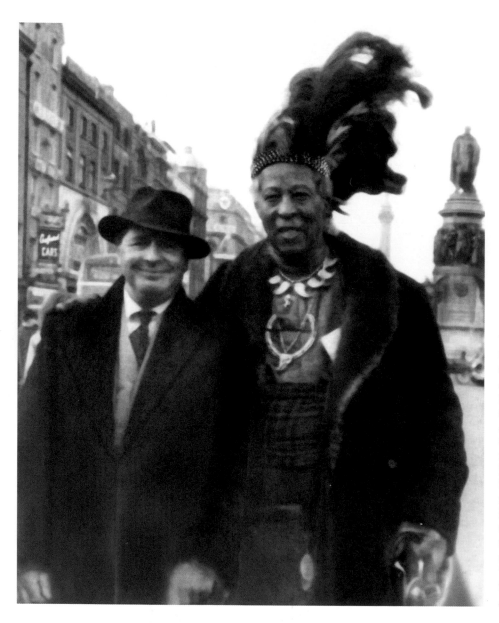

1944 Over the years, many famous people crossed O'Connell Bridge and Arthur's lens captured them. Being a fan of the horses, Arthur did not miss the opportunity to be photographed with a famous street character and horsing tipster, Ras Prince Monolulu. Arthur loved horse racing and no doubt he exchanged some tips with Ras Prince, whose real name was Peter Carl Mackay (or McKay). He was something of an institution on the British racing scene from the 1920s until his death. He was particularly noticeable for his brightly coloured clothing. He claimed to be a chief of the Falasha tribe of Abyssinia, and wore a headdress and a fur coat. As a tipster, one of his best-known phrases was the cry 'I gotta horse!', which was subsequently the title of his memoirs.
Arthur Fields family collection

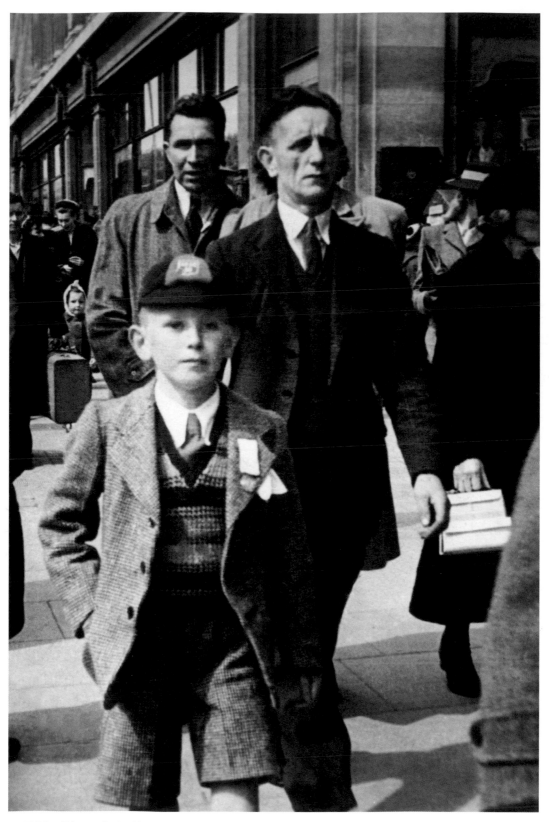

1945 'Myself (Jim Cullen) with my uncle Thomas Ward on my communion day. We were going to the Grand Central picture house to see a film and I had just been to visit my aunts and uncles. We lived in Inchicore at the time and my father, who was a Garda, couldn't get time off work so I went with my uncle instead. Thomas passed away in 1972.' *James Cullen*

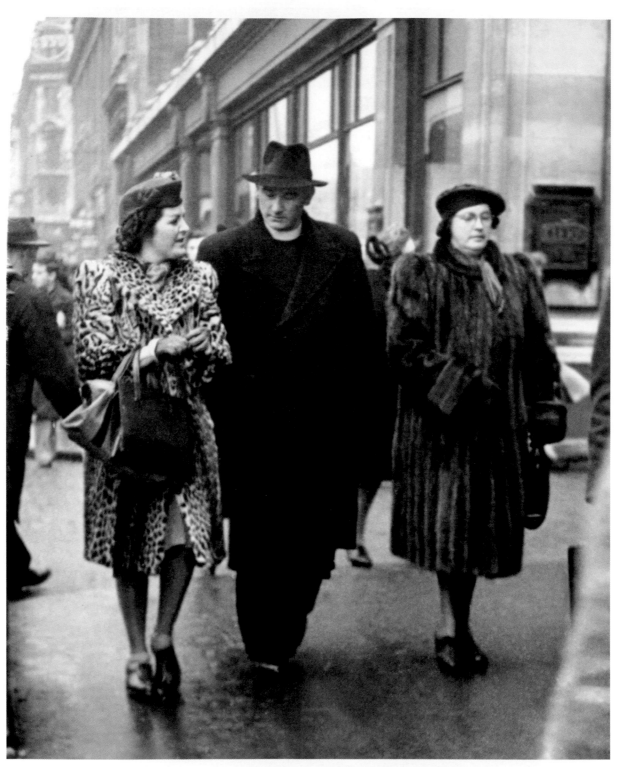

1945 'Olive O'Donoghue (left) and her mother, Molly (née Curtis), both of Hollybrook Road, Clontarf, Dublin. The priest in the middle is probably Father Hugh (Sonnie) or Father Tim O'Donoghue, cousin of Olive, from Killarney, County Kerry. Molly married Michael O'Donoghue in Dublin in 1914. He was one of the first Irish bookmakers and was always known as "Killarney" because of where he came from. Olive married John Sheridan in 1948. He was from Castlederg, County Tyrone; his brother, Joe, invented the Irish coffee while he was a chef in Foynes, Shannon. There is a plaque to his memory in Shannon Airport.' *Sheila Sheridan*

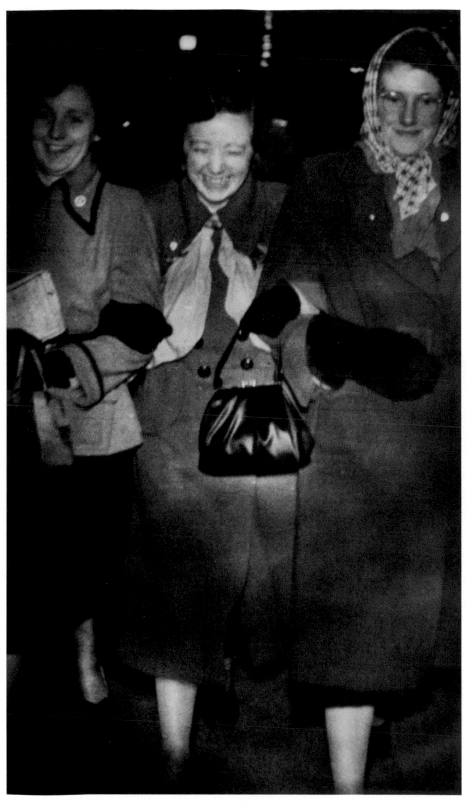

1945 '(L–r): My mother, Kathleen Moles, my aunt Maureen Moles and their lifelong friend Gaye Manson. They all continue to have a great laugh together.' *Lucia Donnelly*

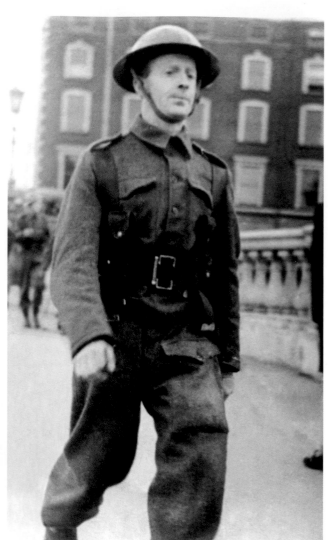

1945 'My father, Robbie Dillon, on his way back from a military parade. He was a member of the Local Defence Force (LDF). Originally he was a bricklayer by trade but there was a slump at the time so he responded to the government call to join the LDF. The discipline that he learnt through the LDF was great for him.' *Joseph Dillon*

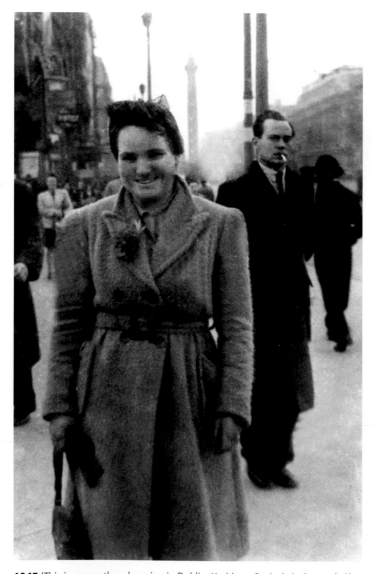

1945 'This is my mother shopping in Dublin: Kathleen Gavin (née Dargan). She had three children. She passed away on 30 April 2014.' *Marie Campbell*

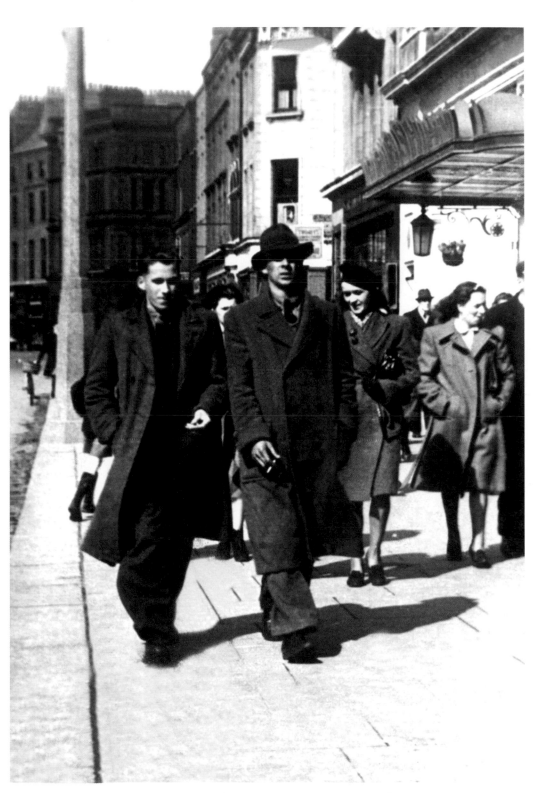

1945 'My future father-in-law, Gerard Beggs (left) and his brother James (right), both from Summerhill Dublin.'
Marian Beggs

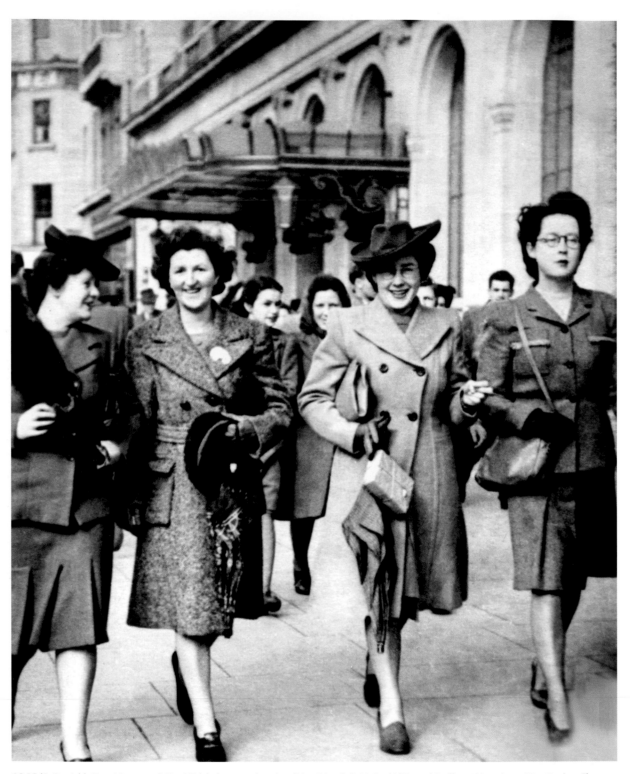

1946 'St Patrick's Day. My mum, (Mina Walshe), my godmother (May Murphy), Maire (O'Hagan) Duffy and her sister, Rita Conlon. They more than likely have just had afternoon tea in the Gresham Hotel, which is in the background. Note how they are all out of step except my Mum!' *Claire Byrne*

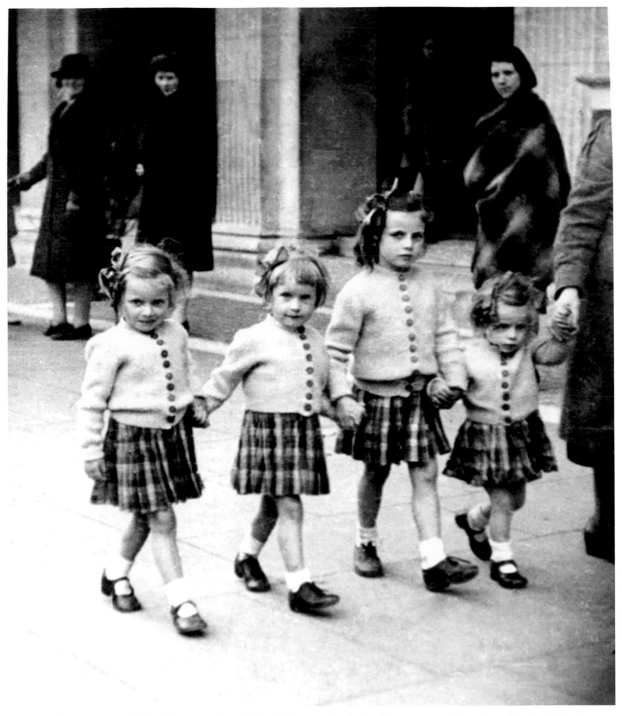

1946 '(L–r): Four sisters: Nellie, Pauline, myself (aged six) and Eithne outside the Gresham. My mum knitted everything, including the clothes we are wearing.' *Lily Meyler*

1946 'I love this photograph of my parents, with the cobbled Dublin streets, the car, the buildings behind – a nice shot depicting the period. My mother looks so fresh-faced here in her beautiful coat. I know that she made all her own clothes at that time, and I remember this coat very clearly. It hung in the wardrobe all of my childhood. If you look closely you can see that my father has a cigarette in his hand. It is an unusual photograph in that regard as he smoked for only a very short period in his life.' *May Frisby*

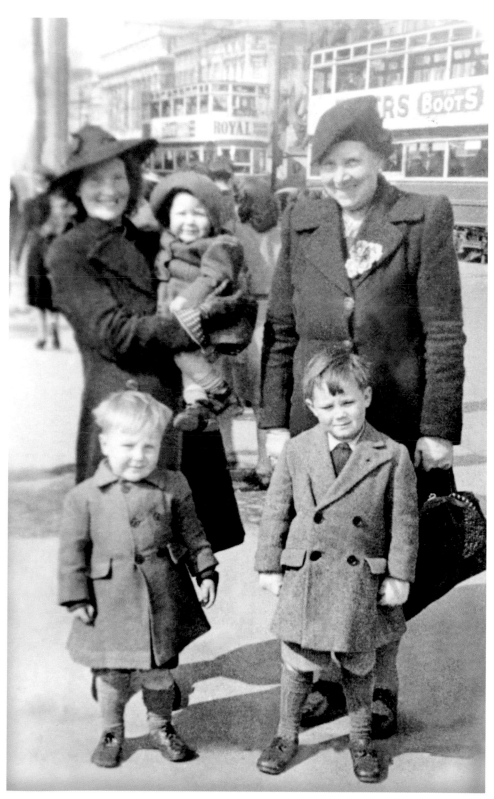

1946 'This is a photo of my mother, Bernadette Browne, as a baby with her brothers Francis (left) and Paddy. With them are my grandmother Grace Browne and my great-grandmother Laura Cowan, who was a good friend of Arthur Fields' wife, Doreen.' *Aisling Murray*

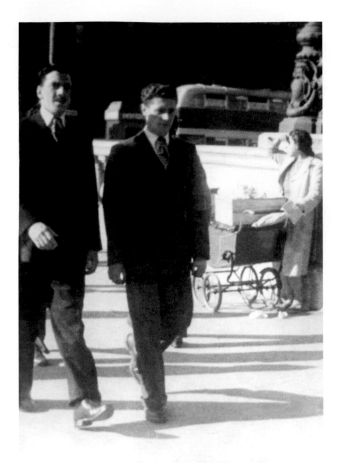

1946 'My cousin Paul Casey (right), aged 17, with a friend. Paul lived in Fairview and worked in Clerys department store in the dispatch office.' *Hilda Beare*

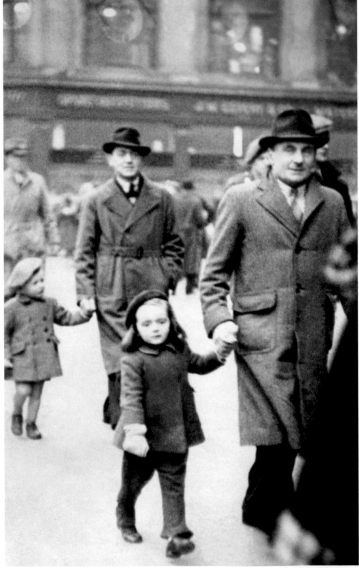

1946 'Me (Jackie Mohan) and my father Paddy going to the ice-cream parlour, the Palm Grove. We lived in Raheny at the time and knew Arthur Fields and his family, as they lived nearby. My dad used to take me into town for a treat, usually ice cream.' *Jackie Thomas*

1946 'My aunt Isralia Cowan. She was one of the daughters of Harry Cowan, another Dublin street photographer.' *Hilary Abrahamson*

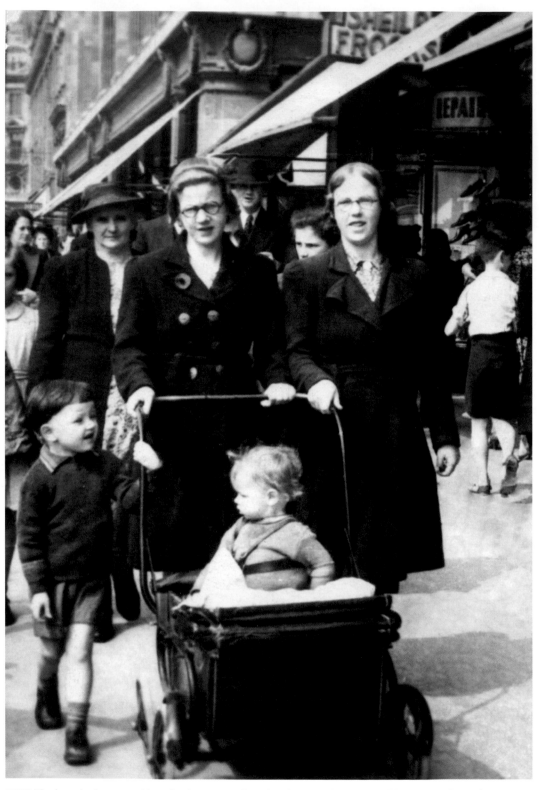

1946 'That's me in the pram with my brother Sean walking beside my mother, Sally, and her sister Margaret.'
Harry McNamara

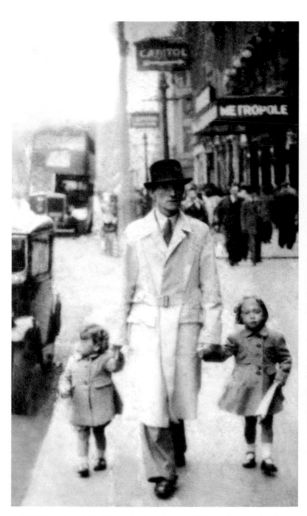

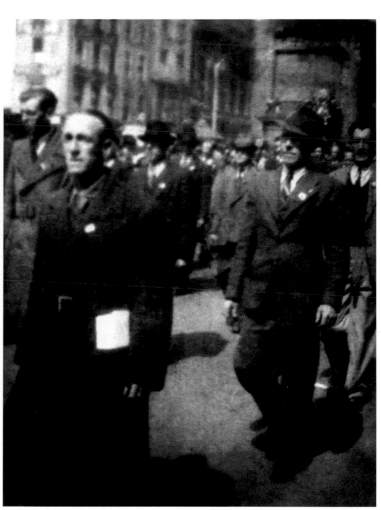

1946 'Brendan O'Sullivan (a chemist at 67 Parnell Street) with daughters Bernadette, aged three and a half, and Ciara, aged two and a half.' *Ciara Byrne*

1946 'The man in the hat is my mum's cousin at the funeral of Sean McCaughey, an IRA leader in the 1930s and 1940s and hunger striker.' *Fionnuala Smyth*

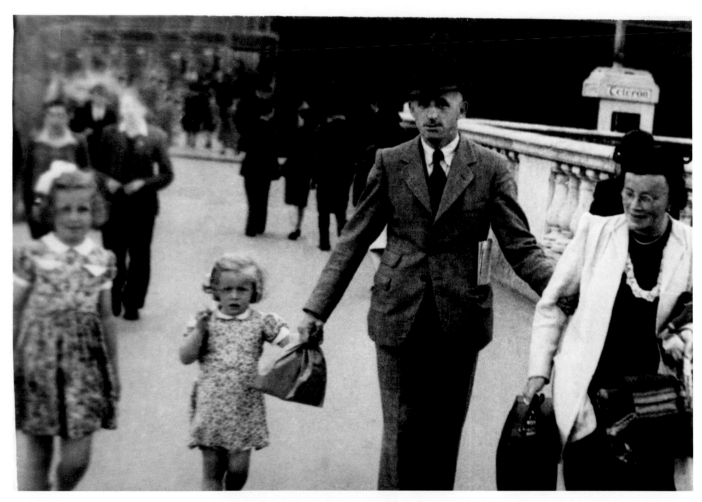

1947 'Taken around 1947 of the Dunne family with my father, Patrick, holding a bag of the famous Hafner's sausages and black and white pudding on his way home from work. My mother, Alice, is carrying all the bags as we were coming back from our holiday in Skerries and we had just met up with him on O'Connell Bridge. My sister, Colette, is on the left and I'm holding my father's hand. My mother is shying away from the camera as she hated having her photo taken so it's a rare picture of us all taken together. I'm hoping he relieved her of the bags after the picture was taken, but I can't remember.'
Miriam Dunne

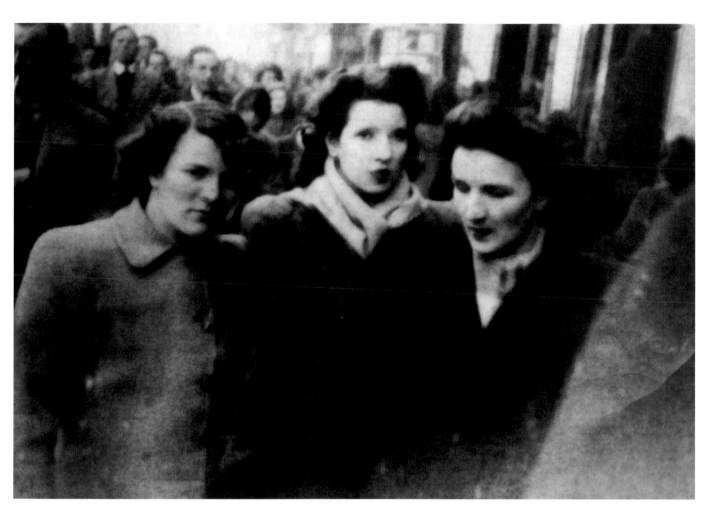

1947 'My mum, Eleanor Bourke (centre), and her two older sisters, Ada (left) and May. They were from Clanbrassil Terrace in Dublin.'
Linda O'Callaghan

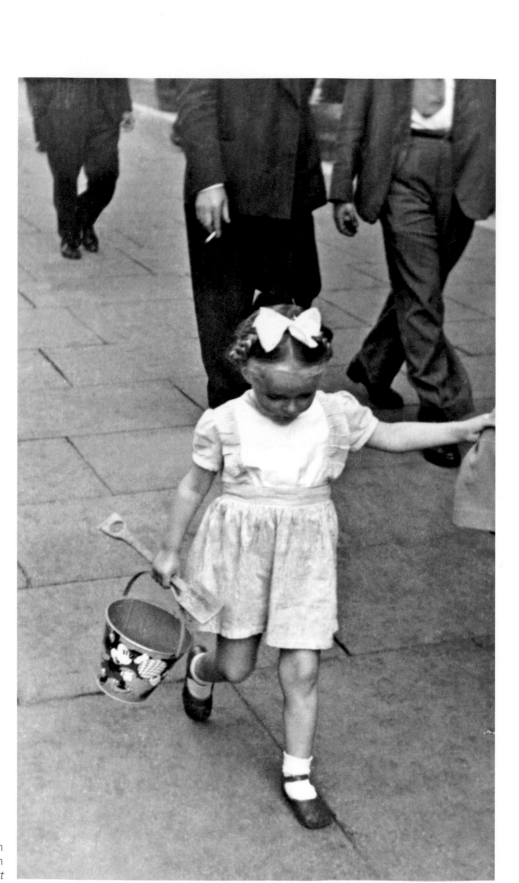

1947 'My mam's first cousin Pauline Burke on a day out in town 1947.' *Mark Hackett*

1948 'My mother Christina McDonnell and me as a baby on the day of my christening.'
John McDonnell

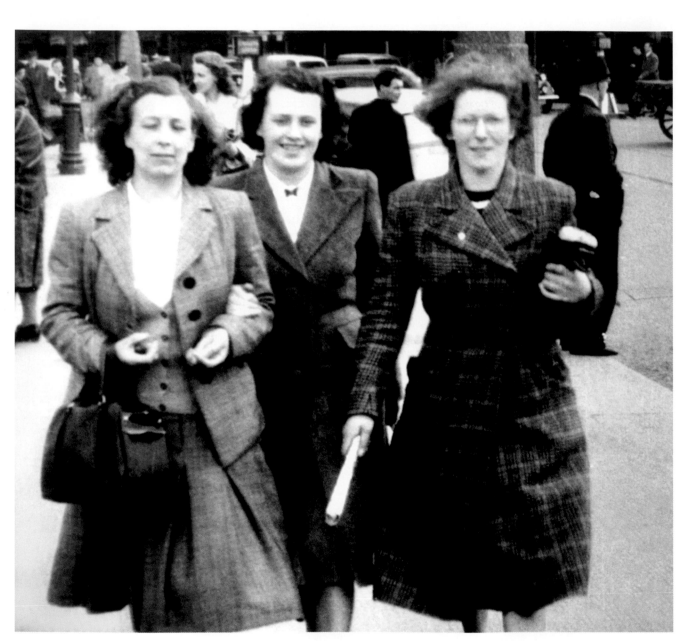

1948 'My grandmother Bridget O'Donnell (centre), out with friends from work. The photograph was taken before she was married and became Bridget O'Loughlin.' *Sinead O'Loughlin*

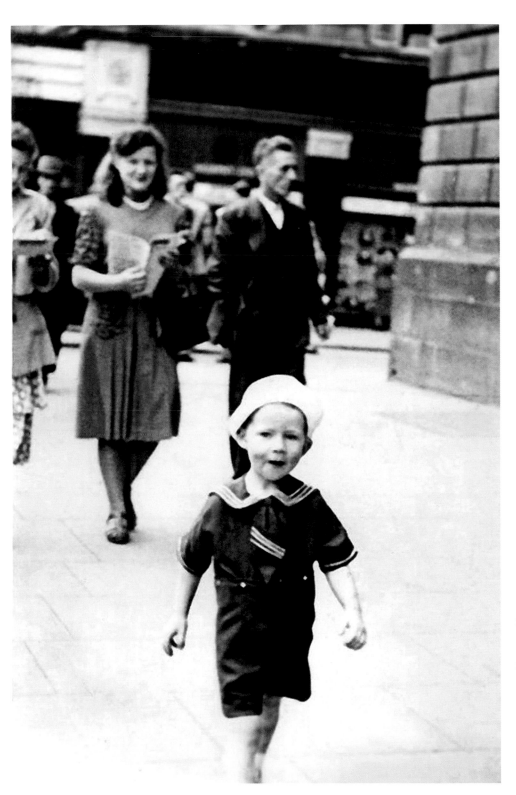

1949 'Myself, Michael Paul, wearing a sailor suit made for me by me grandfather Michael. I was his first grandson and was named after him. He was a shipwright and sailed as far east as Shanghai in 1895 and returned via Cape Horn. My second name remembers my great-grandfather Paul Kenny who was part of the Irish Brigade and who in 1865 fought in defence of the Papal States, which were under siege from Garibaldi. The medal awarded to him by Pope Pius IX for his participation is still in possession of our family.' *Michael Kenny*

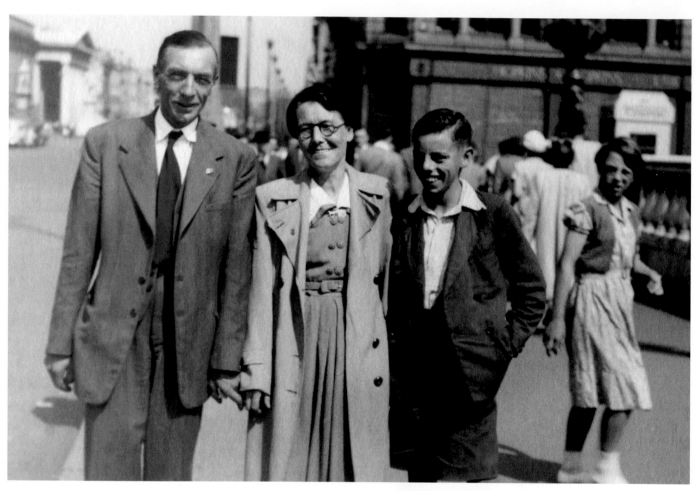

1949 'My grandparents Jack and Mary Whelan, and their son (my uncle) Matt.' *Shona Whelan*

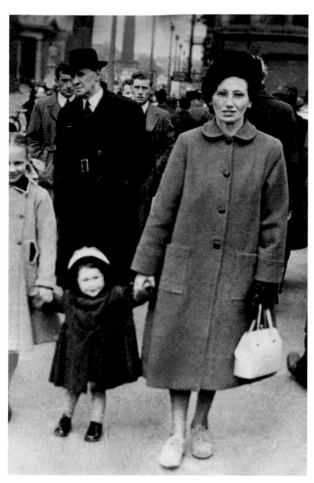

1949 'Me with my cousin Joan (left) and our aunt Alice, a dressmaker who made a lot of my clothes.'
Dolores Fitzpatrick

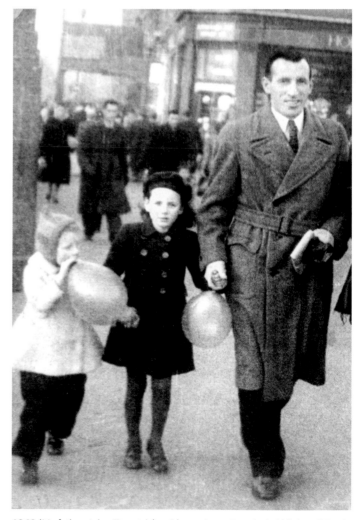

1949 'My father, John Fitzpatrick, with my sisters Brenda (middle) and Nuala, at Christmas 1949. Nuala remembers that they were returning home after a visit to Santa, hence the balloons and the present in my father's hand.'
Willie Fitzpatrick

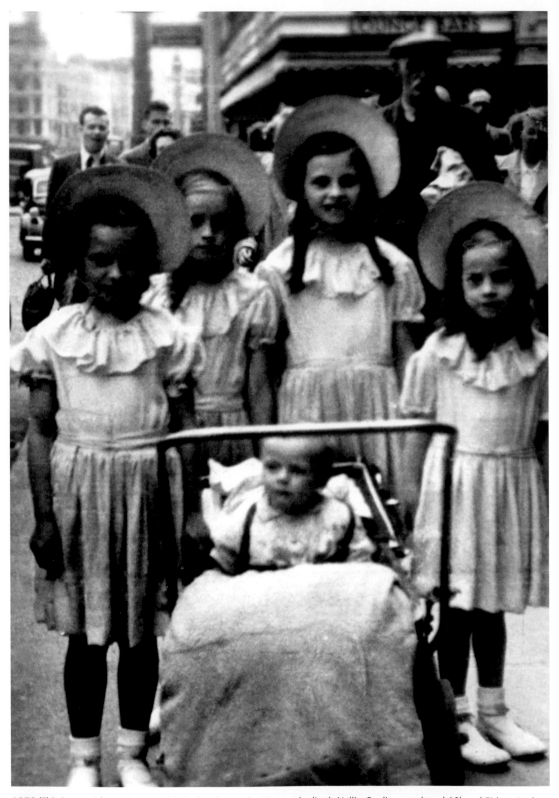

1950 'This is me with my sisters and baby brother at the Metropole. (L–r): Nellie, Pauline, me (aged 10) and Eithne. In the pram is our brother Paul. Our mother always dressed us the same. I remember getting the bonnets in a shop in Pims on George's Street, an old-fashioned drapery and general clothing place.' *Lily Meyler*

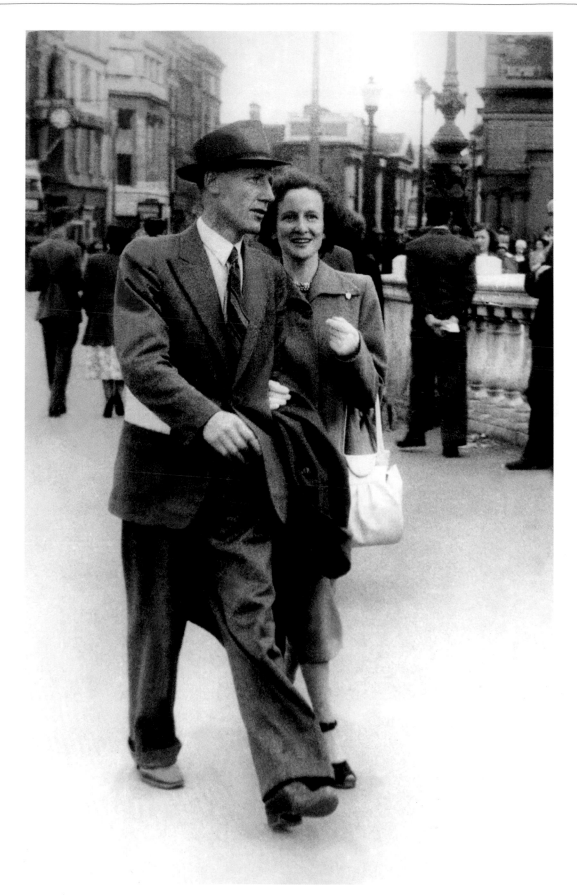

1950 'My grandparents Patrick O'Reilly and Agnes (née Gleeson) *c.* 1950s. They were very much in love. Pictured here walking across O'Connell bridge with the GPO in the background. Note the soldier in uniform in the background and nanny's pioneer pin.' *Aisling Devlin*

1950 'This is me in my car, with the long legs of my father, John "Jack" Joyce, on the right. My mother told me this was taken on O'Connell Street, which was plausible, since we lived just around the corner, in Mary Street.'
Trevor Joyce

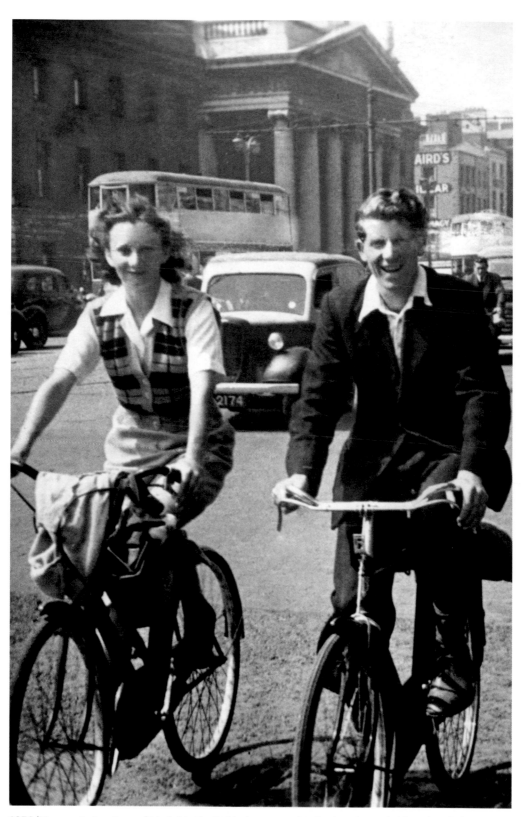

1950 'My parents, Ignatius and Marie Martin. At this time my mother lived on the northside and my father on the southside so they cycled to see each other, before they were married. They worked together in Cahill's, a printing company. My mother died in 2007 but my dad is still going strong.' *Gemma Conlon*

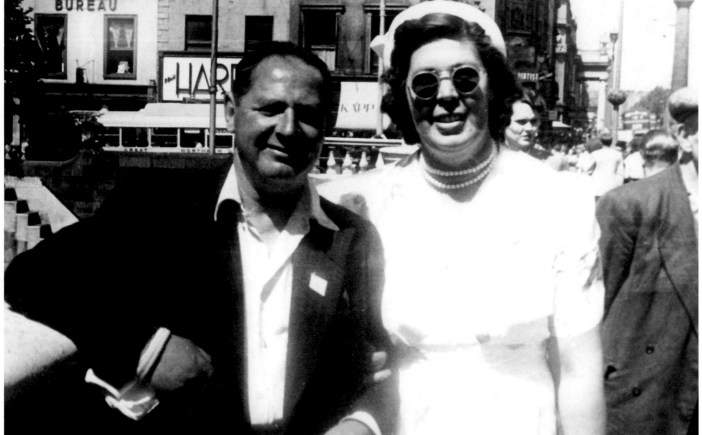

1950 In a photo taken by a fellow street photographer, this is Arthur Fields with his wife, Doreen, on a sunny day on O'Connell Bridge. Doreen frequently visited her husband on the bridge and he enjoyed the time spent with her as it was a break from the long hours spent taking photos of passers-by.
Philip Fields

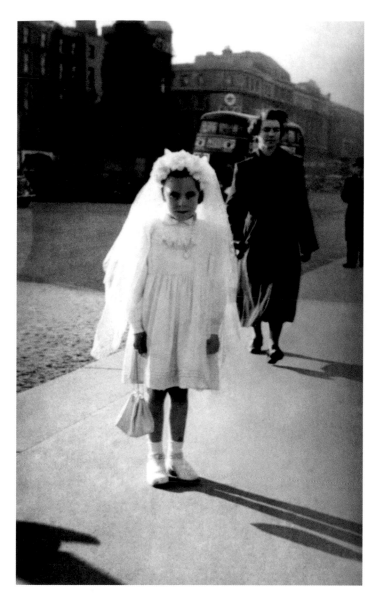

1950 'Me – Marie Gelling – on my communion day. I grew up in Cabra.'
Marie Heffernan

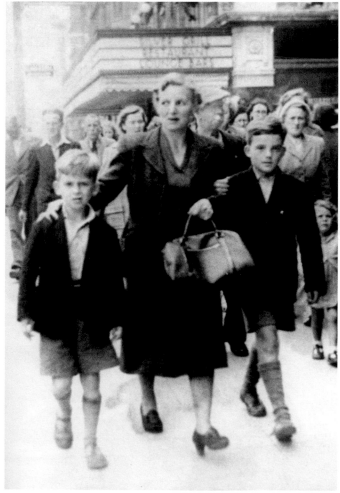

1950 George Harrison, aged around seven, with his mother and brother Pete, on O'Connell Street. They were very close to their Irish family and regularly took the ferry from Liverpool to Dublin to enjoy holidays with their cousins in Drumcondra.

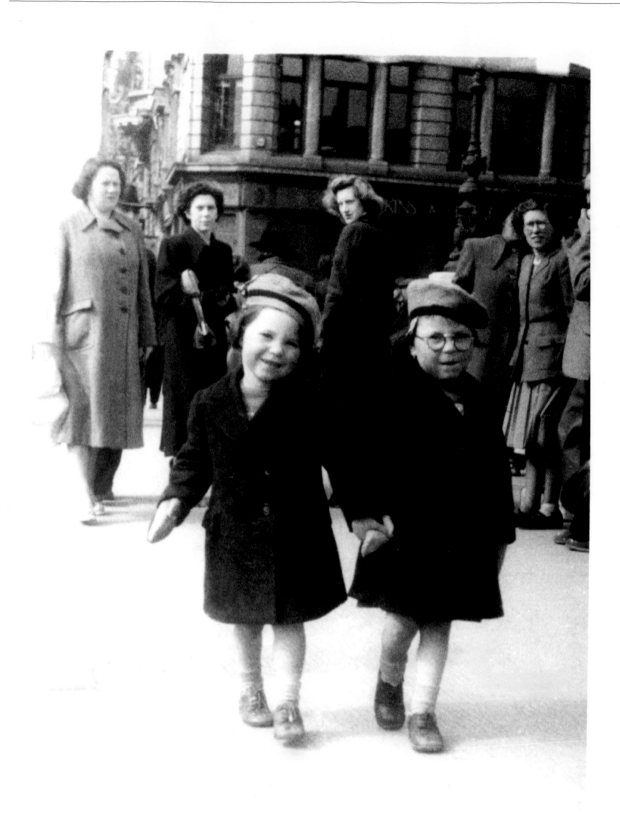

1950 'The Kiernan twins, Deirdre and Therese.' *Therese Kiernan*

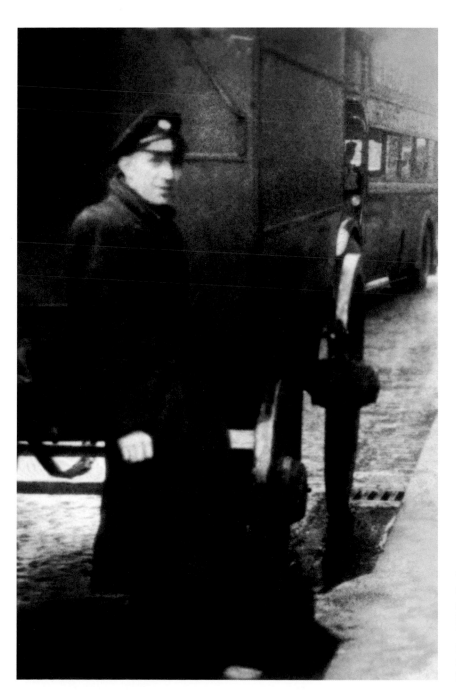

1950 'John (Dessie) Higgins, who worked for CIÉ in the mailyard. CIÉ were contracted to collect and deliver the mail to the mailboat in Dun Laoghaire and to the country trains. The wagon behind him was used to carry the mail. He never liked having to wear a uniform so he was definitely working when the picture was taken.' *Theresa Hannan*

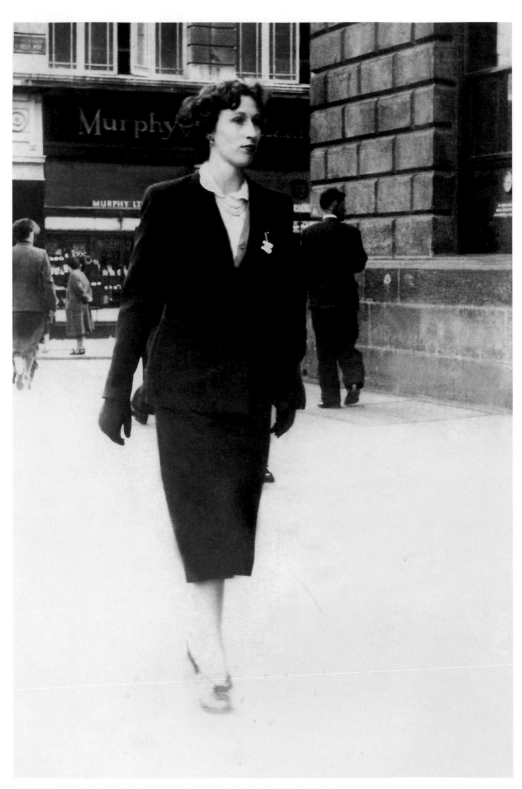

1950 'My grandmother, Pauline Coep, photographed in the 1950s.' *Ray Cranley*

1950 'Myself and my sister Frances Lee, aged seven and ten, on the way into town. Our hair was beautifully curled and we were dressed up in our best coats for our day out. It was a very happy time.' *Rose McCann*

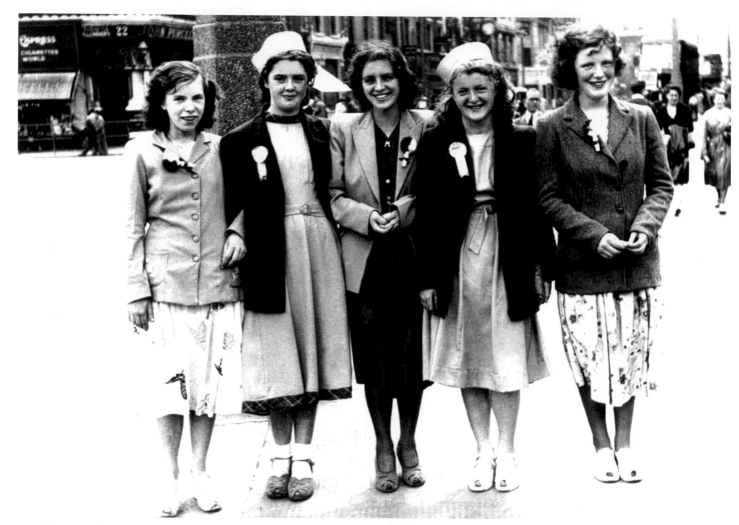

1950 'These girls from Drogheda worked together in the Morco (Sewing) Factory in Drogheda and were in Dublin to watch Louth playing in Croke Park. They travelled to Dublin early to have their picture taken on O'Connell Bridge. (L–r): my mother Frances Leonard, Margaret Mullen, Martha Quinn, Mary Maguire and Martha Heeney. My mother was about 16 at the time; she was born in 1934.' *Terry Collins*

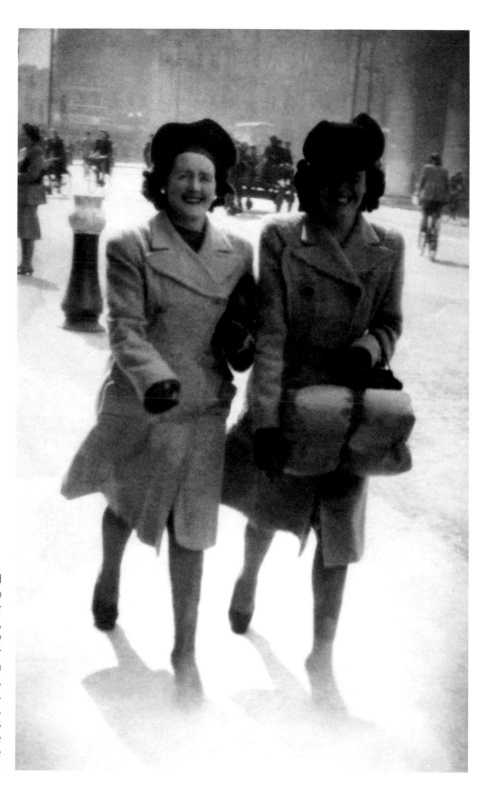

1950 'Two smiling girls: my second cousin Kathleen Cosgrove (left) who served her time in Leon's, the couturier of Grafton St. She lived on Nash St, Inchicore and latterly in Stannaway Road in Kimmage. Kathleen and her youngest sister, Rose, were set up in a tailoring business by their father, Jimmy, at 29 Mary St (now Marks & Spencer). Kathleen was forever young at heart, always saw the funny side of things and she lived by the motto "You're Never Fully Dressed Without a Smile (and a hat)".' *Rosaleen Cole*

1950 'Myself and a friend.' *Catherine Byrne*

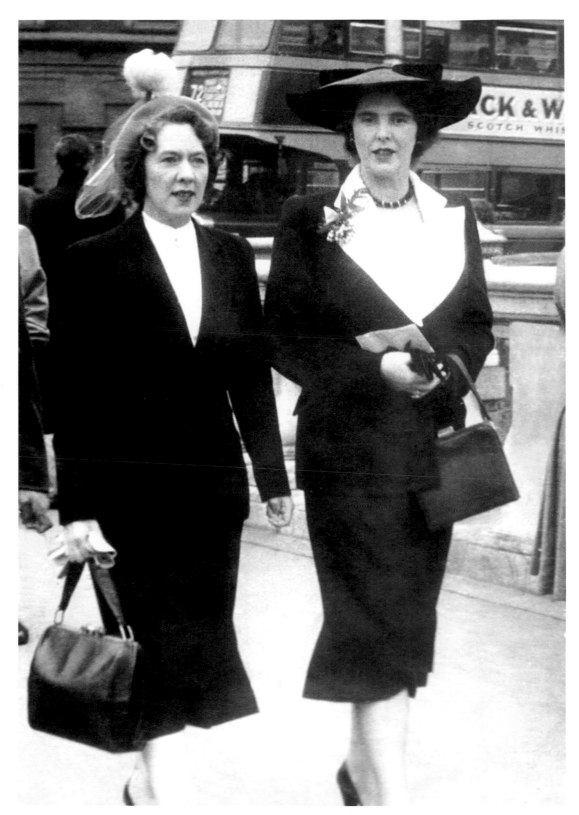

1950 'My nan, Eileen Weatherall (née Henn) on the right, with her friend Lily Lawler. Nan liked to dress to impress.'
Fiona Weatherall

1950 'Maeve and Eileen Flood, mother and daughter.' *Thomas McCann*

1950 'My sister Peggy, aged 18 months, with our mother, Maureen, wheeling the pram behind her. Peggy was trotting ahead – in those days, kids could wander like that.' *Joseph Clarges*

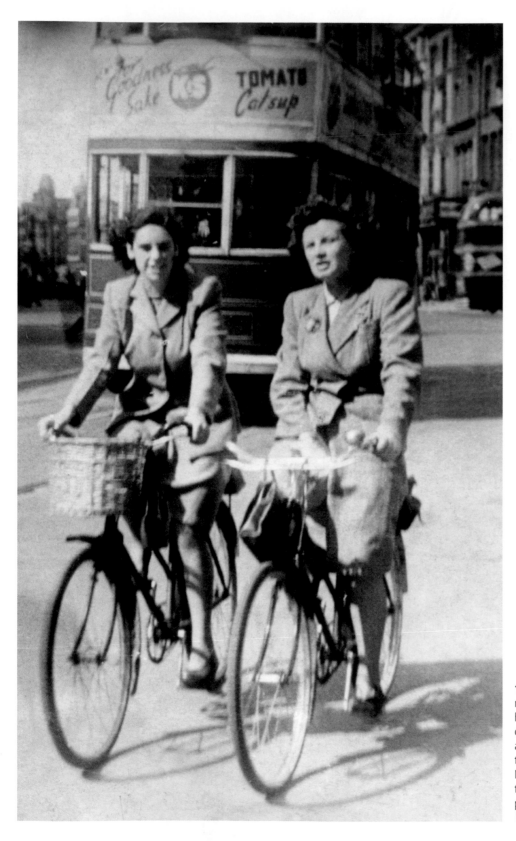

1950 '(L–r): Muriel Rowden and myself (Vera Sargent). We didn't have a car and everyone in the house cycled. I was even in a cycling club and Muriel is my friend from that. In those days we used to cycle as far as Malahide and Rush. We'd have tea there before we came back. In the photograph, we are on our way home.'
Vera Abbott

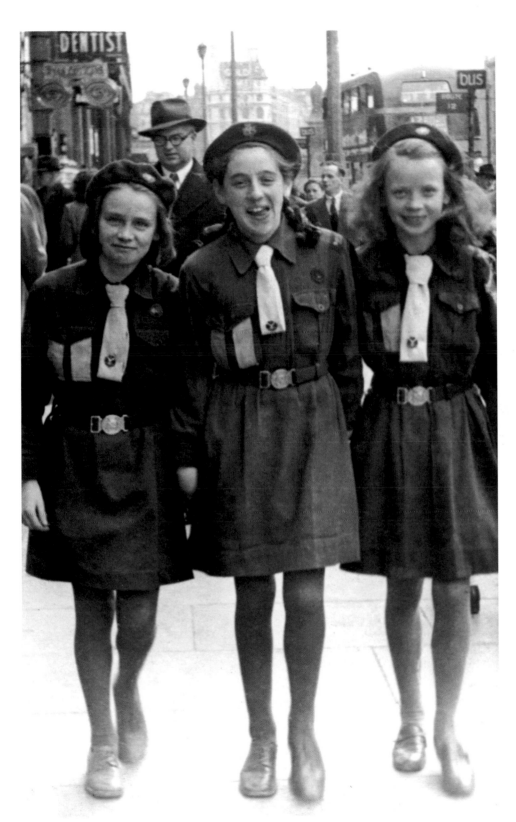

1951 '(L–r): myself (Florrie Scarry), my cousin Marie Harmon and Patty Kehoe. We were Girl Guides at 64 Mountjoy Square. My family lived in Wood Lane off Blackhall Place. People had no money after the war. It was exciting for kids to have their photo taken at the time.' *Florence McElroy*

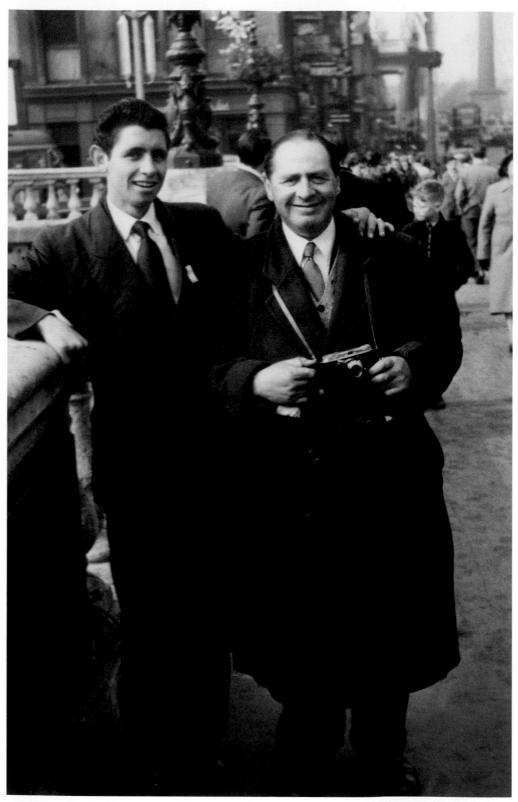

1951 Although perhaps the best remembered, Arthur Fields was not the only street photographer working on O'Connell Street and Bridge. He was part of a community of men with cameras. Here he is with a friend and fellow street photographer Max Coleman. Arthur made lots of friends on O'Connell Bridge. He enjoyed having a bit of banter with them in between taking photos of the famous and not-so-famous passers-by.
Arthur Fields family collection

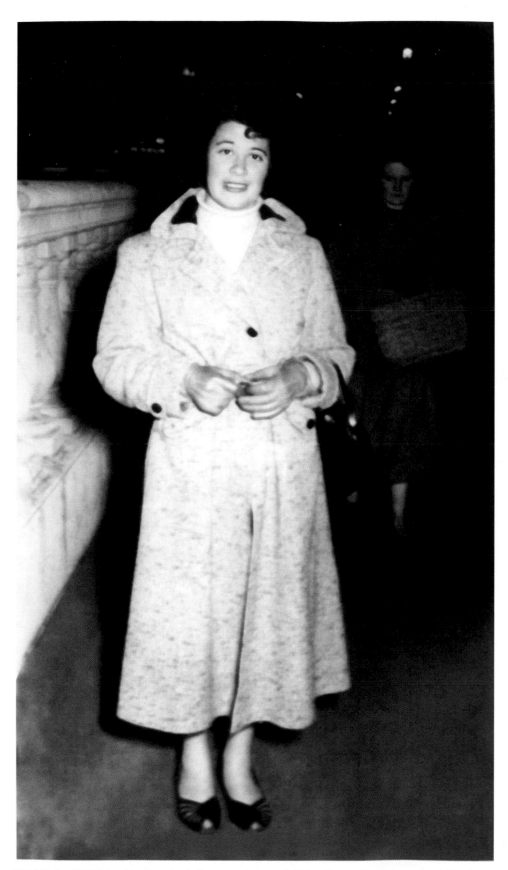

1951 'Arthur Fields' daughter (my sister), Norma, on O'Connell Bridge. Norma always dressed stylishly; she is pictured here on an evening out in Dublin.' *Philip Fields*

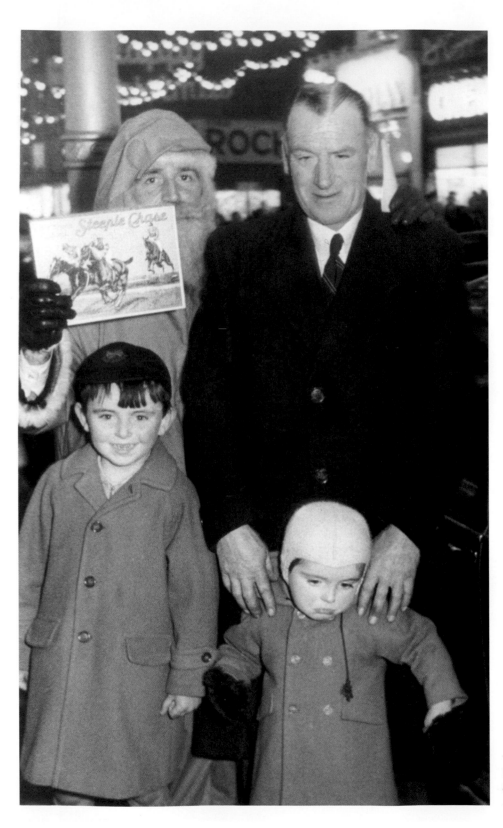

1951 'My grandfather Christy Murphy with my uncles Pat (left) and Chris, and Santa Claus.'
Natalie Christie

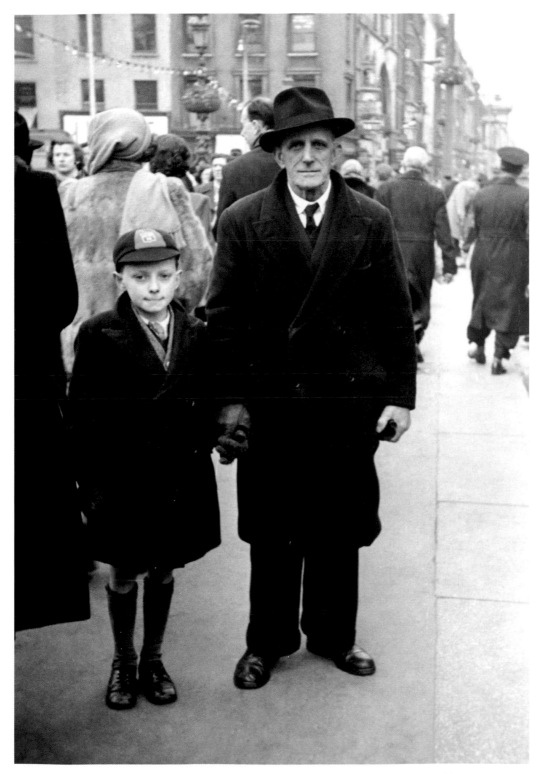

1951 'My father, Patrick, and me. I was about seven or eight years old and my father was 60.' *Paddy McCabe*

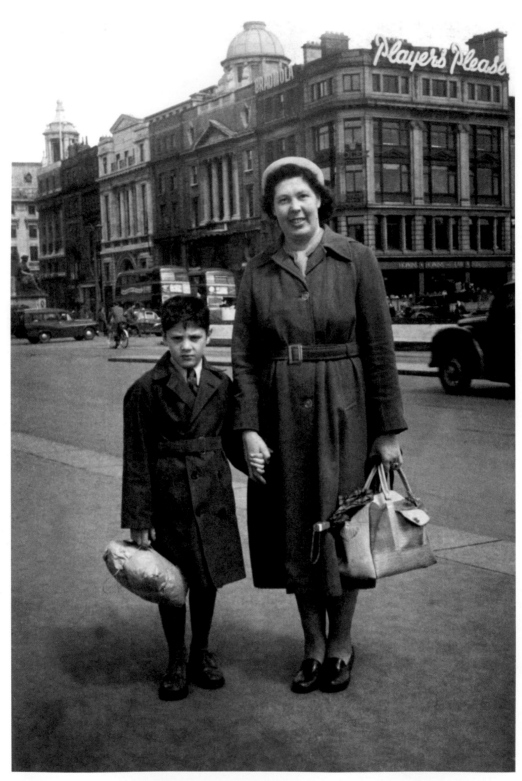

1952 'Arthur Fields' wife – my mother – Doreen, and me, aged six. After buying some new clothes and treating me to shepherd's pie in one of the local restaurants, she always made sure to visit my father on the bridge for another photo.' *Philip Fields*

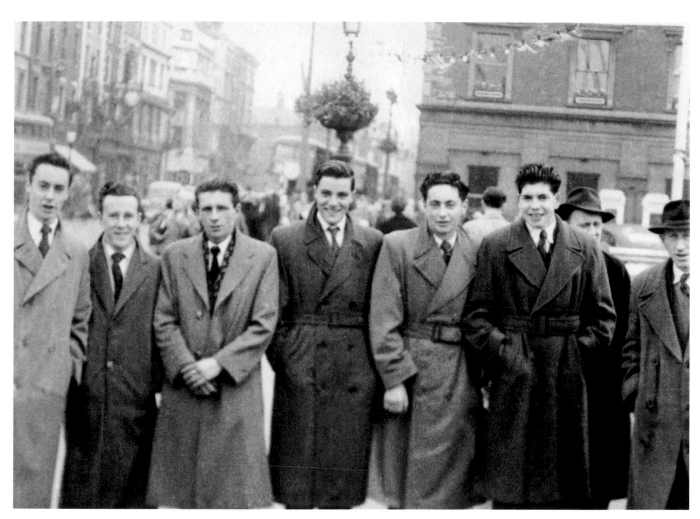

1952 'John Dawson (far left) and apprentice engineering friends: (l–r) John Manning, Hughie Egan, Willie Quinn, Jimmy Fullham and Eddie O'Dowd.'
John Dawson

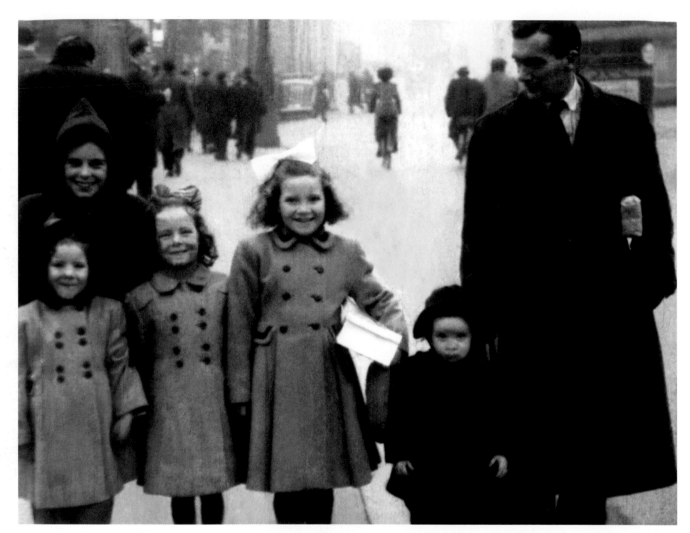

1952 'In this photo my father, Larry (a well-known handballer), is taking me (Ann), my sisters Lily and Mary, and cousins Marie and Mary up to see my mother, who was in hospital.' *Ann Kelly*

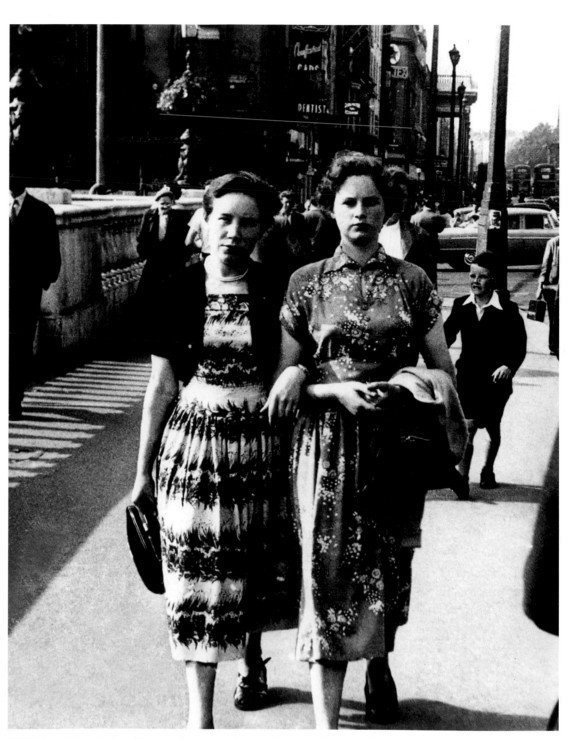

1953 'My mother, Elizabeth O'Mara (left), from Carlow, out for the evening with a friend. This photograph was taken *c.*1953 when my mother first came to work in Dublin. She is 81 now and still going strong.' *Susan Fee*

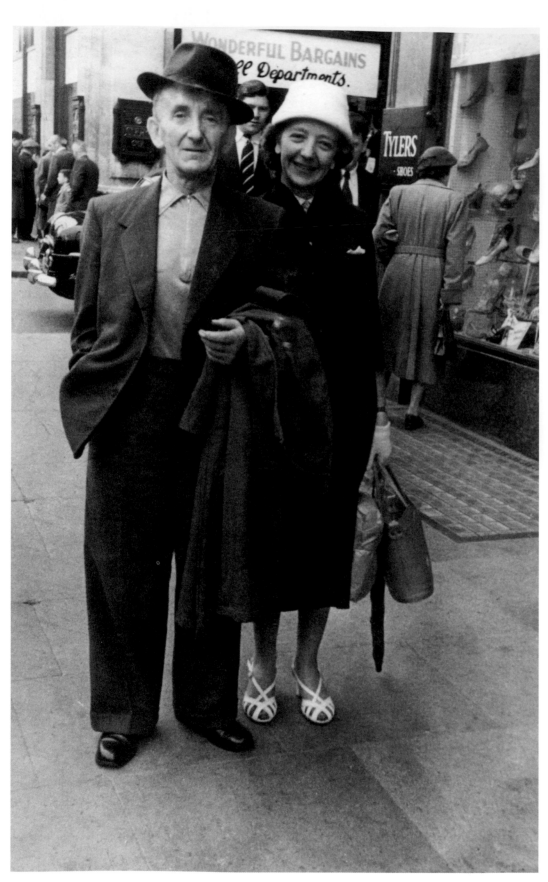

1953 'My grandfather Patrick Moles and his daughter, my aunt Maureen.' *Lucia Donnelly*

1953 'Elizabeth Hedderman (centre) with her sisters Ellie Roche (right) and Jane King on their first visit home to Dublin after emigrating to Canada 40 years before. Jane never returned after this one trip. Elizabeth remarked that on the day her sisters made a show of her "because they were dressed like peacocks".' *Peter Keegan*

1953 'Michael O'Hanlon (left) and Matthew Jackson of Killeavy, County Armagh. They were in Dublin on Sunday 27 September 1953 to support Armagh against Kerry in the All-Ireland football final in Croke Park. Kerry won by 0-13 to 1-6.' *Oliver McDonald*

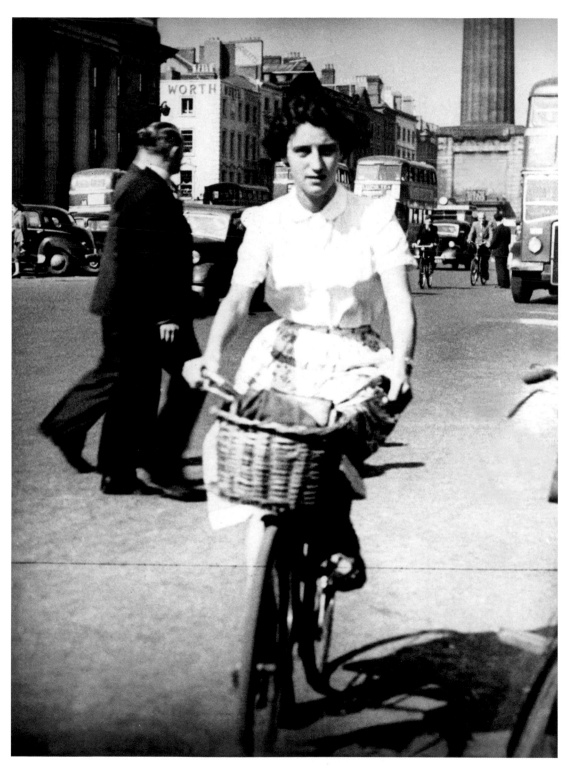

1953 'This is me (Clare Carroll) on my way to work on Nassau Street before I got married to Reggie Kelleher.' *Clare Kelleher*

1953 'My brother Patrick McNamara (right), a Jesuit Brother, with a colleague from Belvedere College. I believe this photo was taken when he moved to Belvedere from Limerick to work as a Lay Brother.'
Sally Dunleavy

1953 'My father, Bobbie, and me when I was aged about three.' *Bob Laird*

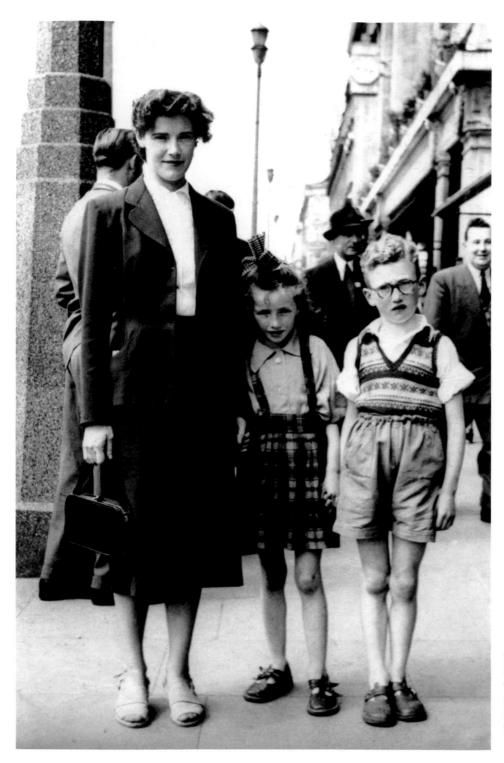

1954 'My aunt Bridget Moore, originally from Castlegordan, County Offaly, home on holidays from England where she worked all her life as a nurse. She is taking her niece and nephew, Mary and Billie Elliffe, to the Adelphi Cinema. The film was *Moby Dick*.'
Catherine O'Shaughnessy (née Moore)

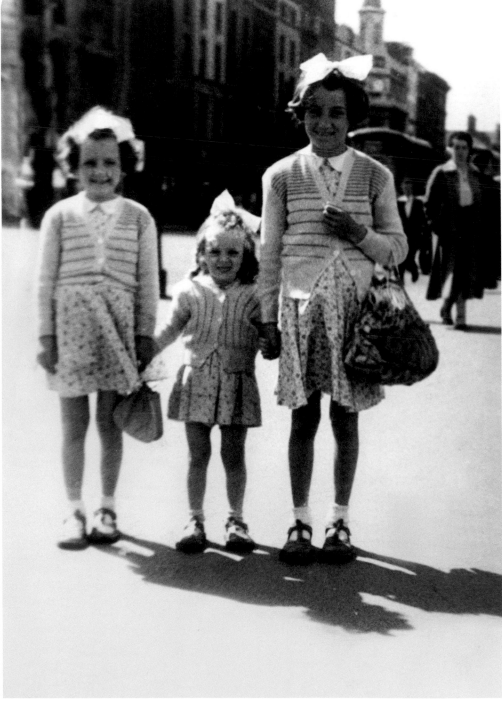

1954 'Three sisters. (L–r): me, Stella and Teresa Reddy. Our mother made the three matching dresses we are wearing.' *Patricia Harris*

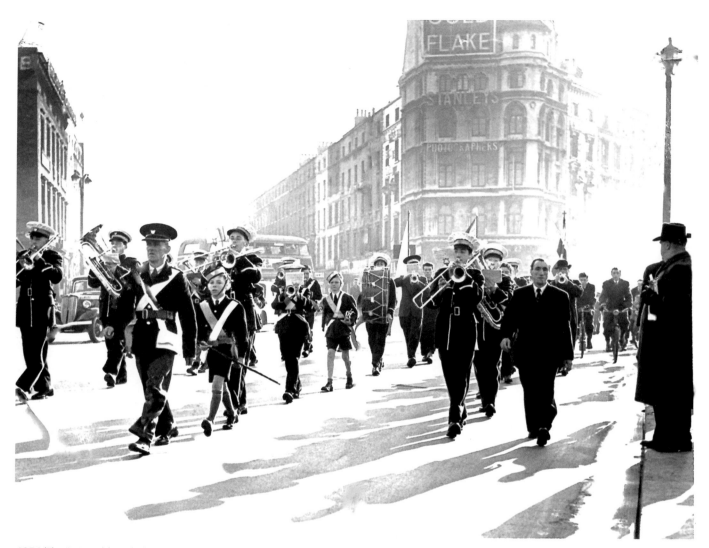

1954 'The St Joseph's Catholic Boys Brigade Band returning from St Audeon's, High St, to their base at Church St, via O'Connell Bridge, after Sunday Mass. That's me playing trombone, nearest the footpath. At the time, the band comprised 30 boys. On this occasion, we were celebrating our new uniform, which was the postman's uniform converted; we raised money for them by playing Christmas carols around Dublin. Included in the photo are: John Tyndall (trombone, far left), Jim Nolan (trombone, middle). Behind John is Frankie Byrne (tuba). I don't remember the names of the younger children. Behind me is Peter Byrne; John Kelly is behind the drummer, who is Shane Nolan; the boy in the front with the staff is Philip Barnes, and the man leading us was known as the Colonel Davis. The man walking on the right-hand side is Tommy Saul. He lived in the Iveagh Hostel for homeless men. You'd see him during the week with his handcart around town and he'd be in tatters. But when we paraded, he would turn up in his best suit and march alongside.' *Tom McManus*

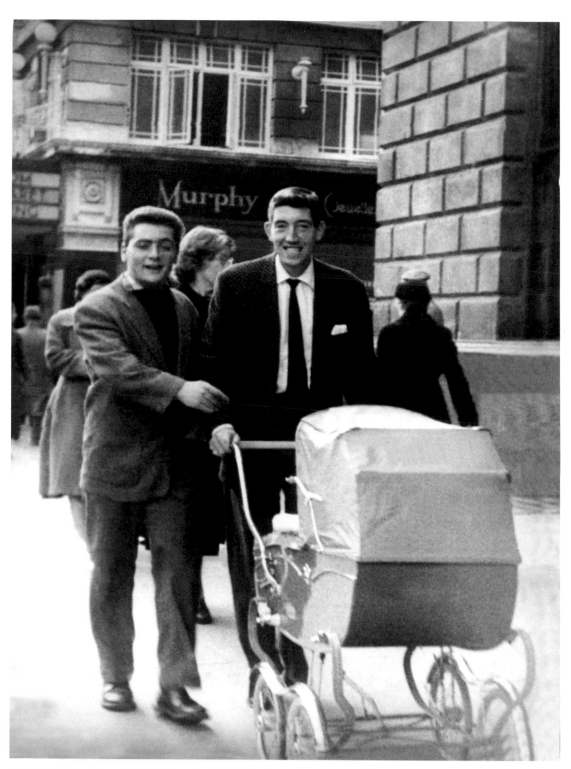

1954 'My husband, Tony Mack (right), and a friend, John Curtis, going around Dublin with a baby in a pram. Men were too macho in those days to wheel a pram so it was kind of a dare. Everyone was staring at them.' *Joan Mack*

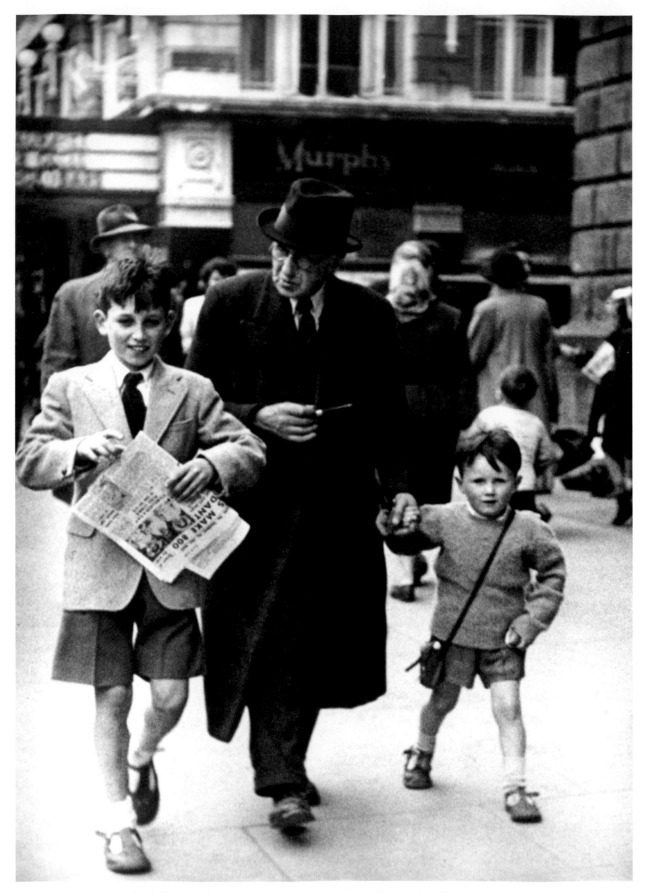

1954 'My brothers with a family friend. (L–r): Brian Quinlan, John Territ and Pat Quinlan.' *Brid Griffith*

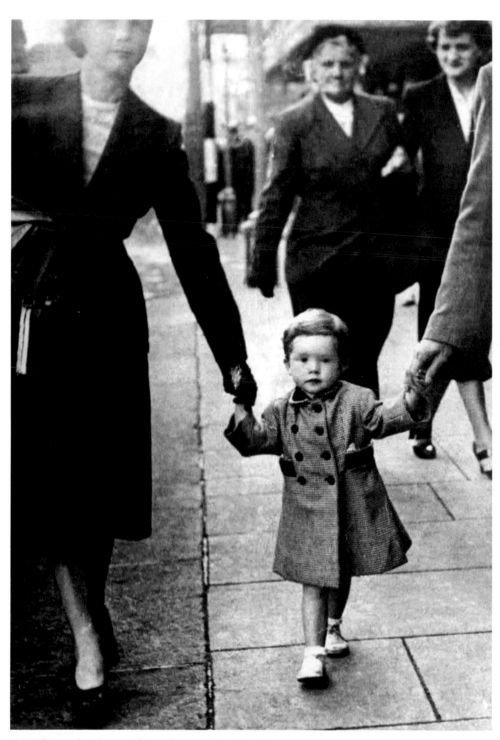

1954 'My mother, Grace Hickey, and me, aged two.' *Julie Flaherty*

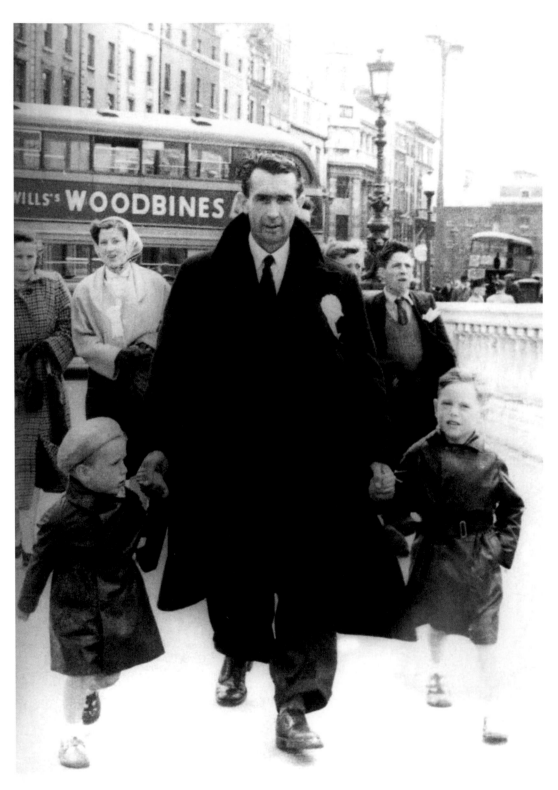

1955 'My father, Jimmy Nolan, with me (Kieran, right) and my brother Shay. My mother, Maureen, and my aunt Dette (wearing headscarf) are in the background. Most likely, we were heading home after a Kildare match in Croke Park.'
Kieran Nolan

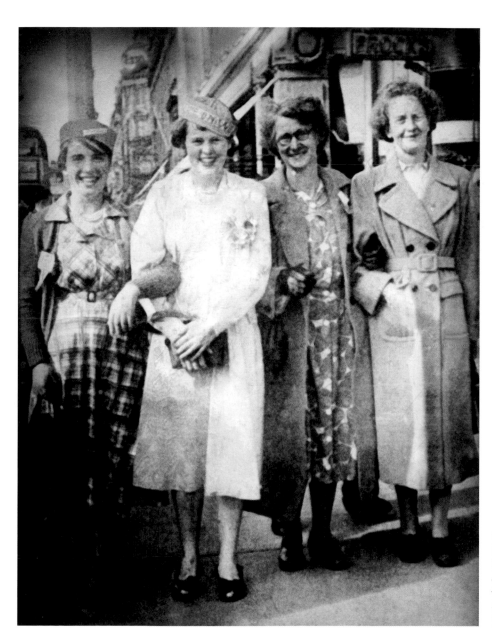

1955 '(From right): my grandmother Margaret (Peg) Doyle with her mother-in-law Annie Doyle, a friend and Annie's daughter, all from Wexford. They were up for the day to go to a Wexford match in Croke Park. Peg later moved to Dublin with her husband Patrick.' *Margaret Gibbons*

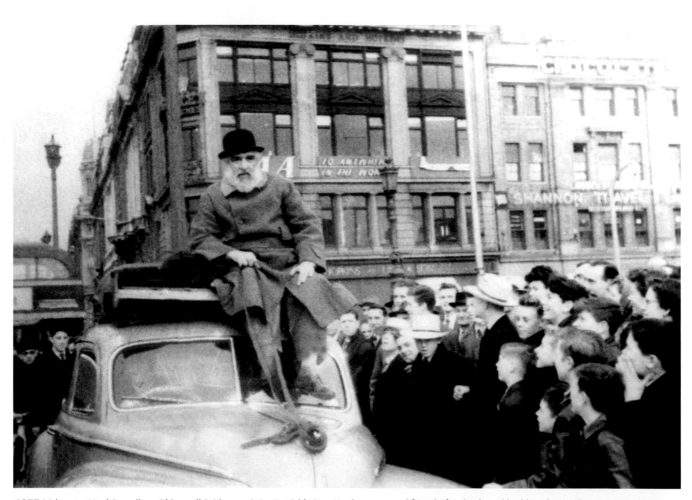

1955 Irish actor Noel Purcell on O'Connell Bridge on Saint Patrick's Day. Noel was a good friend of Arthur's and had his photo taken many times on the bridge. *Arthur Fields family collection*

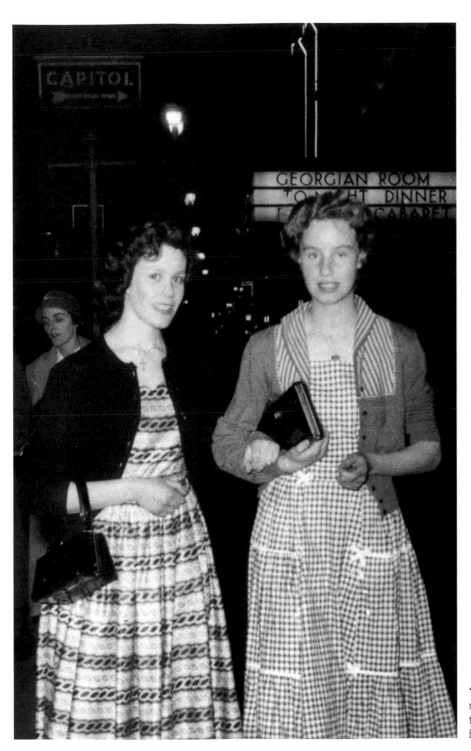

1955 '(L–r): Myself, then Marie Murphy, and my friend Jean Crawford. We had many happy times together. The old Metropole is in the background.' *Marie Dunne*

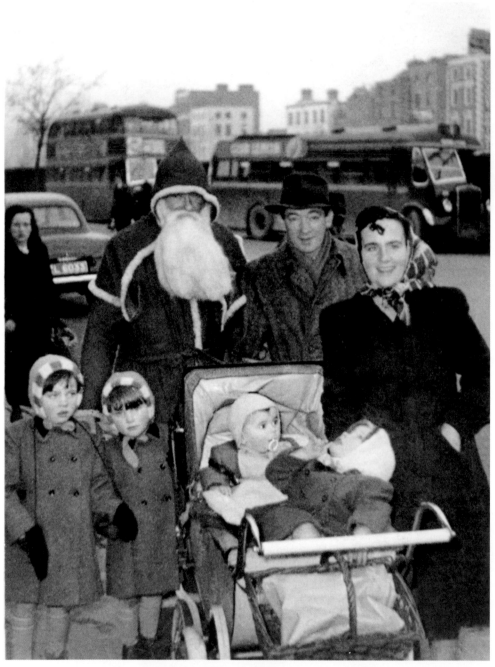

1955 'My grandparents Patrick and Kathleen Williams with their children (l–r) Teresa (my mother), Rita, Gerard and Phyllis outside McBirney's department store at Christmas.' *Sandra Moran*

1955 'The 18th Dublin Scout troop coming home from a hike, including John Gibson (middle), now my husband.' *Maria Gibson*

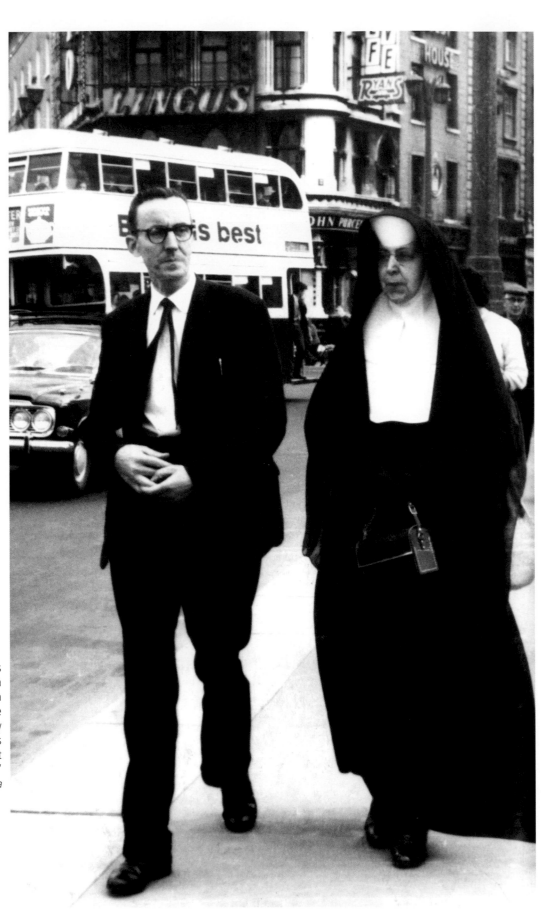

1955 'My father, John Melia, and his sister Mary (Sr Michael) who was a nun in the USA. She was home on a holiday which was granted every five years and had to be accompanied by my father (John) when out in public as she could never be out alone. She left Ireland to become a nun at age 17.'
Frances Melia

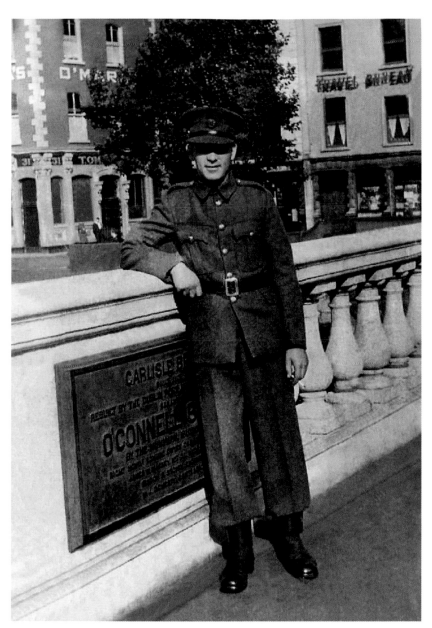

1956 'This is my father, William O'Hara, at the age of 19. He is from Gorey, County Wexford. He was serving in the army at the time and was stationed in Cathal Brugha Barracks in Rathmines. He is now 76 and still lives in Gorey.' *Fiona O'Hara*

1956 'Carmel Kelly (right, my mother-in-law) and her sister Mary, in Dublin on 5 June 1956, the day before Carmel's wedding to Vincent McMahon. Carmel had just got her hair done for the wedding. Mary Kelly has since passed away, but Carmel is still going strong, happily surrounded by a close-knit family and a large circle of good friends.'
Elaine McMahon

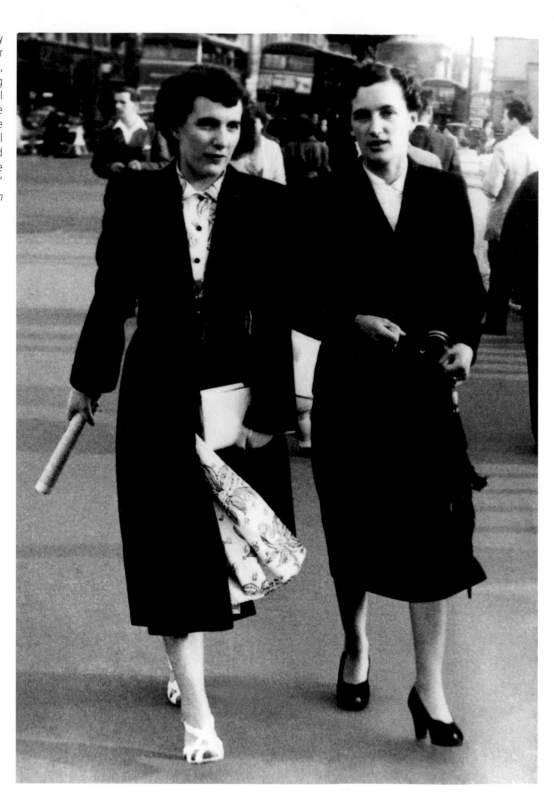

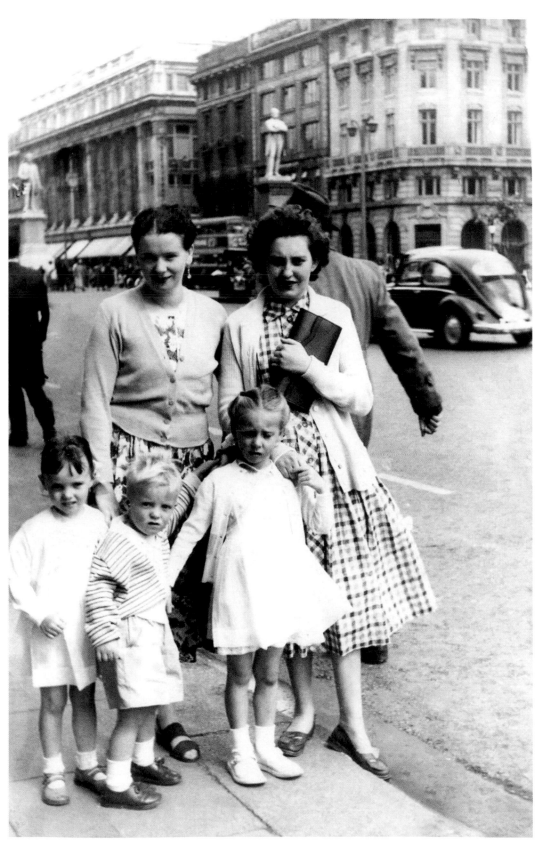

1956 'Our aunt Nan McKinney (left) with her friend Nancy Ball who were visiting us from Derry. The children are (l–r) Anne (me), John and Kathleen Toner.' *Anne Toner*

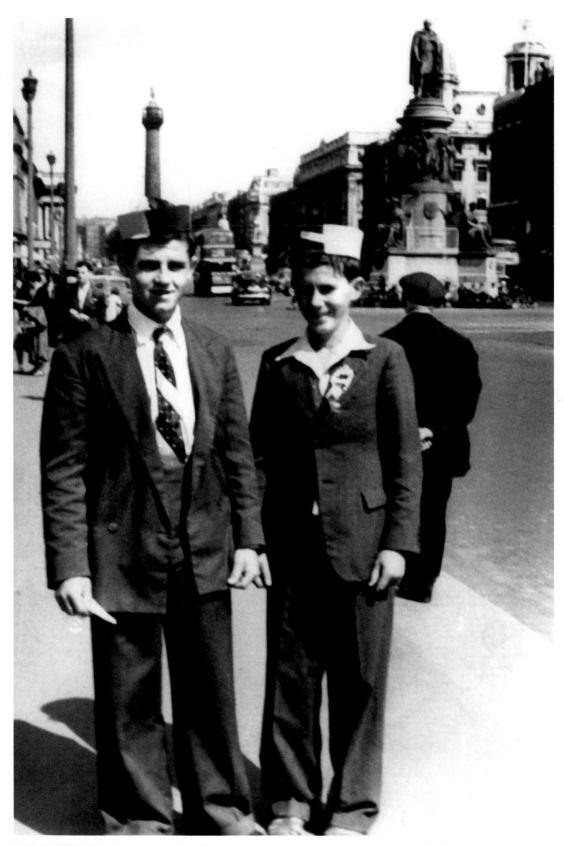

1956 '(L–r): Myself and my long-time friend Michael Cantwell on the way to Leinster Hurling final in 1956. We did everything together. Both of us are Kilkenny men but sadly on that day Wexford beat Kilkenny. We're still loyal Kilkenny supporters and we are still very much friends.' *Michael Leahy*

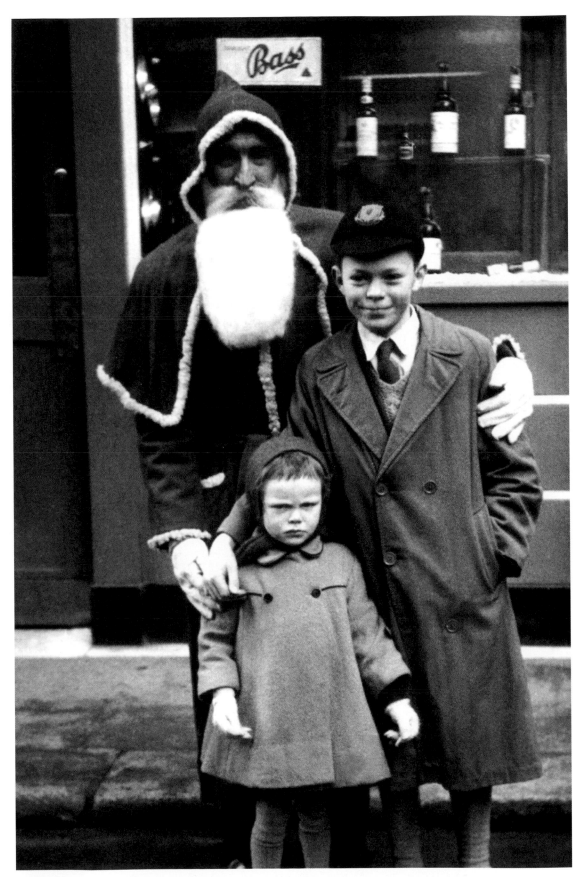

1956 'My husband, Ken Bracken, with his niece Eileen O'Brien and Santa. Ken was nine and Eileen was four at the time. Eileen now lives in Toronto and Ken lives still in Portmarnock.' *Anna Bracken*

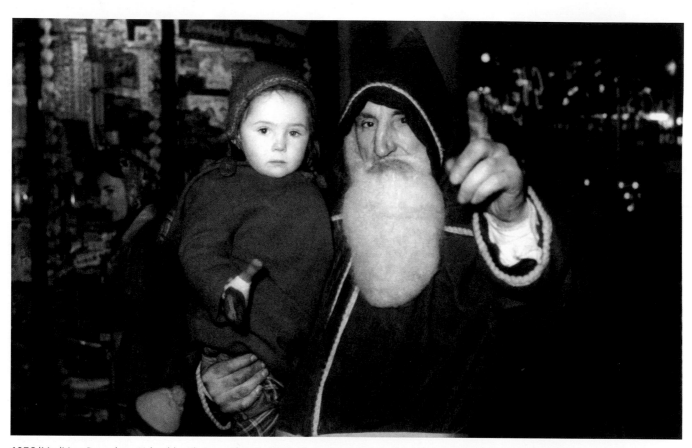

1956 'Me (Mary Bernadette Richards) with Santa Claus in 1956. My uncle brought me in to Clerys to see Santa.' *Mary Richards*

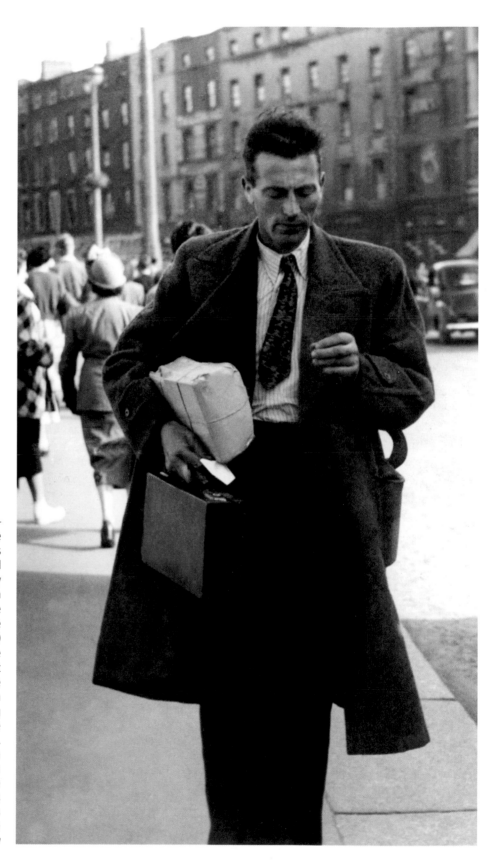

1957 'My father, William Guidera (1920–2010), a farmer and avid reader, made frequent trips to the second-hand bookshops of Dublin from his home in a village called Knock, 5½ miles from Roscrea in County Tipperary. He would cycle to the train station in Ballybrophy and return home on the same day. Once, he famously cycled the whole way there and back, a round trip of over 150 miles. Before heading for Heuston Station, he would have a bite to eat in the Monument Bakery on Grafton Street. It was there he met my mother, Mary O'Dwyer, also from Tipperary, and a courtship began, culminating in their wedding in 1960. We found the photograph in his belongings after his death. Because he was such a modest and shy man it is surprising he agreed to it at all. Although the suitcase is a little mysterious, the package under his arm almost certainly contains books. He is smoking a Woodbine. This picture was taken on 5 August 1952 when he was 32.' *Anita Guidera*

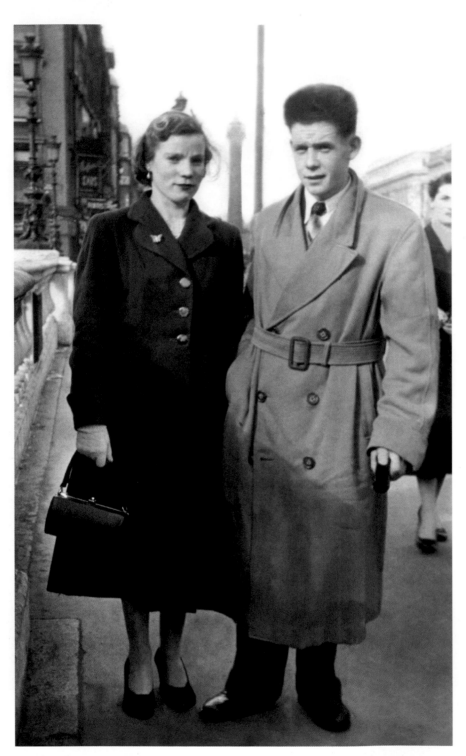

1957 'Me (Theresa Farrell) and Harry Doolan. This was our first day in town together and we went on to get married. We are still happily married 53 years later.' *Theresa Doolan*

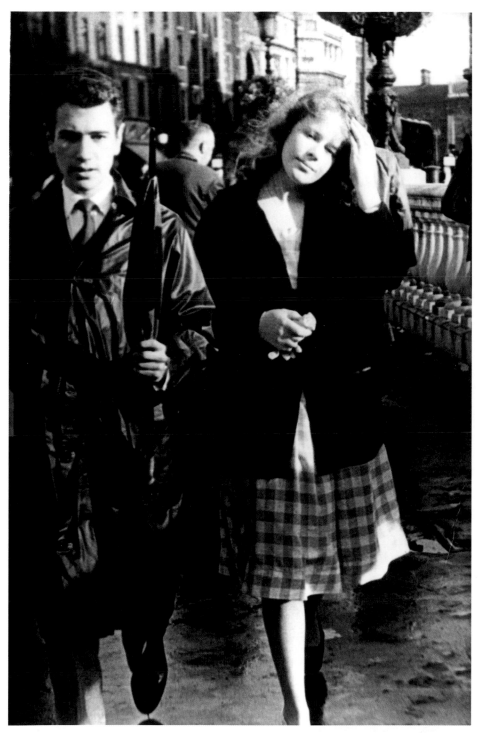

1958 'Enrique (a Spanish student) and myself on our way to the Metropole to see *Carve Her Name with Pride* in August 1958. I'm wearing a pink checked dress made out of a tablecloth and a hand-me-down dyed black duffle coat that once belonged to my sister. It was my first proper date and I felt a mess but Enrique was very romantic. He had climbed up on a fence to reach my bedroom window with a red rose in his mouth, taken from a neighbour's garden, to ask me out – very different from the Irish boys I knew. I felt such a freak in the picture because there was very little money in those days and I couldn't afford to go to the hairdresser, whereas the Spanish students were very groomed and sleek. Mrs Fricker (Brenda Fricker's mother) ran an English-language school for students in Dundrum where I lived. They couldn't go out with girls without a chaperone in their own country but it was different here.' *Miriam Dunne*

1958 'Taken when I was in town with mother when I was about four. I was an only child so my family thought the world of me and liked me to be photographed. I loved posing for the photographer but when I saw this picture when it was developed I cried because it looked like I only had one leg.' *Attracta Berkery*

1958 '(L–r): My cousins Ger and Brian, me and my sister Lorna.' *Honra Walsh*

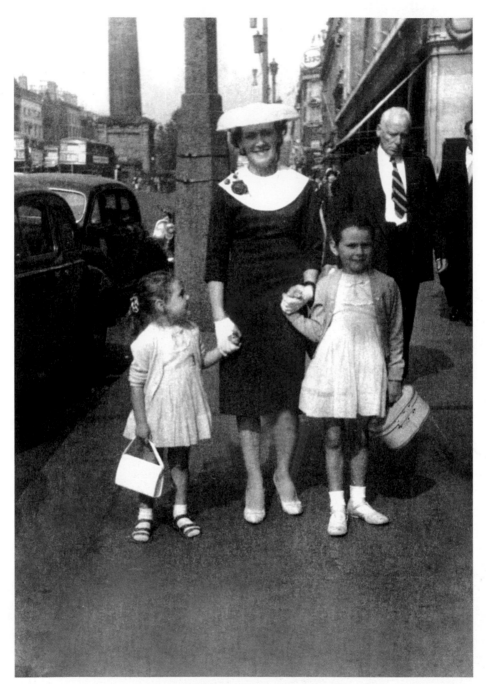

1958 'Me (Honra), my mother, Bridie Greene (who was manager of Sherry's restaurant on Abbey Street), and my sister Lorna.' *Honra Walsh*

1958 'This is a photo of my father Tom Ruane and his sister Mary Coyle (née Ruane). He was up from Mayo for a scan which revealed he had a brain tumour, and the prognosis was not good. This photo was taken before his operation. He was the first to survive this particular type of invasive brain surgery carried out by Dr P. Carey in Richmond Hospital.'
Joe Ruane

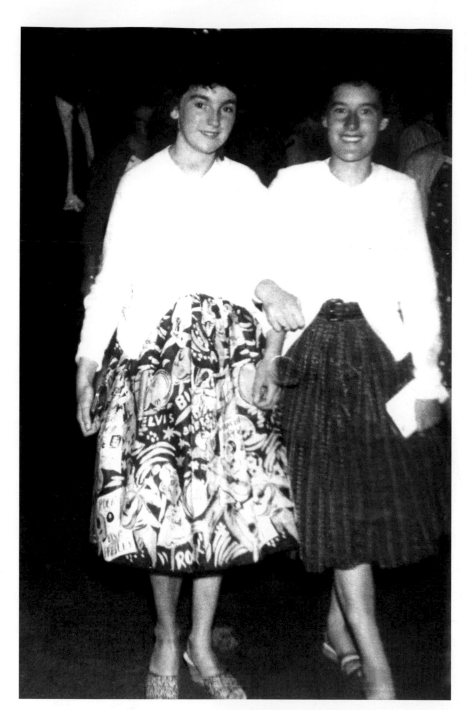

1958 'My girlfriend Joan (left) and her friend Carmel Kerr. Both from Crumlin. Note the Elvis skirt. Great days.'
Patrick Doyle

1959 'Friends from the Ballybough/North Strand area: (l–r) Tommy Swan, Richard Mulligan, Fergus McGrath, Tony McGuigan, me, Gabrielle Sands, Joe Murphy and Willie Boyle. We'd always be knocking around together, gallivanting and playing football.' *Des Maguire*

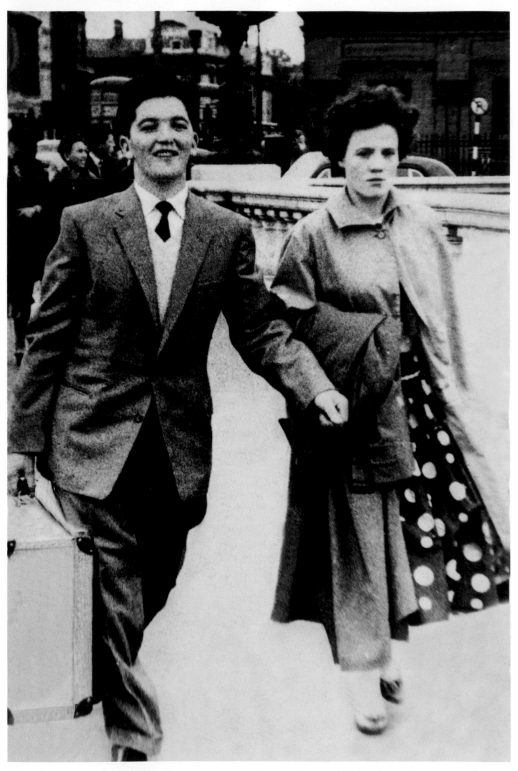

1959 'My parents, Oliver and Mary Gorman, on a return trip home from the UK. They had emigrated in the late 1950s. I've always loved this shot of my late father, smiling and delighted to be back in Ireland and my mother shattered after the boat trip. To this day she remembers with horror the *Princess Maud*, the boat that sailed the Dublin–Holyhead route from 1949 until 1965.' *Mark Gorman*

1959 '(L–r): My sister Philomena, myself, our dad and my sister Margaret (Madge) coming home from the cinema. Philomena had made her confirmation and as a special treat we were brought to town to see a film. My father is ten years dead now. He brought us everywhere so this photo is a treasured memory. Even though my mum is not in the photo, her care of us is evident, as she made all our clothes and knitted our cardigans.'
Colette Laird

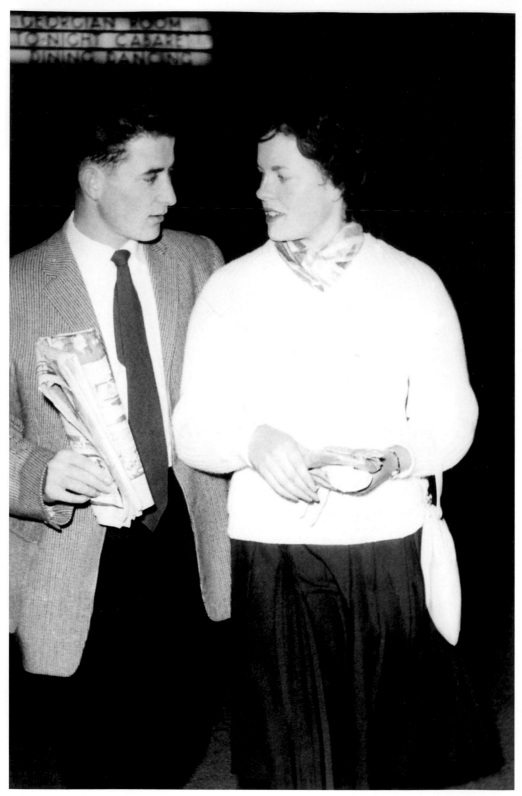

1959 'In everyone's life there is a special summer and the summer of 1959 was ours. We were walking through the portico of the GPO on O'Connell Street in Dublin one evening and were so wrapped up in each other that we never noticed we were being photographed. The memory of that summer has been kept alive for us with the help of Arthur Fields.' *Kieran Griffin*

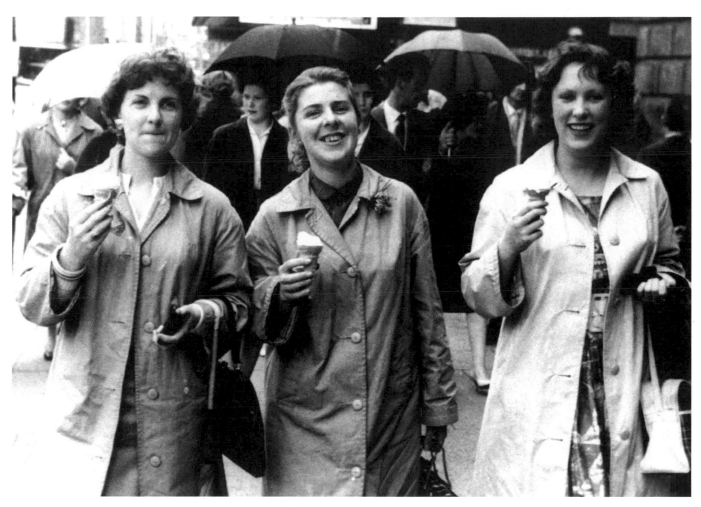

1959 '(L–r) My wife, Margaret (née Roden), with her sister Clare Reid (née Roden) and their cousin Veronica Flynn. They got the ice creams from Cafolla's ice-cream parlour.' *Frank McNamee*

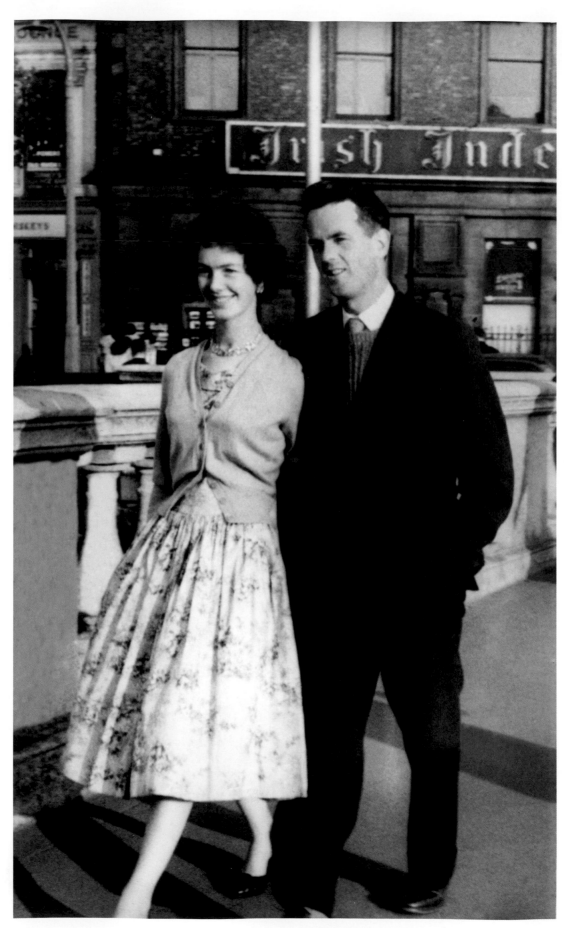

1959 'Me and my fiancé Michael Farnan. We got married in 1961.' *Sheila Phelan*

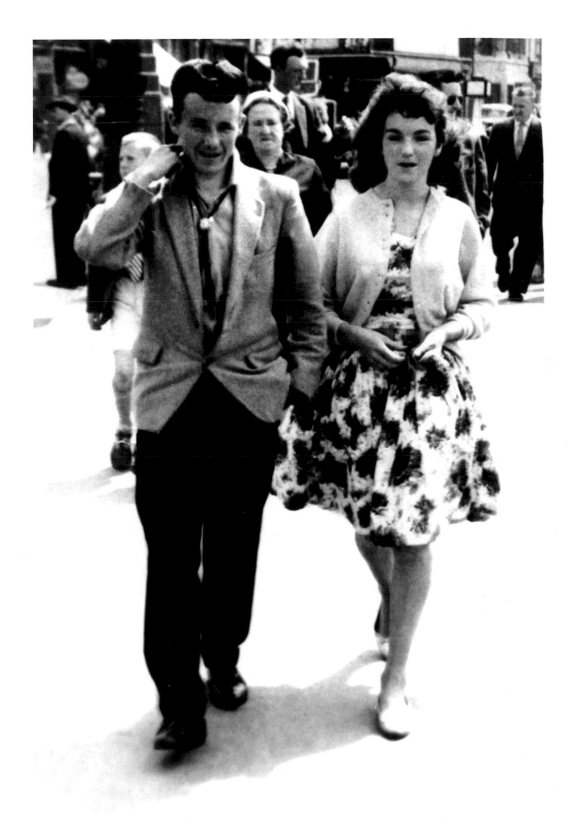

1960 'Me and my girlfriend at the time, Joan Smith. We were on the way to the Carlton Cinema to see *The House on the Haunted Hill*. We were married in 1964 – fifty years ago!' *Patrick Doyle*

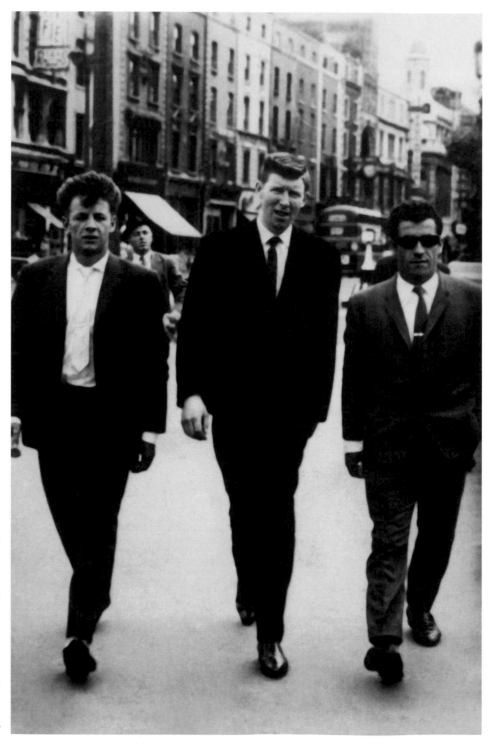

1960 '(L–r): Philip "Flop" Chapman, my father, Tony "Tex" Kane, and Eddie Chapman. They grew up together in Crumlin and were best mates all their lives. Eddie was dad's best man at his wedding and they went into business together, running KC car cleaners in Donnybrook. My dad said that they would always go to the Savoy for the Saturday matinée, then head down to the Broadway cafe to see who else was around and what pretty girls they might want to dance with later at the Crystal. They had their suits made by a tailor, very fancy, and made a point of walking by Mr Fields to get their photo taken because they didn't own a camera.' *Dawn Farley*

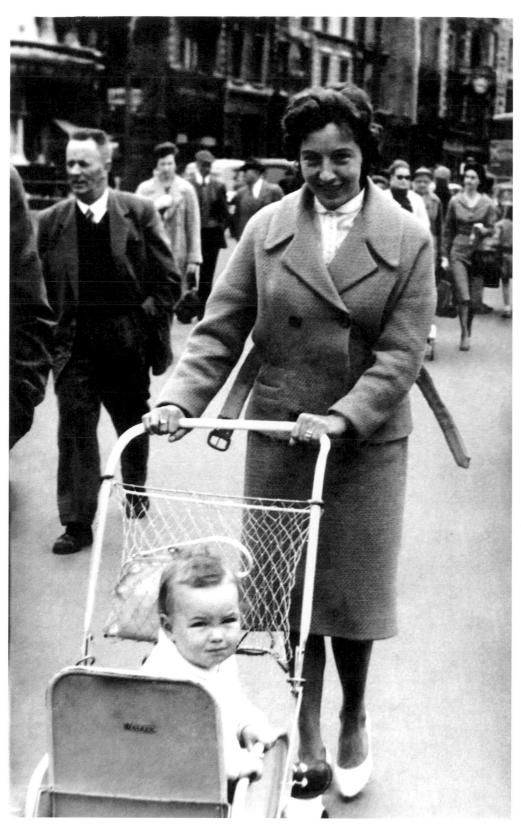

1960 'Myself and my son John. I was coming from the ESB office after paying a bill. It was such a nice day, we decided to walk over O'Connell Bridge to the Number 19 bus stop.' *Helen Byrne*

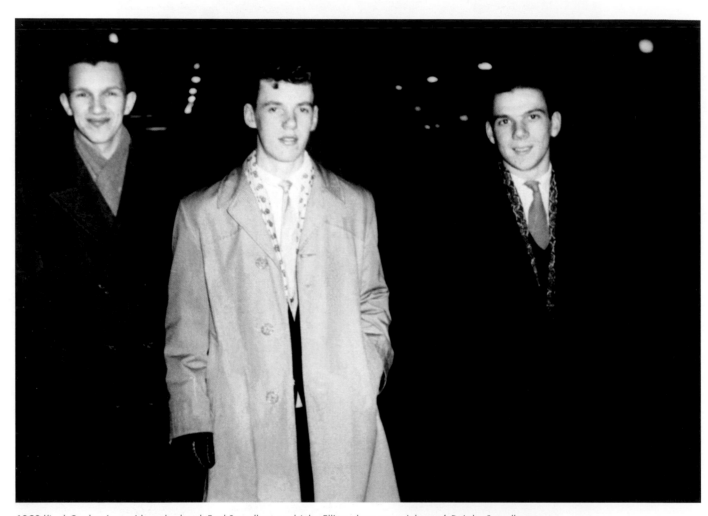

1960 '(L–r) Gordon Aust with my husband, Fred Spendlove, and John Elliot – boys on a night out.' *Deirdre Spendlove*

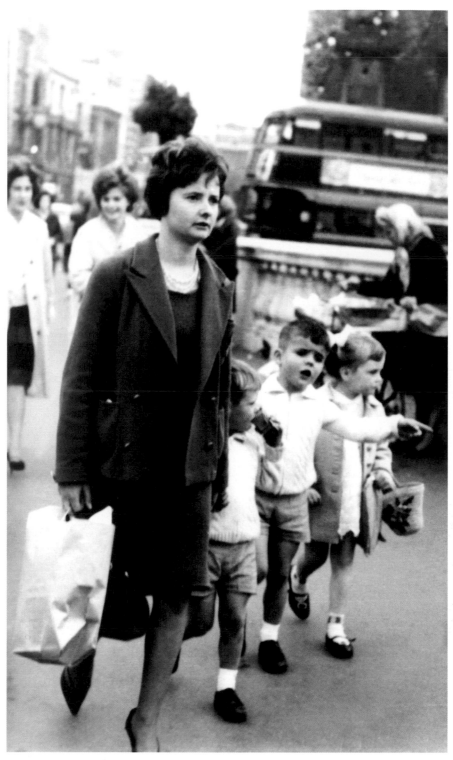

1960 'My mum, Maura Cuthbert (now Redmond), with (l–r) her nephews Desmond and Stephen and niece Karen on their way to visit her boyfriend (now husband of 50 years – Jim Redmond) in Mount Pleasant Square, Ranelagh.' *Suzanne Redmond*

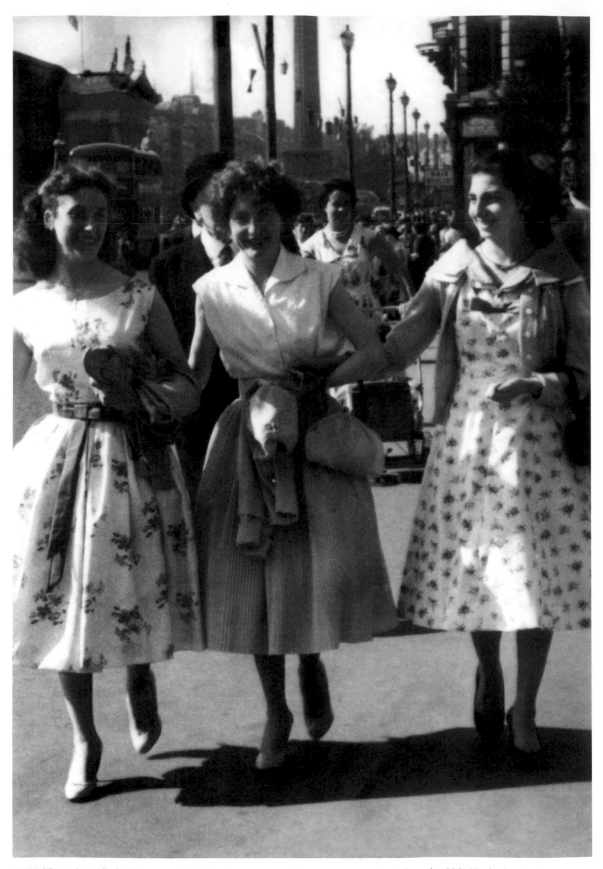

1960 'Three sisters (l–r): Rita, me and Christina in our summer dresses, on our way back from the GPO. Rita had just got married and we were posting her letters and newspapers to her husband who was in the Royal Navy. As sisters, we always used to be around O'Connell Street, going to the cinema every Wednesday, Friday and Sunday or eating ice cream in Cafolla's ice-cream parlour.' *Marie Daly*

1960 'My parents, Sally and Vincent Keogh, and me, crossing O'Connell Bridge in 1960. The photograph was taken around Easter time as that looks like an Easter lily in my father's lapel.' *Justin Keogh*

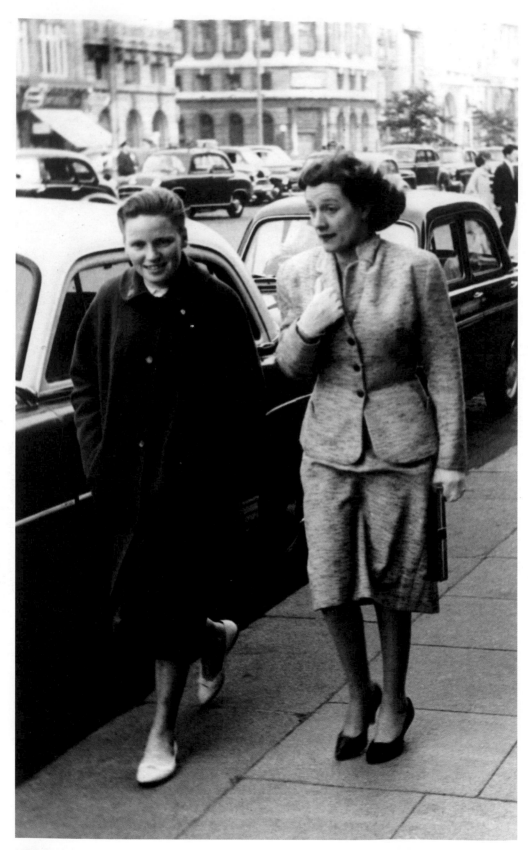

1960 '(L–r): Me (then Una Quinn) and Mary Carr, a friend from cycling with the City of Dublin Road Club.'
Una Foley

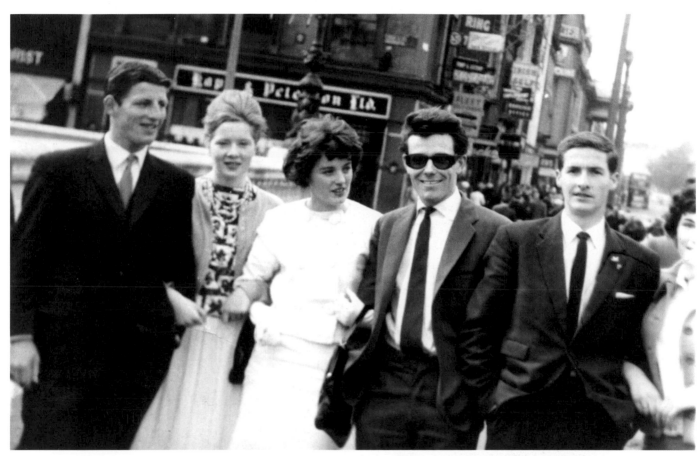

1960 'That's me, Treasa Kirwan as I was then, in the white suit (gloves from Madame Nora's, the suit was made by my mother) with my future husband, Peter McCarthy, in the sunglasses. He was wearing a pioneer pin and he stuck to it. He's dead over 40 years now. I love the photo as it brings back memories. The other people in the photograph were Pete's friends from Drimnagh. We were on our way to Bray and were crossing over O'Connell Bridge to get the bus around by the Royal Theatre. Peter always loved the music of Buddy Holly and the Everly Brothers. He was always singing their songs.'
Treasa McCarthy

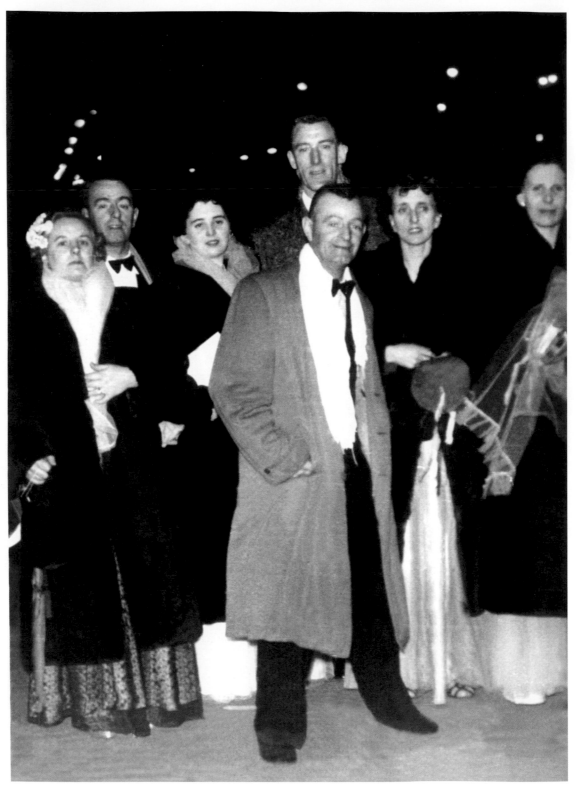

1960 'Coming home from a dinner dance at the Metropole: on the far left are my parents, May and Joe Devlin. My uncle Vincent Devlin is centre front wearing a white scarf, and his wife, my aunt Margaret, is on the far right. I remember them coming in after the dinner dances with a bit of cake or a fancy hat.' *Joe Devlin*

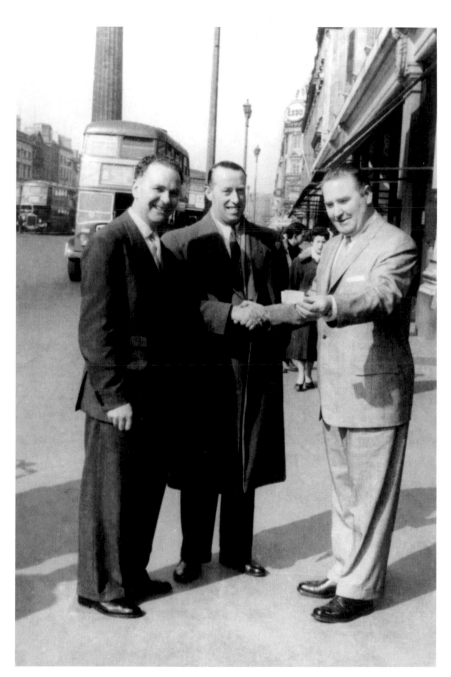

1960 'Tenor Joseph Locke (right) shaking hands with a fan. My late husband, John Byrne, is on the left. He was a Kerryman and built several dancehalls in the UK as well as the O'Connell Bridge House office buildings. He and Joseph had just had lunch in the Gresham.' *Ciara Byrne*

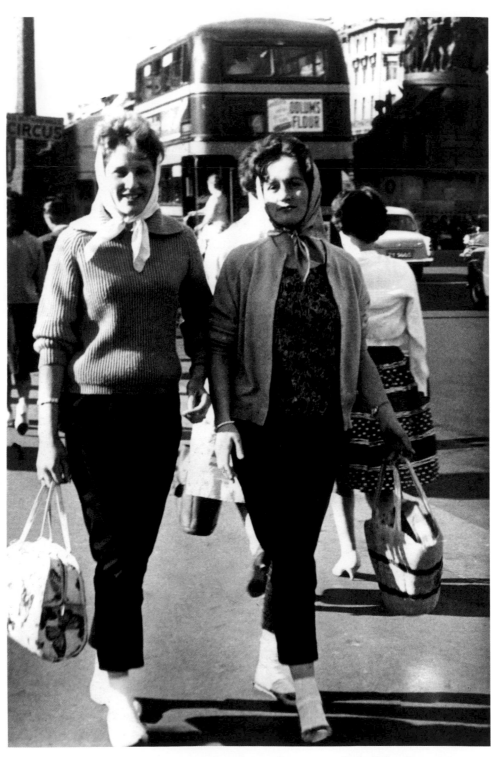

1960 'My aunt Margaret Burke and Margaret Ryan. They used to work together in Bird's Jellies at Dublin Castle. My aunt was lovely and brought us everywhere. She went on to marry Pierce Finnegan, a lovely man. She was always very glamorous and still is.' *Mark Burke*

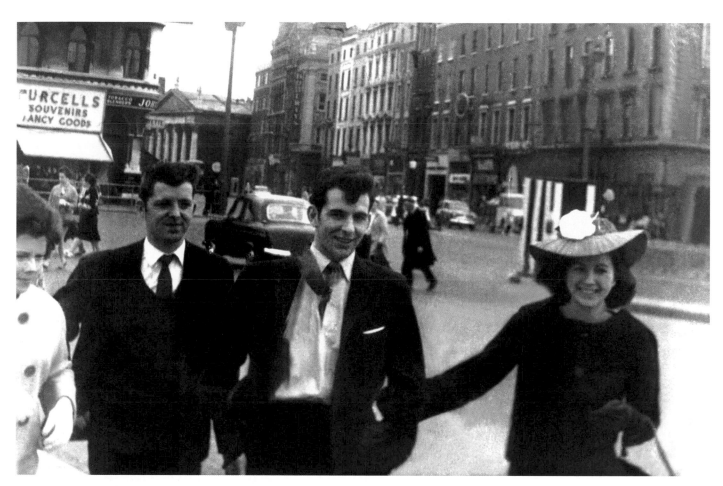

1960 '(L–r): Treasa Cullen, Karl Rogers, Paddy Rogers and me (Annette Watson).' *Annette Rogers*

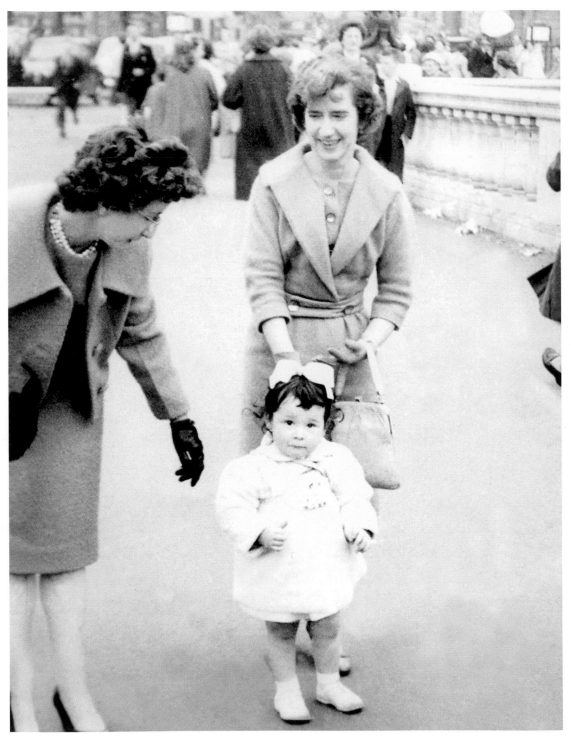

1960 'My mother, Mona Fitzsimons (née Doyle, left), me and my aunt Mai Doyle on O'Connell Bridge. These days, my mother doesn't remember who we are, sadly. Every so often, though, we show her photographs and sometimes she reacts to them. Recently, I showed her this photo and asked "who's that?" She said, "that's my baby daughter".' *Marie Sheridan*

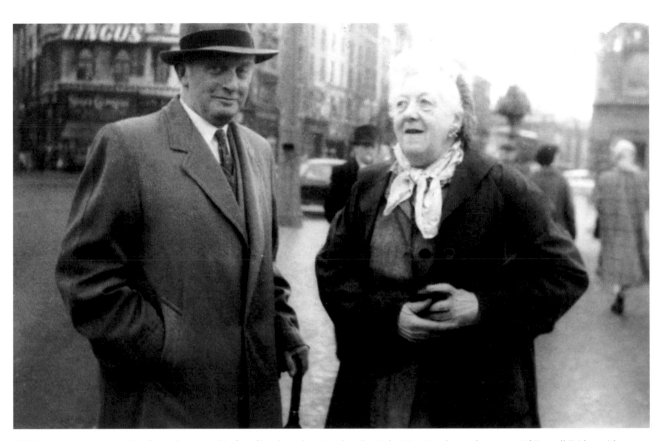

1960 Actress Margaret Rutherford who starred in four films based on Agatha Christie's *Miss Marple* novels, crosses O'Connell Bridge with her husband, Stringer Davis. *Arthur Fields family collection*

1961 'Me (Marion Gleeson, right) and a friend.' *Marion Gerety*

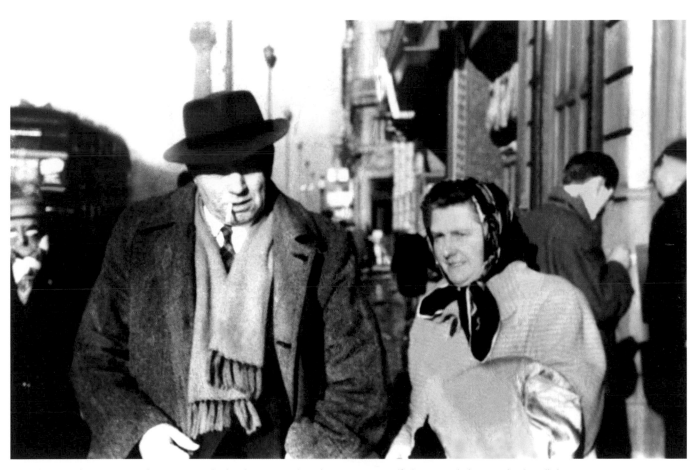

1961 'My grandparents Mr and Mrs Quinn, who lived in Drimnagh at the time. My grandfather was a baker in Bolands Mills.' *Ann Burns*

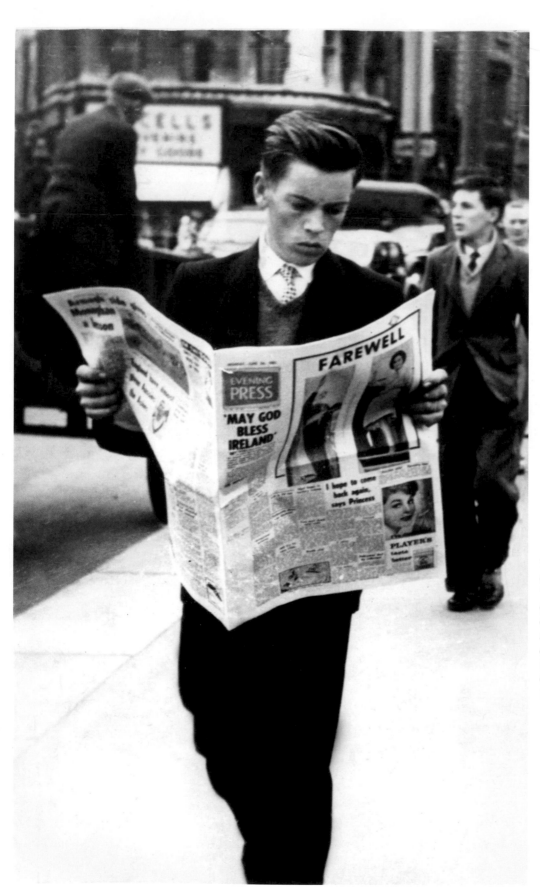

1961 'Wally Cassidy, our uncle (on our father's side) at the age of about 16. He worked as a milkman with our grandfather. When he was 21 years old, he fell off the milk cart. He died of a brain haemorrhage in 1966. This is one of the only photos we have of him. It was taken on the last day of Princess Grace's official visit to Ireland in 1961.'
Wally and Alison Cassidy

1961 'My husband, Mark Downey, at the age of two with his uncle/godfather James (Jembel) Downey.'
Maureen Downey

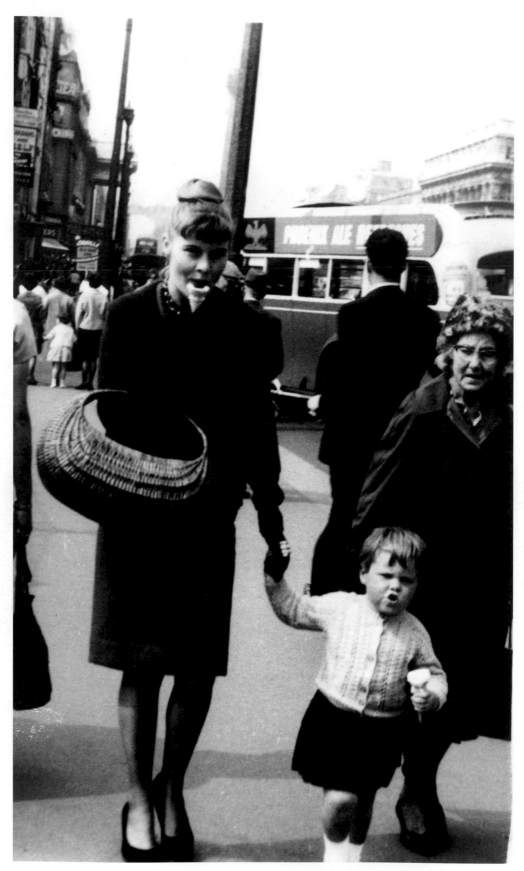

1961 'My sister-in-law Patricia Quinn (who died in 2012) and daughter Suzie. They lived in Sussex at the time and were home to visit. On the right is Aunt Eileen, who reared Patricia when her mother died in childbirth.' *Ann Burns*

1961 '(L–r): My brother Billy and his wife, Maureen, then Joan and me, out for dinner in the restaurant Paradissimo on Westmoreland Street. It was a very famous, very tip-top restaurant, where all the celebrities went.' *Thomas Courtney*

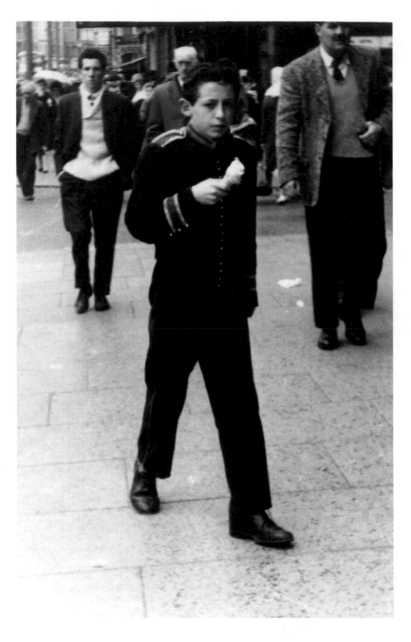

1962 'This is a photo of me taken near the Metropole in 1962. I worked as a page boy in the Gresham Hotel. I was on a message for a resident and had just dropped off a prescription in a pharmacy. The wages in Gresham were very low (£4 a week) but you could come home with anything between £15 and £25 in tips (all currencies) and the ice cream was from that. You'd be doing errands three or four times a day and invariably you'd have three or four ice creams a day. I worked in the Gresham Hotel from late 1961 to late 1965. It was an exciting the place to work. RTÉ was launched from outside the Gresham. President Eisenhower, Bing Crosby, Grace Kelly, John Wayne, James Stewart, Pat Boon, Liz Taylor, Richard Burton, The Beatles, Laurel & Hardy, Gene Tierney, Louis Armstrong, Ella Fitzgerald and so on: I met them all. When James Stewart was staying there (he spent a considerable amount of time there), he would get 10 or 12 telegrams a day. Every time you delivered his telegrams, he'd give you a $5 tip. When he had three telegrams, I was inclined to deliver them individually. My job was primarily to call out people's names around the foyer and the cocktail lounge when they were telegraphed. "Mr O'Donohue, a phonecall", I'd shout. Actually you'd sing it rather than shout it. If they were American, you'd shout in an American accent. Sometimes people would tip you $10 just to call their name and impress the people they were with. I then got an offer to work as a night porter in the Anchor Hotel which was a better salary. It was right across the road from the Gate Theatre. I was there at 1.32 a.m. on 8 March 1966, standing outside the Anchor looking at the patrons coming out of the Ierne Ballroom, when Nelson's Pillar was blown up. I remember a loud blast, a cloud of dust, and panic on the streets. Strangely, people were running towards it instead of running away. Natural curiosity. For the remainder of the night there was a whole clatter of police and cordons, thousands of people arriving in to town trying to get souvenirs and memorabilia from it. A week later, the Irish army organised a planned explosion. They put in a lot of preparation with silencers and detonators but, when it went off, windows were smashed from one end of O'Connell Street to the other. Hardly a window was broken with the original explosion.' *Gerard Griffin*

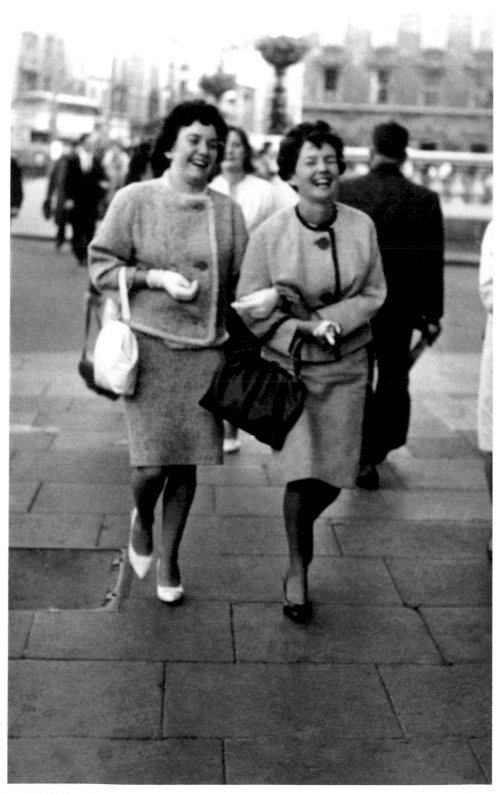

1962 '(L–r): Me and my sister Mary Halligan on a day out in town, having a great laugh.' *Anne Halligan*

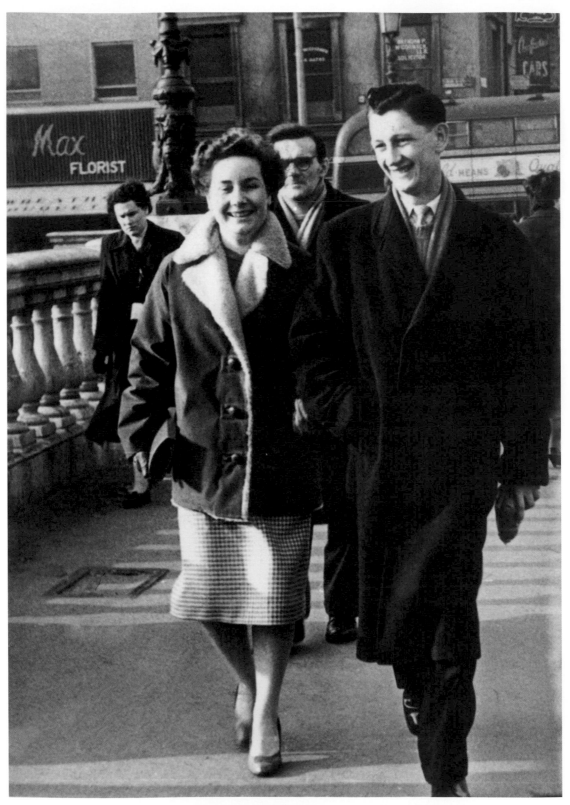

1962 'My aunt and godmother, Carmel, and her husband, Jimmy Martin, out for a Saturday afternoon stroll a fortnight after they were married. Carmel lived with us when we were younger and was more like a sister. Jimmy was originally from New Ross and worked as a tailor for Louis Copeland.' *Gabrielle Deans*

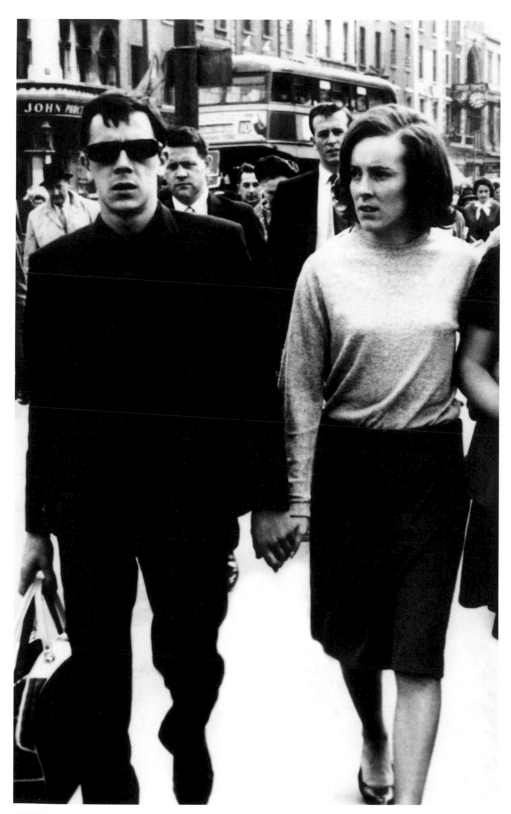

1962 'My husband, Fred Heffernan, and me, Marie (née Gelling), home from London on a visit. Originally from Cabra, we moved to Shepherd's Bush for four years.' *Marie Heffernan*

1962 'My parents, Brendan Spain and Margaret (née McLeod) on their way down O'Connell Street to the Savoy cinema on one of their first dates.' *John Spain*

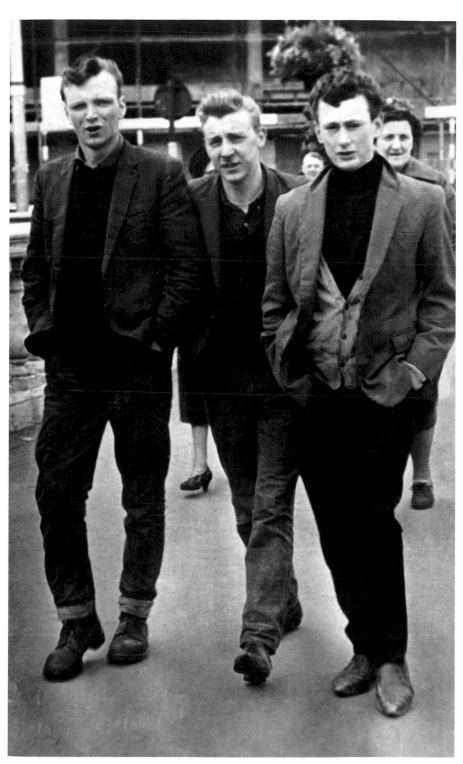

1962 '(L–r): Paddy Kearns, me and Jimmy Russell. At the time, we were apprentices on the building under construction behind us, the O'Connell Bridge House. We often strolled up town on our lunch break.' *Pat Kelly*

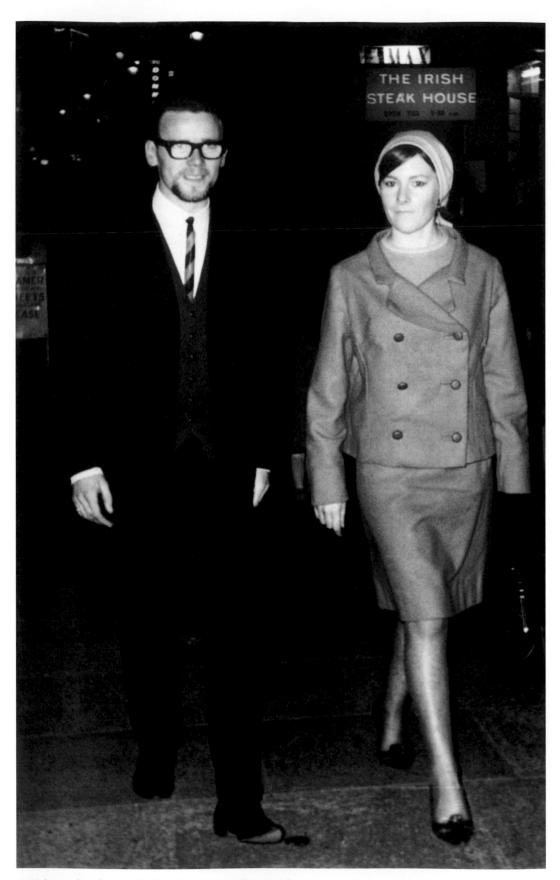

1962 'Me and my future wife, Mary Kavanagh.' *William Ormsby*

1962 'I was coming home from work from the dress designer Cybil Connolly on Merrion Square. I was a seamstress and these are clothes I made. I took the ticket from the photographer and thought I looked so good that I had to buy the photo.'
Elenor Hegarty

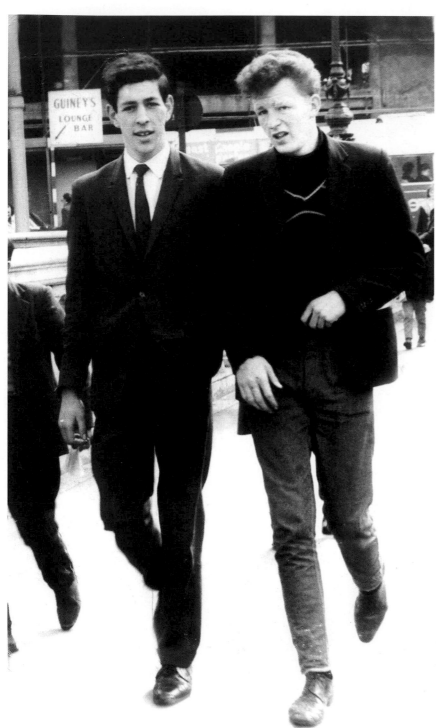

1962 'On the left (looking very respectable!) is Brendan Scanlon. Ted Murphy is the 'cool dude' on the right. He was later to become my husband, and died in 2013 after a long illness. I love the photo because it captures a unique time in our history and also says something about their friendship. They grew up together in Rathfarnham, south Dublin. Even though they were completely different, there was always a very special bond between them. They remained lifelong friends and Brendan spoke at Ted's funeral.' *Meg Murphy*

1962 'My parents, Brendan and Marie Douglas, from Cabra. Mam is no longer with us. They were married in 1963. Dad still loves ice cream.' *Brenda Douglas*

1963 'Going to buy my first pair of glasses. I was 15 years old and wearing the first dress I ever made.' *Myra Field*

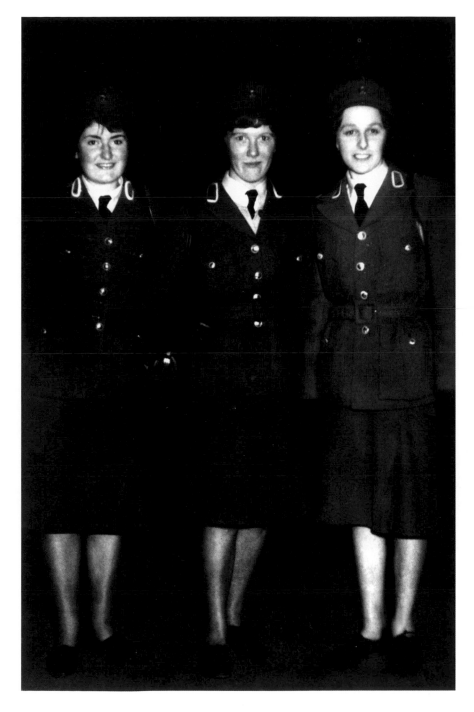

1963 '(L–r): Me, Claire Bolger and Anne Rafter. We were going door to door in housing estates around Dublin collecting money for uniforms for the Order of Malta on 22 November 1963, the night of JFK's assassination. The news was only breaking as we started out. As doors opened, people were crying and giving us updates as the evening progressed. I remember one woman saying that he was only shot in the neck and that he was going to be okay. As a first-aider I knew that if he was hit in the neck, it would be difficult to survive. On the way back, we decided to get our photo taken, not with any purpose or any logic that this date would become so famous.' *Annette Owens*

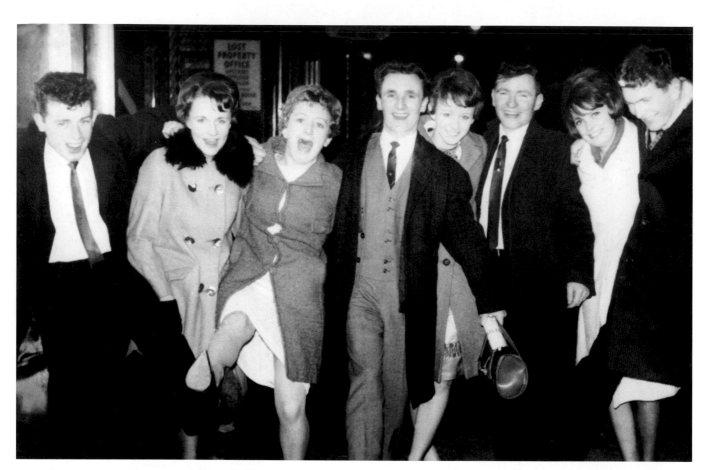

1963 '(L–r): Me and my future wife, Maeve (née Behan) out with family and friends – Anne Boyle, Jimmy Behan, Amy Whelan, John Behan, Marie Hogan and Eddie McDonald. We had so much fun together!' *Christy Hogan*

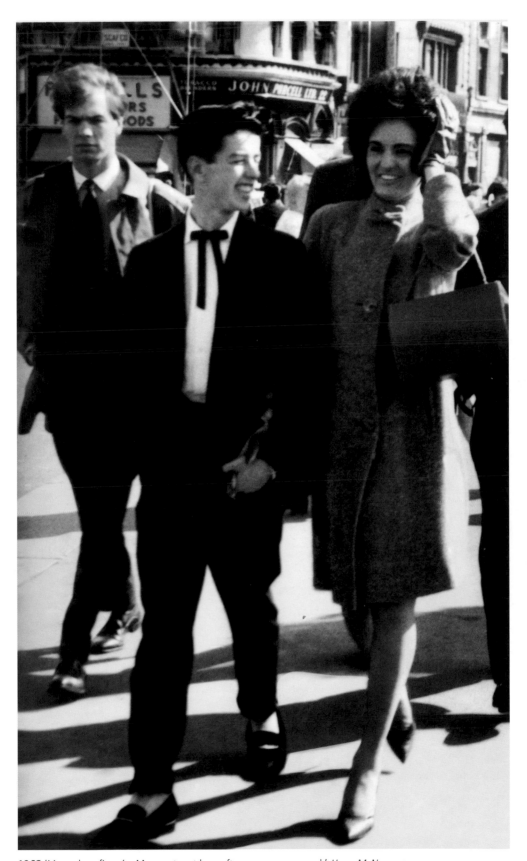

1963 'Me and my fiancée, Margaret, not long after we were engaged.' *Harry McNamara*

1963 'This is me, Anne Woods, on my confirmation day.' *Anne O'Byrne*

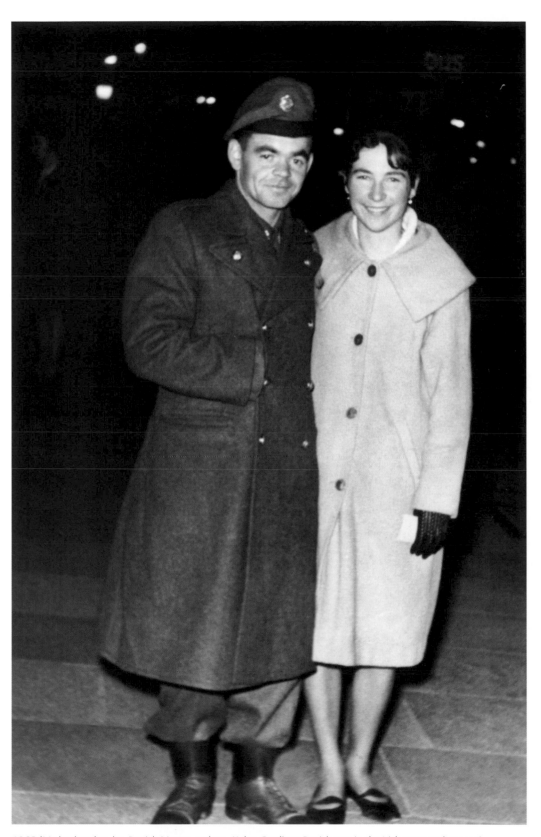

1963 'My husband-to-be, Patrick Moran, and me, Helen Gardiner. Patrick was in the Irish army and spent three years at the Curragh Camp. He came to Dublin to date and we would meet in the Irish club in Parnell Square.' *Helen Moran*

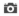

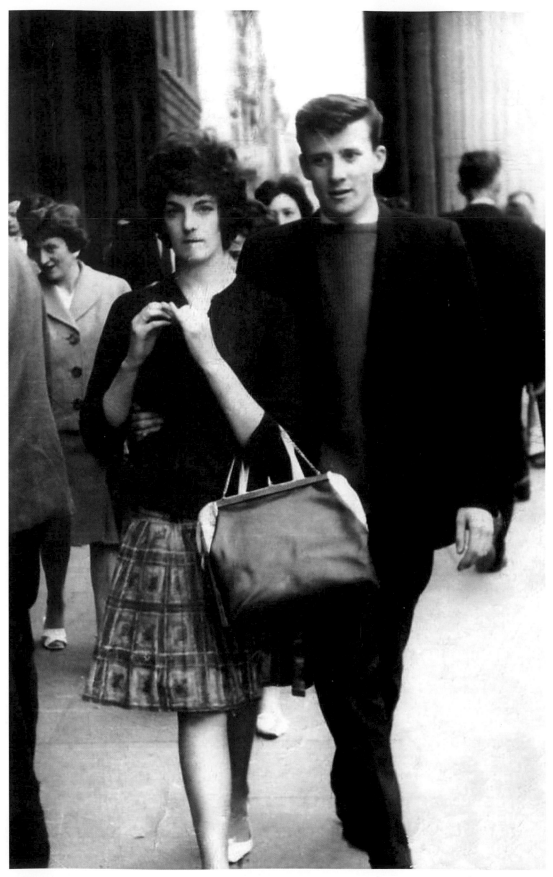

1963 'Dermot and Barbara Cooke outside the GPO.' *Andrea Cooke*

1963 '(L–r): Angela Curtis, Maureen Maguire and me, Maura Voyles. I worked in Browne & Nolans on 42–44 Nassau Street. I was secretary to the General Manager, a Londoner called Price. Angela was a typist in the general office. We became great friends and still send Christmas cards to one another and try to meet in Dublin once a year. Maureen Maguire was in secondary school with me, St Agnes in Crumlin. We remained friends for quite a time but eventually lost touch. This photograph was taken on a Saturday afternoon as we all worked five days plus until one o'clock on Saturdays. We were probably going shopping and then to the pictures. Life was very simple then. The last bus left town at 11.30 p.m. We never stayed out too late.'
Maura Moraghan

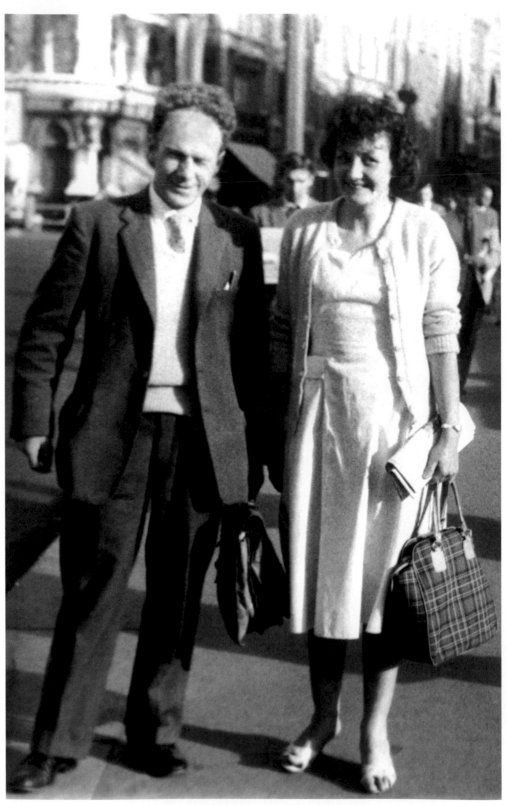

1964 'My father, Cornelius Keane, also a street photographer, with my mother, Ettie, coming from the Capitol Cinema.' *Vivian Quinn*

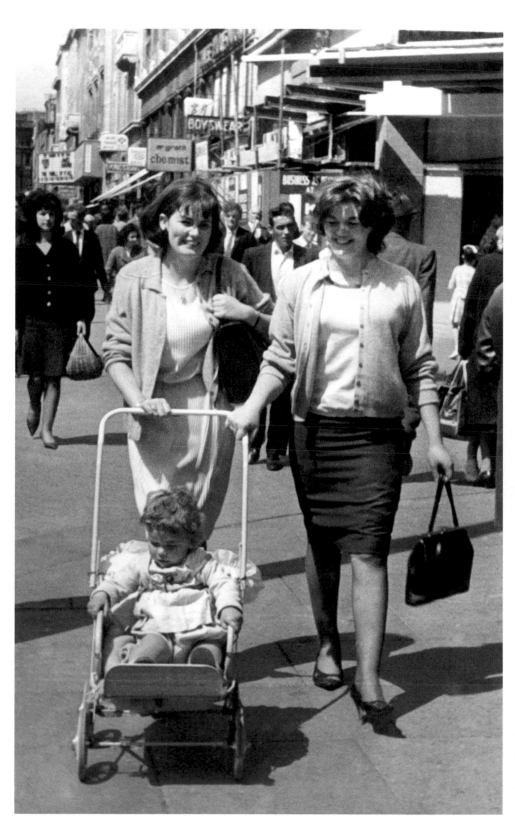

1964 '(L–r): Myself, Maura Voyles aged 18, and my work colleague Angela Curtis from Brown & Nolans. My brother Colm is in the pram. There was a huge age gap between us. We all loved him and I was showing him off.'
Maura Moraghan

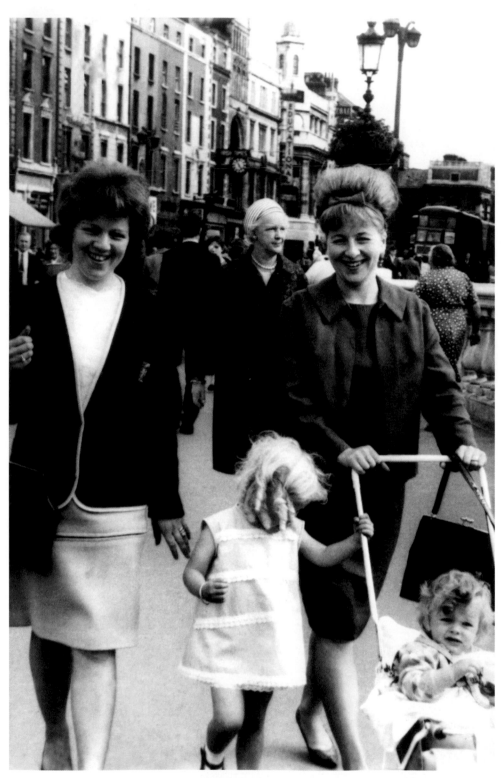

1964 '(L–r): Me, my sister Carmel Corcoran and her two children, Caroline (left) and Denise (in buggy) – our husbands were going to Croke Park and we went for a walk. We all lived in Ballyfermot.' *Anita Morrissey*

1964 '(L–r): My daughter Valerie and my niece Marie Blount. My wife, Angela, made their clothes.'
Tom McManus

1965 'My mother, Elizabeth Richards (née Maguire), and me on O'Connell Bridge. We collected a bouquet of ferns and roses from a friend's garden each year. Mum is carrying a basket of gooseberries. We were crossing over the bridge to the catch the bus home.' *Mary Richards*

1965 'My late father, Matthew Moore, and me pictured in O'Connell Street going for a stroll and window shopping while walking the dog, Kim. Just look at how well the dog is dressed and the cut of my own shoes!' *Joan Moore*

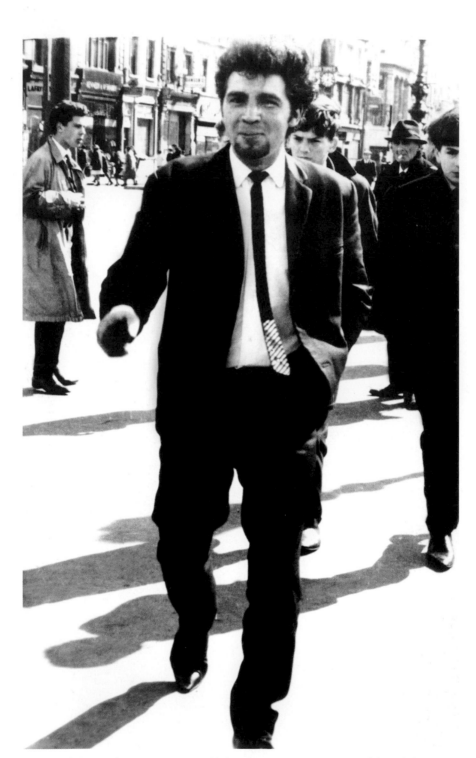

1965 'My father Noel Moran. He was a Teddy boy. It was all about the hair and the style.'
Sandra Moran

1965 'My parents, Robert Warrington and Joan (née Barnett), on their way to the cinema.' *Sandra Creevey*

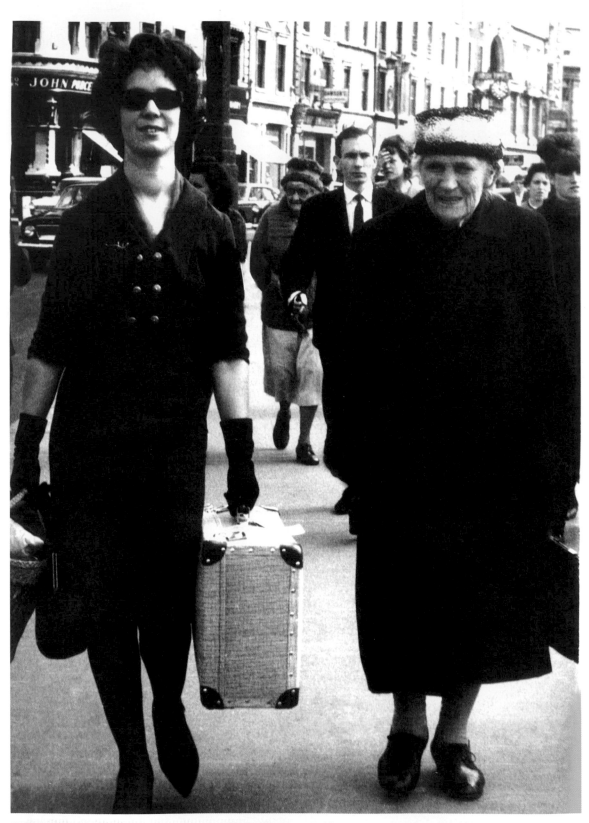

1965 'Myself and my grandmother Maria Ginty, who was coming to Dublin to visit me for the weekend.' *Angela O'Grady*

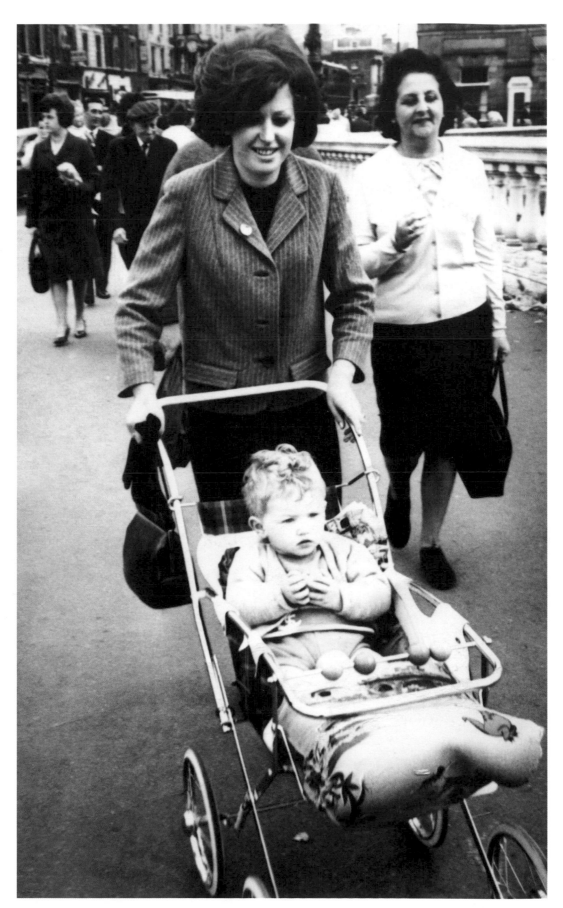

1965 'My sister Ivy Finglas with her nephew George.' *Michael Finglas*

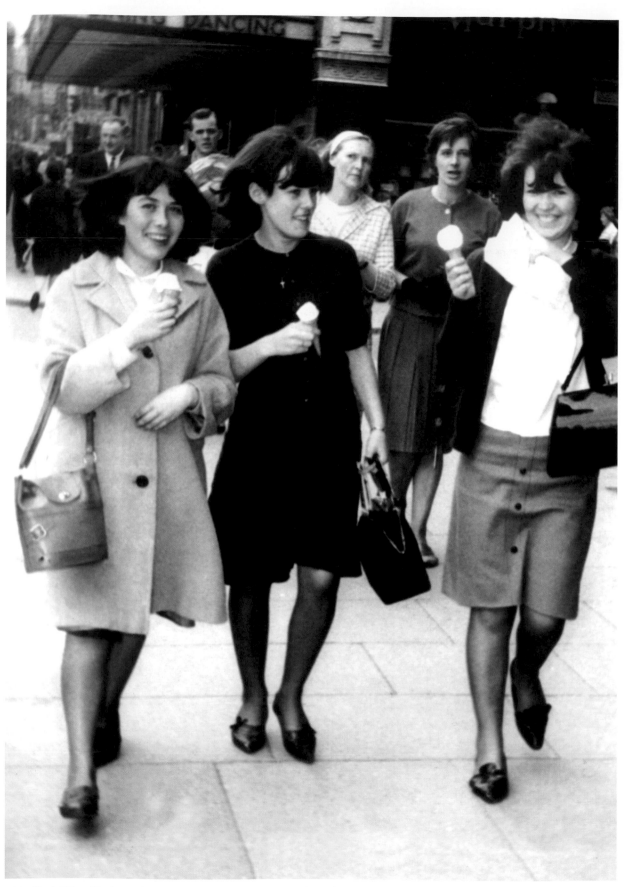

1965 '(L–r): Eithne Monks, me (Maria Gill) and Anne Hogan coming home from work. We worked on Dawson Street in the accounts department in Jordan Estates.' *Maria Gibson*

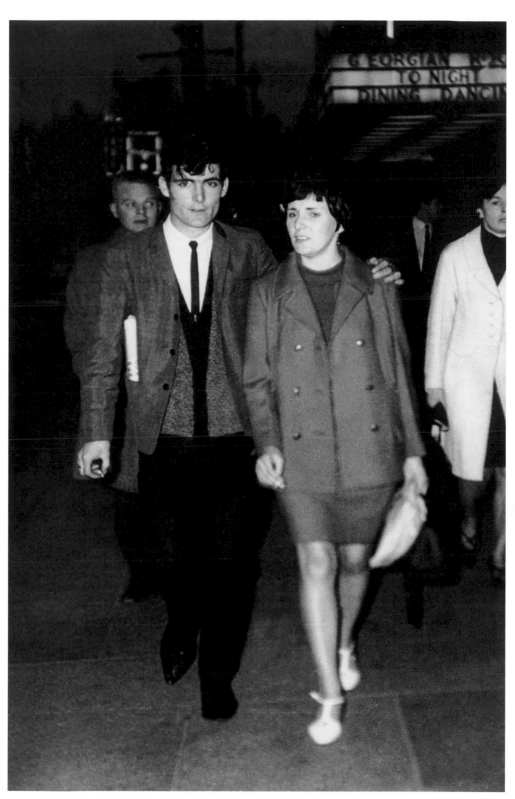

1965 'Thomas O'Brien and me, Christine Coleman, coming from the cinema.' *Christine O'Brien*

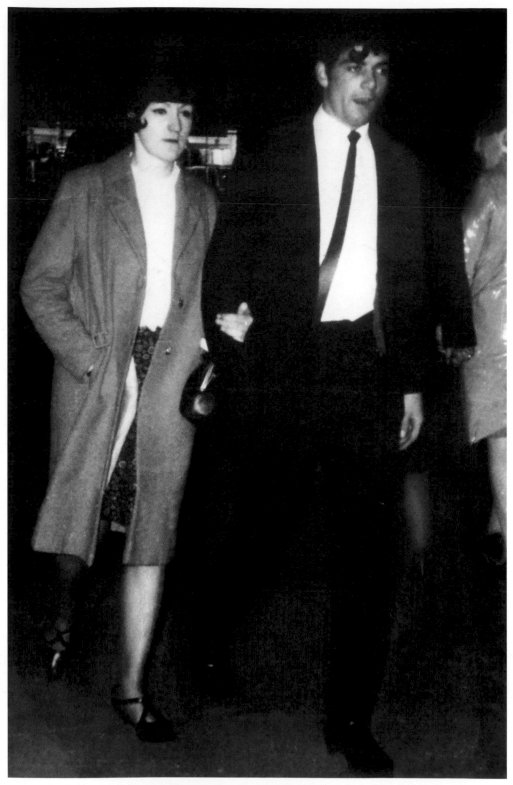

1965 'My parents, Mary and Jimmy McArdle from St Anne's, Raheny on their way to the cinema. Dad lived in Marion Park, Baldoyle, and worked as an apprentice carpenter at the time. My mam lived in Portmarnock and was a seamstress then. They always enjoyed meeting up in Portmarnock and heading off to the Carlton Cinema in town. They got married in 1970.' *Glen McArdle*

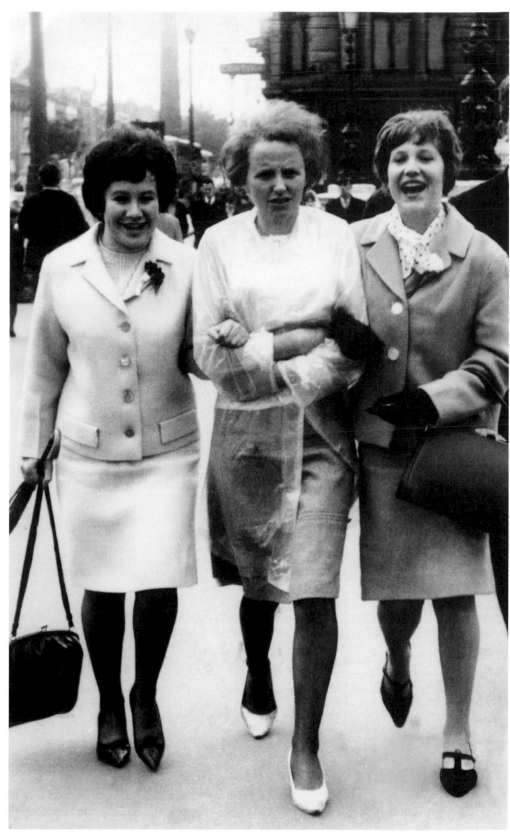

1965 '(L–r): Me (then Dolores McGrath), my cousin Madge Kane and her neighbour Rosemary Kirwan. We were coming from Madge's sister's wedding and Madge had no coat and I just happened to have a rain jacket so I lent it to her.'
Dolores Fitzpatrick

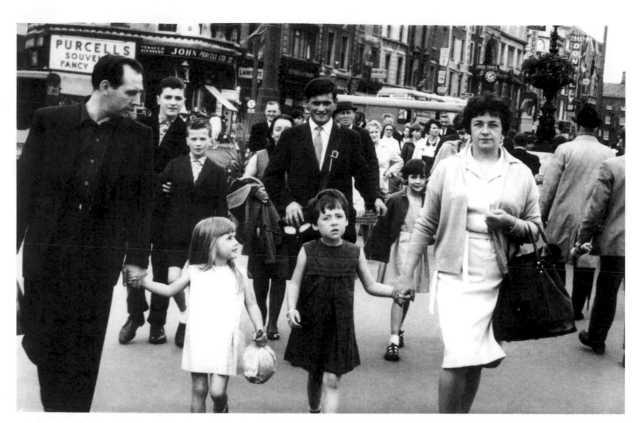

1966 '(L–r): My father, Walter Weatherall, my sisters Donna and Jacinta, and my mother, Angela (née Patterson). This photograph was taken in 1966 (three years before I was born). I love the expressions on my sisters' faces, something along the lines of "Mum, what's that man doing?" and my mum with a bit of a scowl as if she's thinking, "ah no, I look a mess." A classic moment in time.' *Fiona Weatherall*

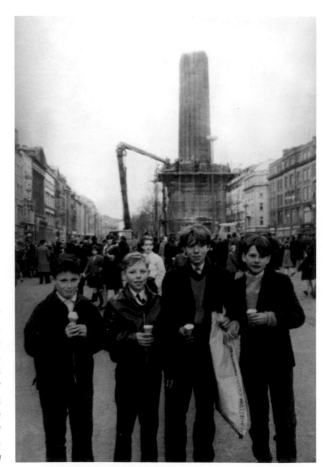

1966 '(L–r) Peter Pender, Peter Morrissey, Gerard Deveraux, and my brother Robert Keane (father of footballer Robbie). Gerard Deveraux had pigeons and had come into town to buy the food for them on Patrick Street, hence the bag. The photograph was taken shortly after Nelson's Pillar was blown up by the IRA.' *Vivian Quinn*

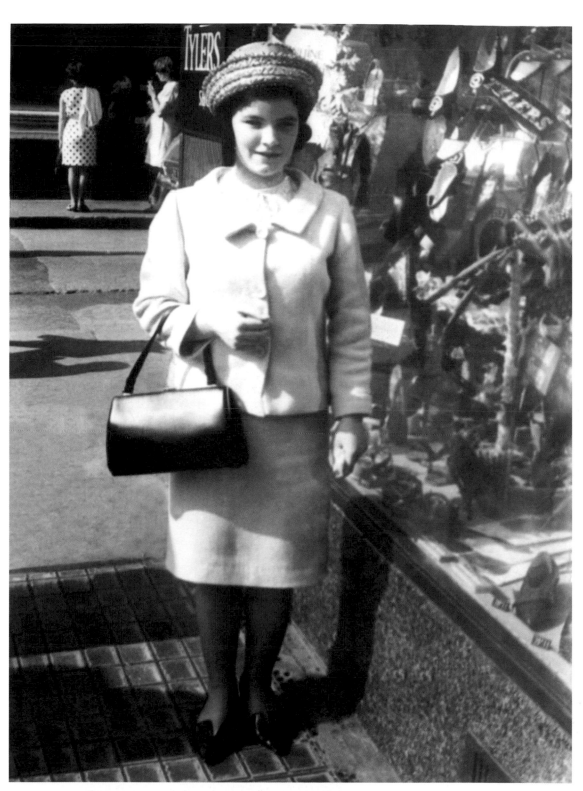

1966 'This is me coming up to Dublin for the first time from Longford. It was for an interview for my first job – which luckily I got! – in St Patrick's Hospital on James Street and I remember that suit like it was yesterday; it was lime green.' *Marie O'Neill*

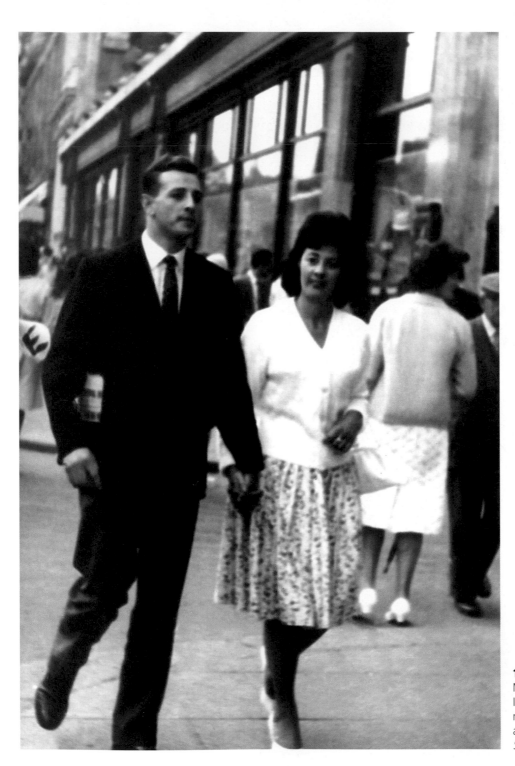

1966 'Arthur Fields' daughter, Norma, with her husband Arthur Ingram in 1966, the year they married. Norma is the eldest child and only daughter of Arthur.' *Shirley and Melanie Ingram*

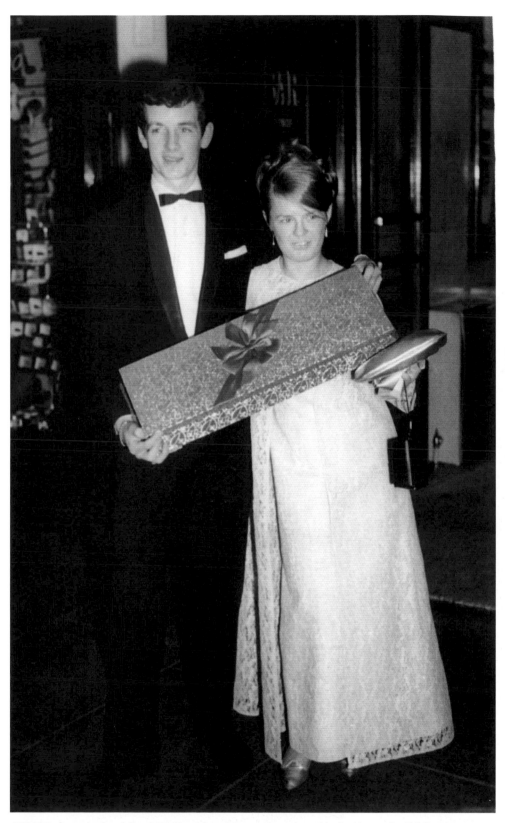

1966 'My future husband, Derek Walsh, and me (Yvonne Cooper) outside the Metropole. Childhood sweethearts, we were married in February 1970 and are still married today, with two children, Darryl and Donna.' *Yvonne Walsh*

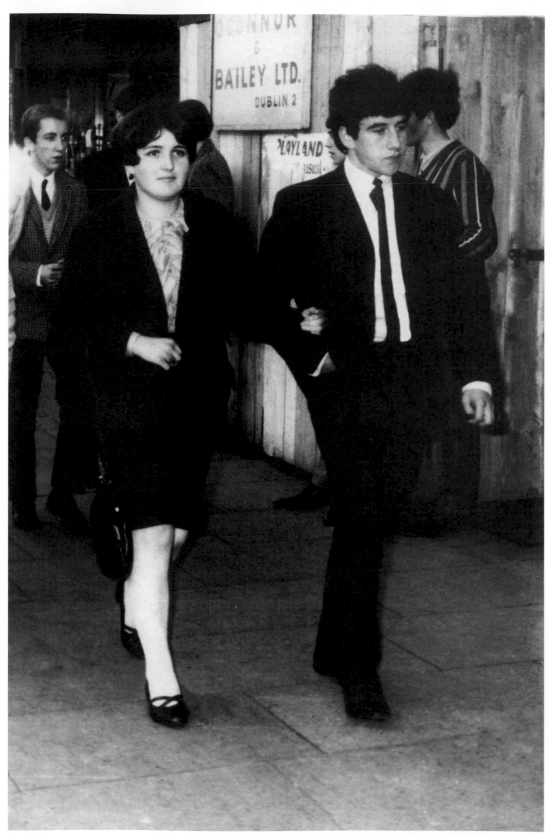

1966 'James Doyle and Angela Kavanagh (my sister-in-law). They were single at the time. Family lore says Phil Lynott is the busker in the background.' *Frances Feeney*

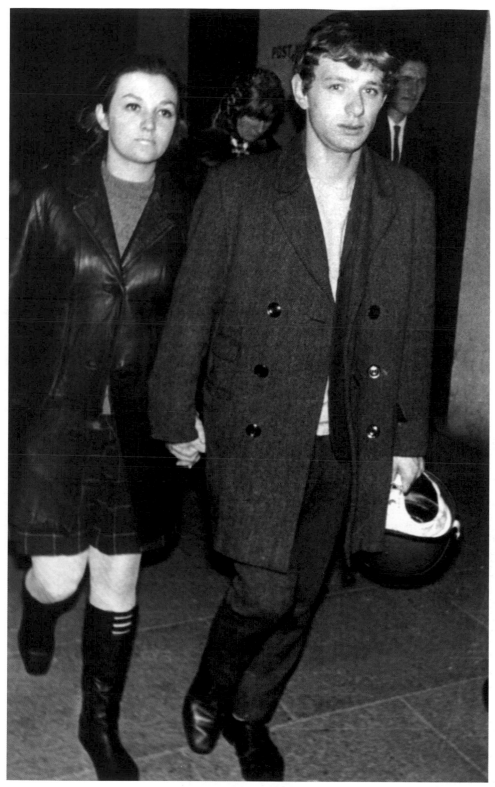

1967 'My girlfriend Cora (née McDonnell) and me on O'Connell Street before we were married. We are still together over 40 years later and happily married.' *Brian Lawless*

1967 'Myself and Mary McDonald. I was a student in Dublin and we were going to see *A Man For All Seasons* at the Regent Cinema. It was an intellectual movie so I wore glasses to give the impression of intelligence.' *Liam Bluett*

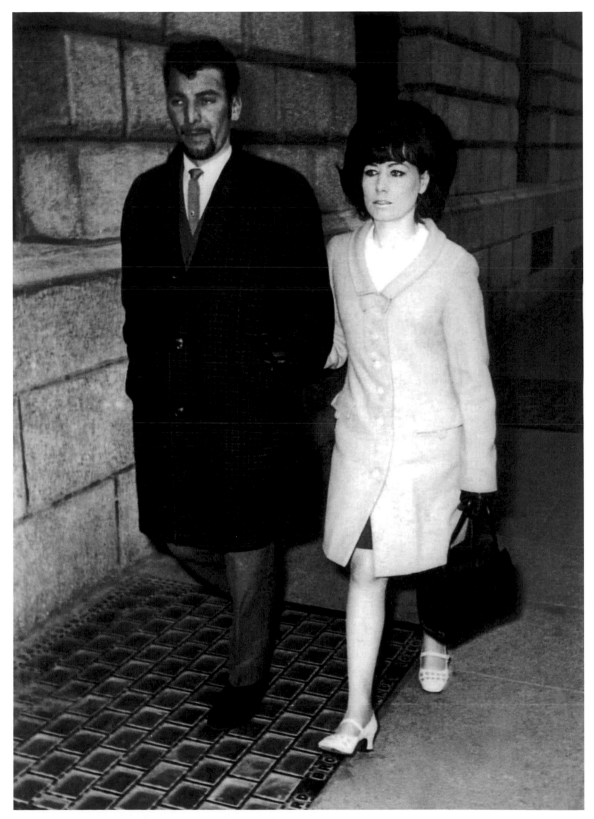

1967 'My parents, Michael and Helen Higgins, on O'Connell Street.' *Darren Higgins*

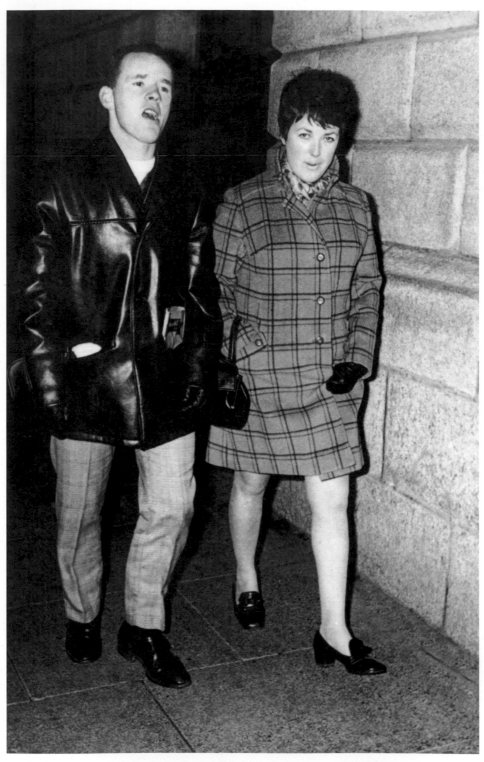

1967 'Myself and Colette Coogan on our way out for a meal. I was home for Christmas from Boston and Colette was working in Arnotts. We got married a couple of years later, in 1970.' *Liam Kane*

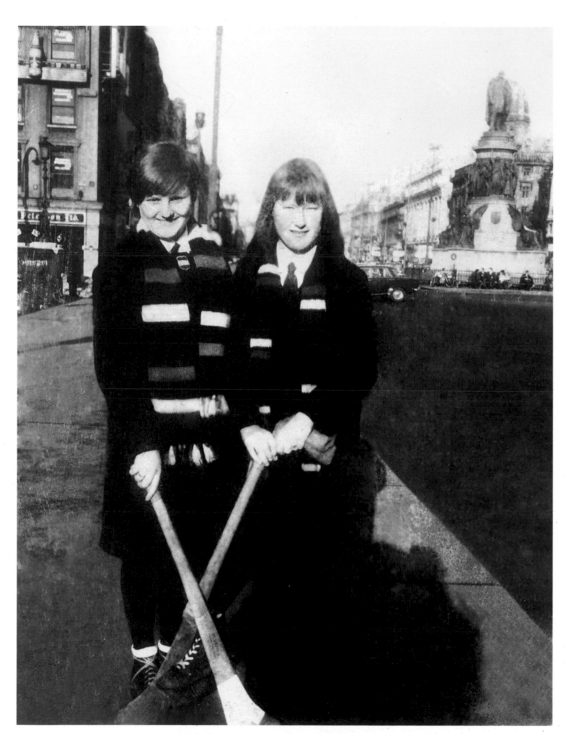

1967 'January 1967 on O'Connell Bridge. Off to a camogie match, myself (Janet Coyne, left) and my best friend Carmel Campbell.' *Janet Brady*

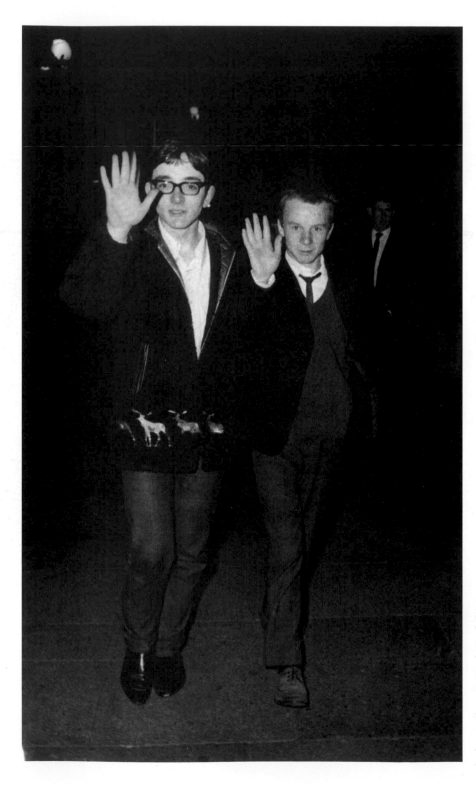

1967 'My husband, Peter Sheridan (right), and his friend Tommo Hogan. They both lived in Seville Place, Dublin, in the 1960s, Peter in Number 44 and Tommo in Number 47. One of Peter's books is called *44, a Dublin Memoir* and it relates stories of his family in Seville Place. His father worked in CIÉ, while Tommo's father worked as a docker. Peter founded the theatre in the Project Arts Centre in 1970 with his brother Jim, the film director.' *Sheila Sheridan*

1968 'Myself and fellow CIÉ workers at Kingsbridge (later Heuston) Station. (L–r): Mary Handley, Ann Ryan and me, Pauline Duffy. I can't remember the name of the guitarist.' *Pauline Walsh*

1968 'Me and my husband Patrick Whyte.' *Collette Whyte*

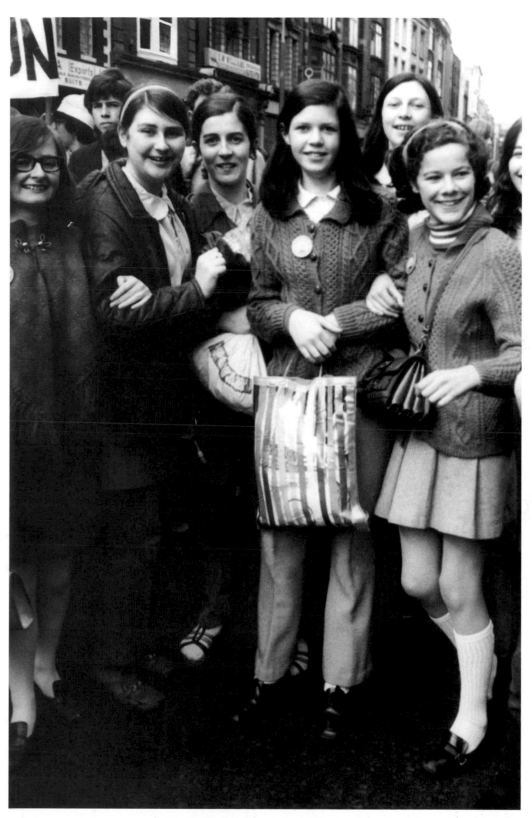

1968 'We were all school friends from Ballyfermot. (L–r): Anne O'Neill, Barbara Taaffe, Mary Farrell, me, Yvonne Whelan, Bernadette Buckley and Ann Buckley beginning the CRC (Central Remedial Clinic) walk on Abbey Street, sponsored by the *Evening Herald*. The walk went to Baldoyle racecourse where there was a free concert. A local Ballyfermot hearththrob boy-band, the Bye-Laws, were playing as part of the line-up that day.' *Marian McCarthy*

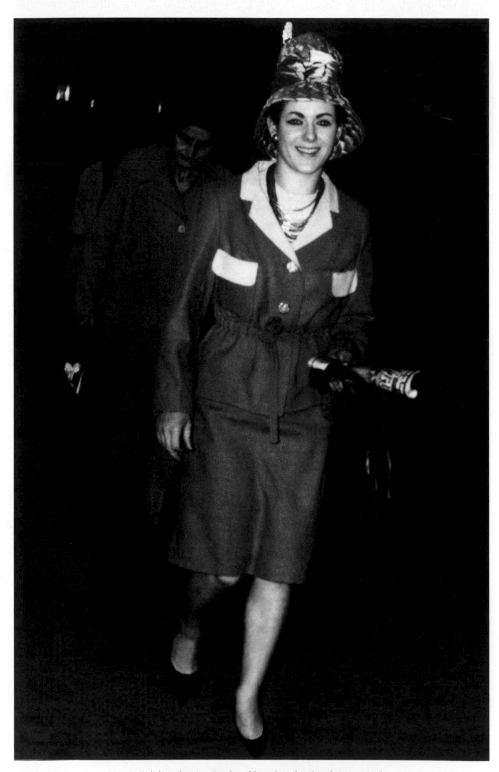

1968 'This is me wearing a pink hat that I owned and loved at the time.' *Joan Mack*

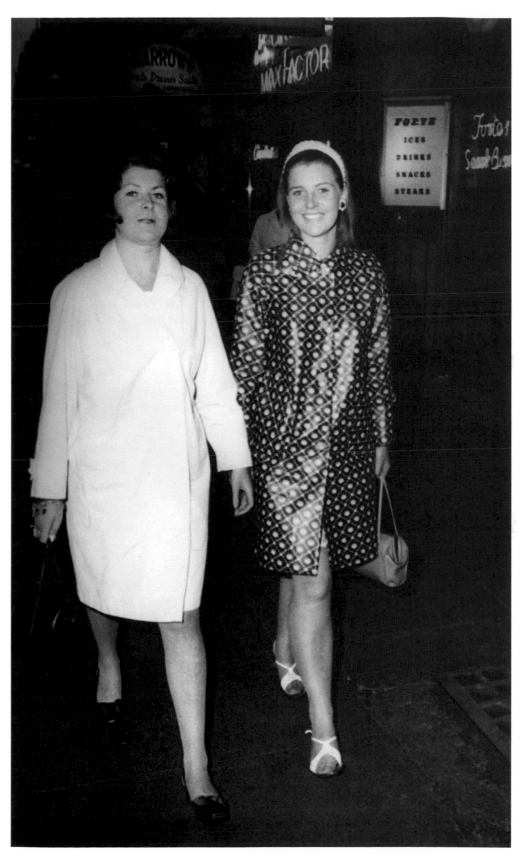

1968 'Myself with my friend Jeanne Kennedy having a night out. I was living in Swords at the time and Jeanne was from Whitehall.' *Kathleen Brady*

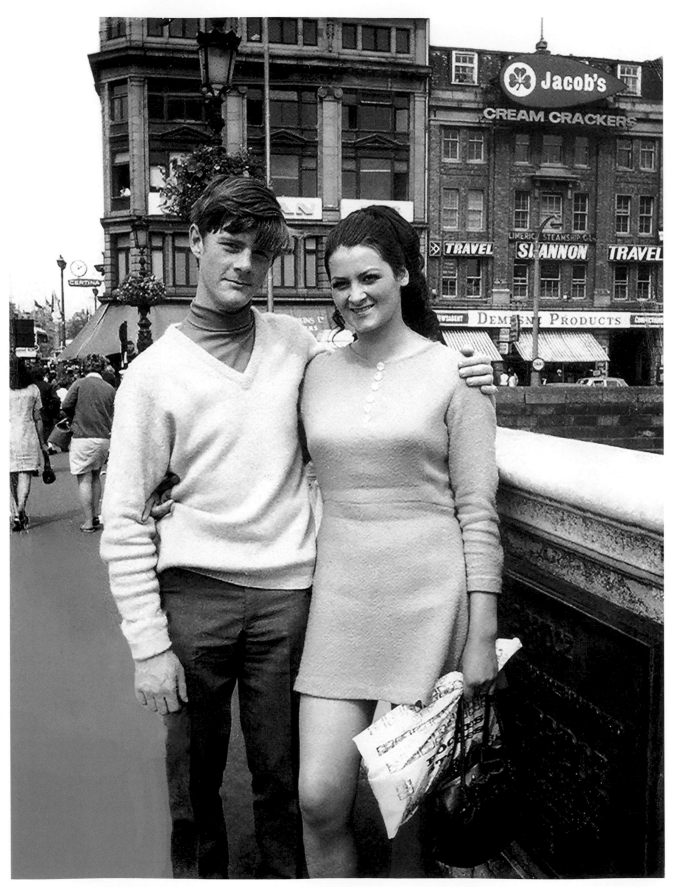

1969 'Me and my wife-to-be, Evelyn Duffy, up in Dublin from Westport for a shopping trip before our wedding. We were married on 10 June 1970 and went on to have five healthy children. Our marriage was very happy but sadly my wife passed away in September 1999. I now have five grandchildren, all living in Westport.' *Eddie Browne*

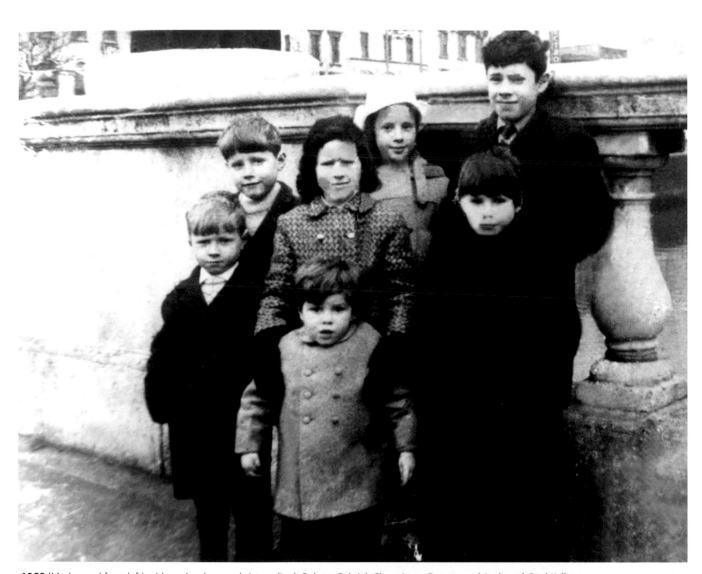

1969 'Me (second from left) with my brothers and sisters. (L–r): Robert, Gabriel, Clare, Anne, Frances and Anthony.' *Paul Kelly*

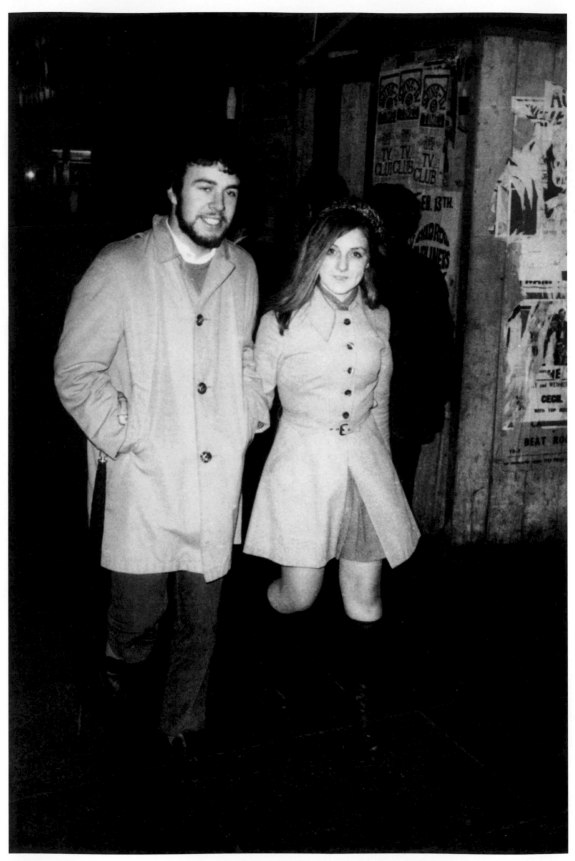

1969 'Me and my future wife, Marie Hughes, on a night out. Our first date was in a place called Moulin Rouge on Camden Street, New Year's Eve, watching Skid Row with Phil Lynott. The hoarding on the background has posters for both The Dubliners and Skid Row.' *Pat Sheils*

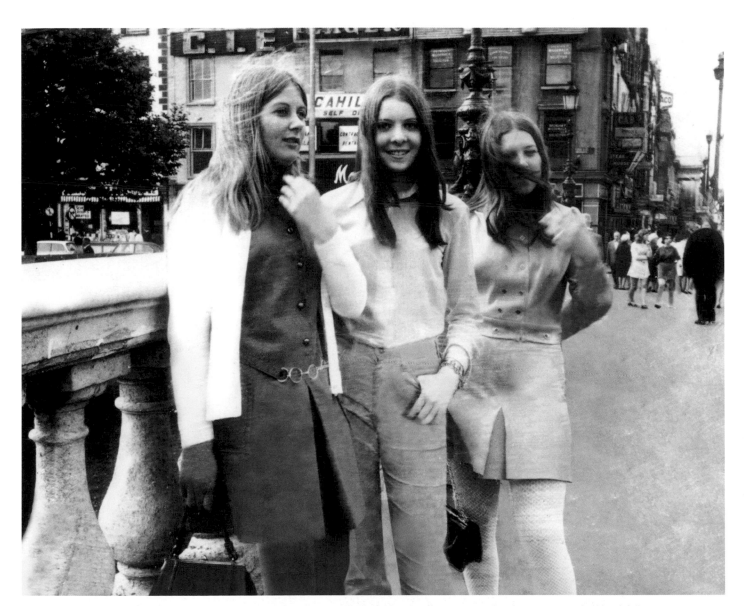

1969 '(L–r): Myself, Cathy Talbot and Marie Larrigan. Three friends in town having a laugh, off to see a pop band, Deep Set. We had been following them everywhere.' *Ann Clarke*

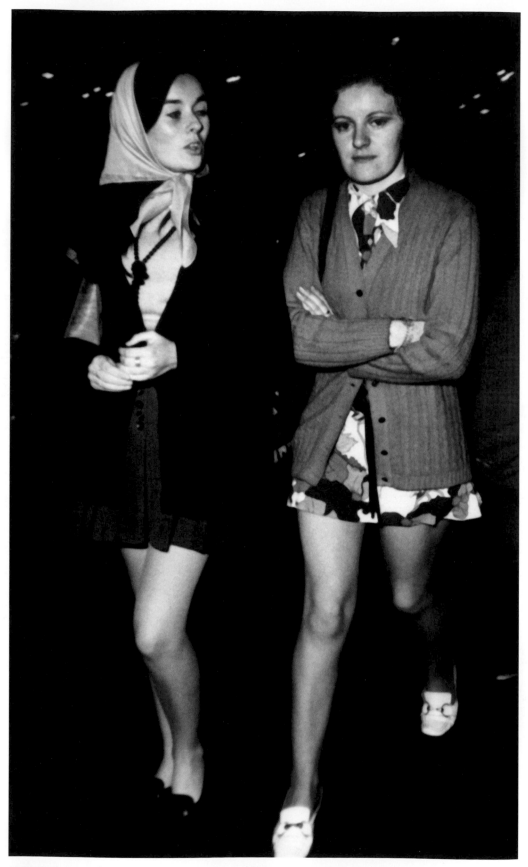

1969 '(L–r): Ann Hickey and me, Mary Delahunty, coming from work in the Revenue Commissioners.' *Mary Malone*

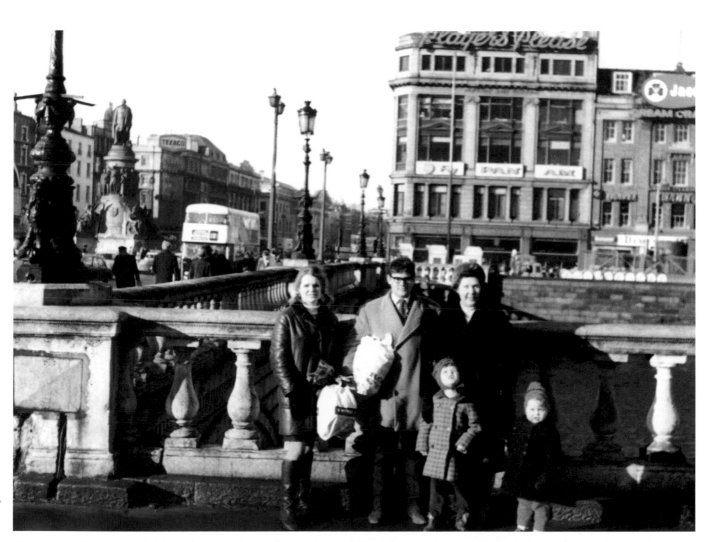

1969 Arthur Fields' own family visiting him on Burgh Quay. (L–r): Arthur's daughter-in-law Judy, his son David, granddaughter Trudie, Arthur's wife Doreen and another granddaughter, Danielle. *Arthur Fields family collection*

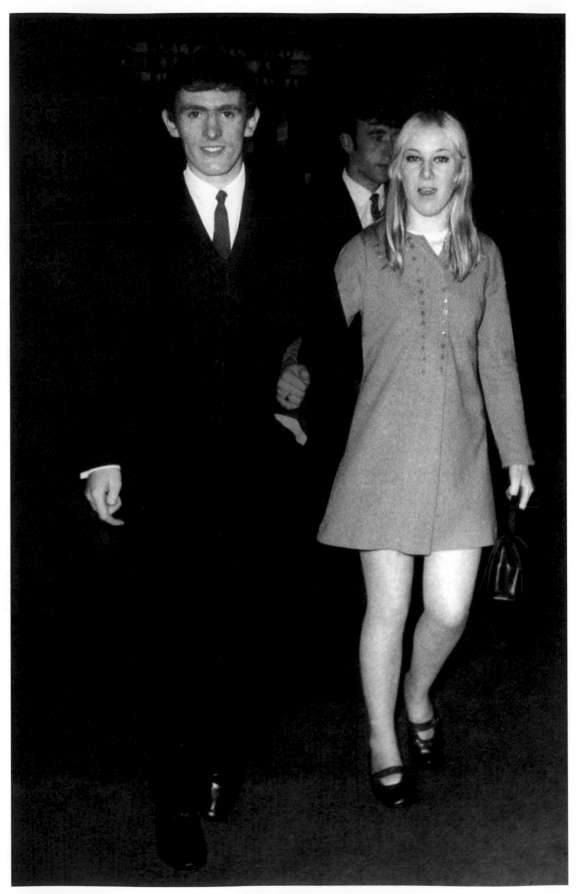

1970 'My parents, Danny Farrell and Patricia (née Cullen), out on a date to the cinema before they were married. My dad had returned home from England.' *Gavin Farrell*

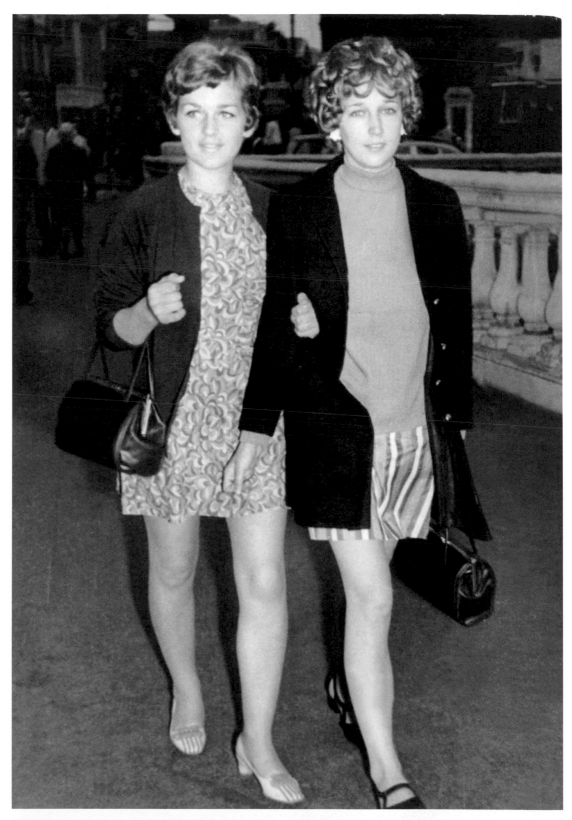

1970 'My aunt Mary Bermingham (left) and a dear friend of hers, Breda Butler. They grew up together in Milltown, Dublin. Always determined to look their best, they went to town sporting their best clothes and hairstyles. This photograph is a reminder of the pair's happy days spent together.' *Rebecca Bermingham*

1970 'My fiancé Anthony Daly and me (Margaret Armstrong). This was the occasion of our engagement, Saturday 3 October 1970. We were coming from the Abbey Theatre where we attended the play *At Swim-Two-Birds* by Flann O'Brien.' *Margaret Daly*

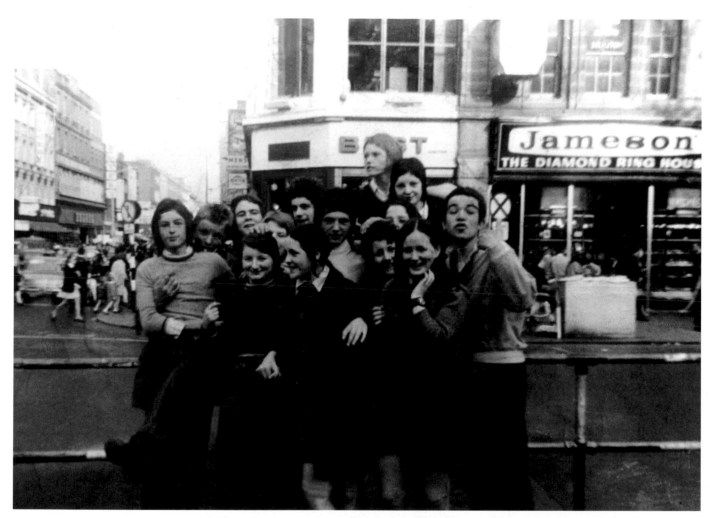

1970 'My go-go dancing friends. With go-go dancing, you'd swing your arms up in the air and all around. As a group, we went clubbing all the time, Monday, Wednesday, Friday, Saturday and Sunday. Arthur would always be there taking our photos. Before the clubs opened, we'd hang around the monument where O'Connell Street and Abbey Street meet. We were with the Scooters/Mods. On the other monument opposite, The Hells Angels would be hanging out there. Arthur was a very busy person with all of us. I'm still in touch with this group of friends and I still dance the go-go.' *Mary Nibbs Murphy*

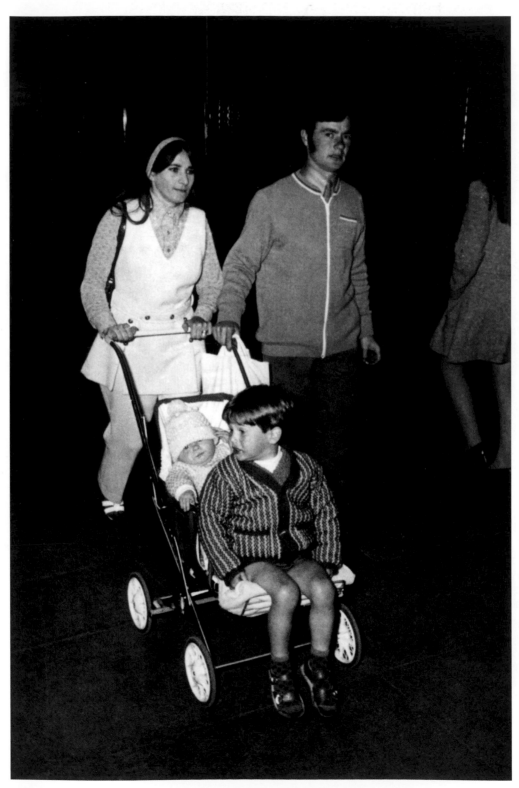

1970 'Me, my husband Joseph and our two sons, Francis and Alan.' *Elizabeth Egan*

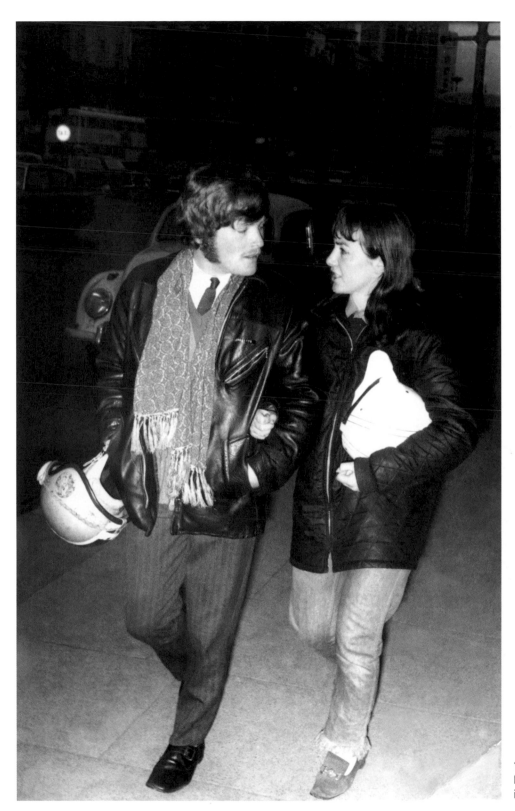

1970 'Myself and my wife, Eileen (née McGuinness), in town.' *Paul Doyle*

1970 'Me and my son Ciaran and one of his friends. I was given this toy horse when I was a child and then passed it on to my sons. This horse is still in the family and I recently refurbished it for my grandchildren.' *Patrick Kinahan*

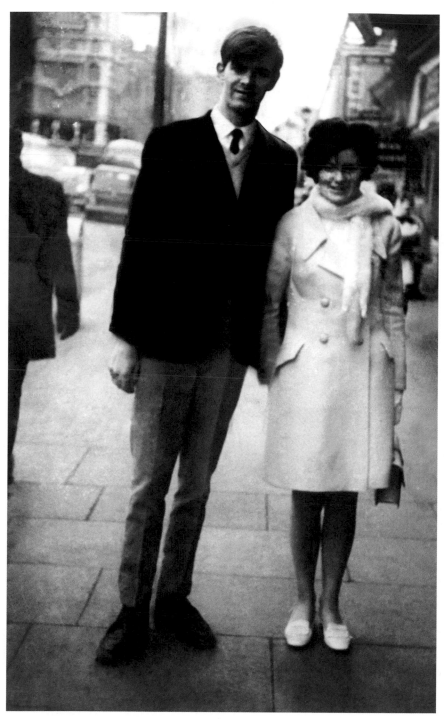

1970 'I'm from Newbridge. Our parish priest, Monsignor Miller, used always say that if you don't get a woman in your own town, go into the next one. I met my wife, Phyllis, in Kildare town. This is us on 1 January 1970. It was the first day of our honeymoon and we spent a few days up in Dublin in the Shelbourne Hotel. We went to the pantomime in the Gaiety, *Fiddler on the Roof* in the Ambassador, and *Oliver* in the Carlton Cinema on O'Connell Street.' *Liam O'Keefe*

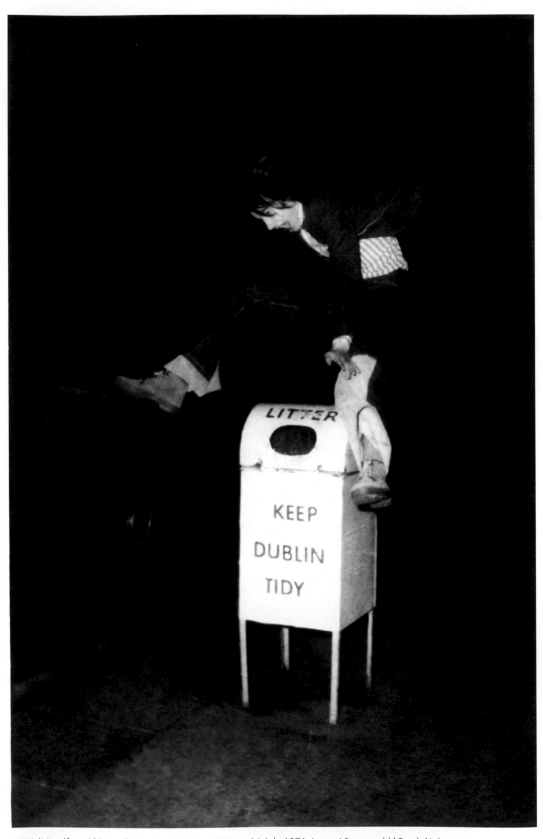

1971 'Myself on O'Connell Street outside the GPO on 21 July 1971. I was 16 years old.' *Frank Nolan*

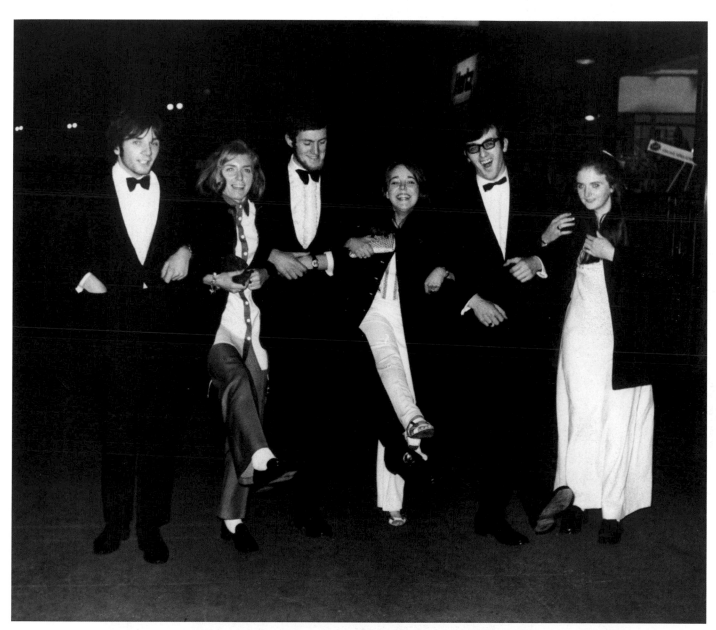

1971 'This is myself (second from right), aged 21, with (l–r) Shay Ford, Maria Consadine, Paul O'Reilly, Marion O'Doherty and Irene Consadine on our way to a dinner dance in the Gresham Hotel. Irene and I have since been married for 40 years.' *Barry O'Neill*

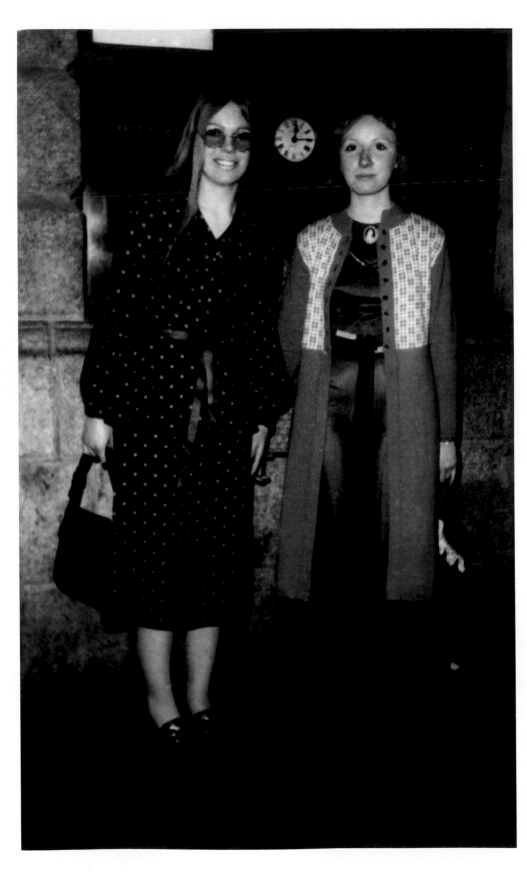

1971 'This is me, Trish Jolley Nunes (left) and my best friend Phyllis Caffrey, outside the GPO.'
Trish Nunes

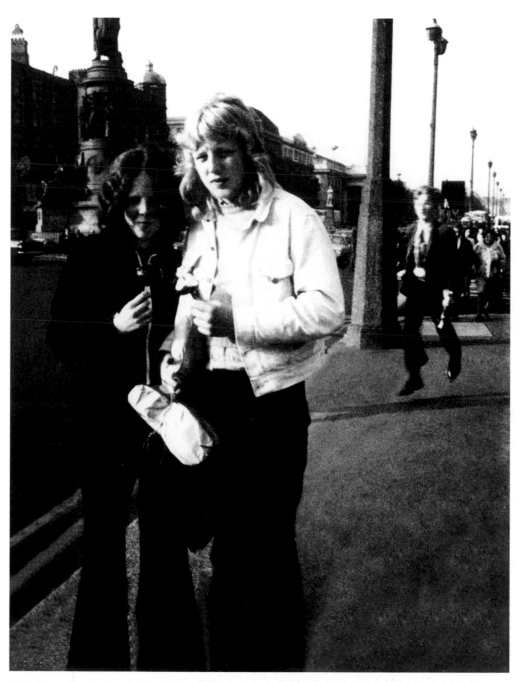

1971 'Me and my future wife Bee Gaule over 40 years ago – toffee-apple time. In my hands is a pair of shoes I bought, wrapped in the paper. We love the boy in mid-air behind us. Everyone who has seen the photo seems to comment more on him than us.' *Jody Hickey*

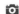

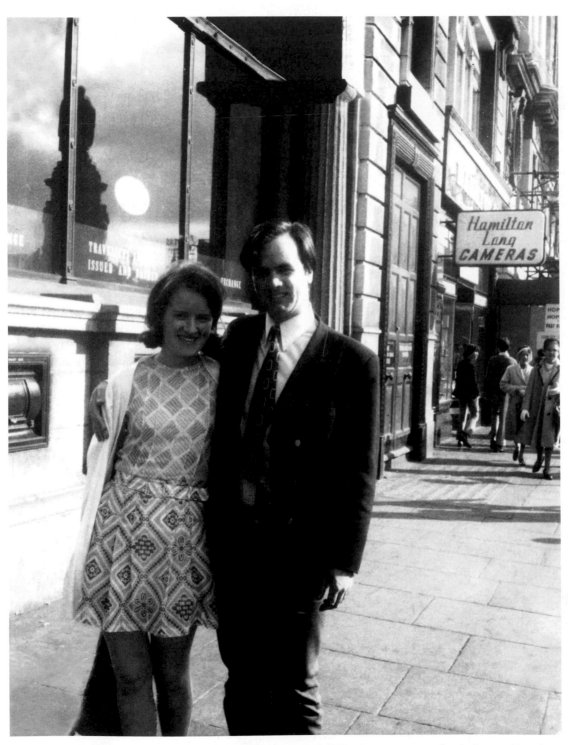

1971 'My parents, Carmel Moran and Paul Comiskey, in the summer of 1971, a happy young couple who became Mr and Mrs Comiskey in 1972. They went on to have seven children and moved to Cavan.' *Paula Comiskey*

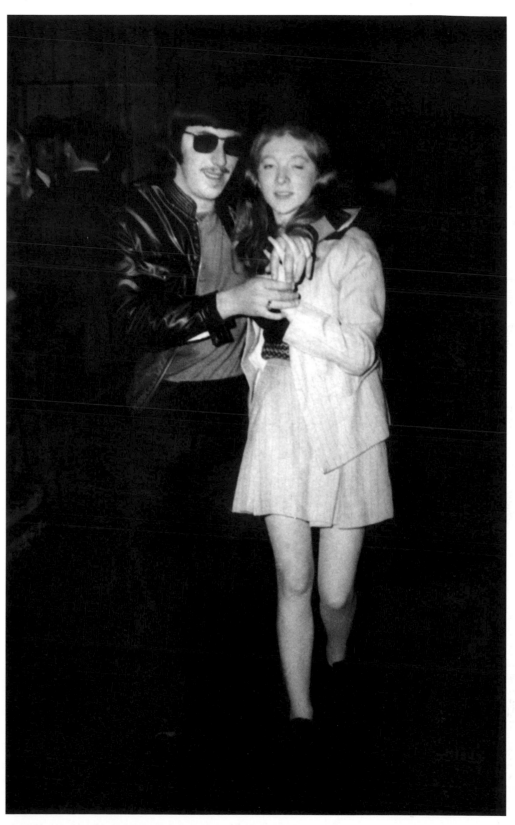

1971 'This is me with Antoinette Martin, my then girlfriend and future wife. We were probably on our way to the Carlton Cinema for the late-night show, a horror film with Christopher Lee. I used to dress like the musicians I liked such as The Beatles, The Faces, The Kinks, Cat Stevens, etc.' *Maurice Ward*

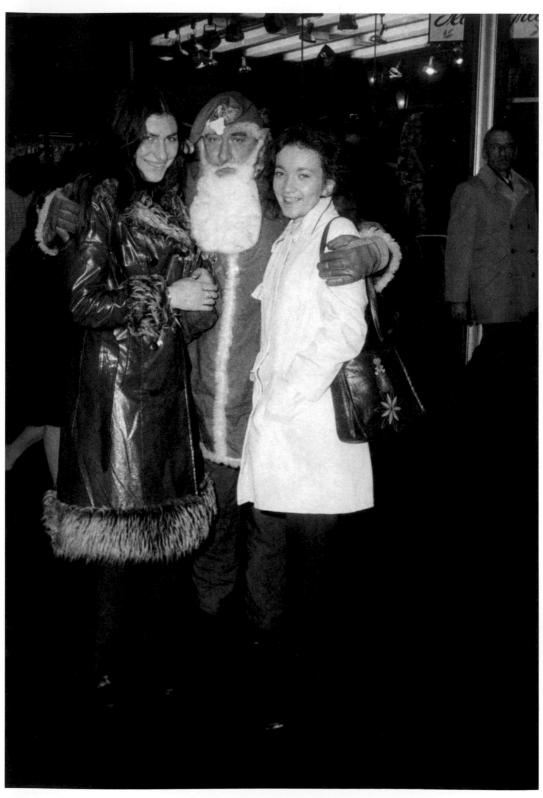

1972 (L–r): This is me, with Santa and Geraldine Feely. We were student nurses from County Down and took a pre-Christmas break in Dublin.' *Helen Hobbs*

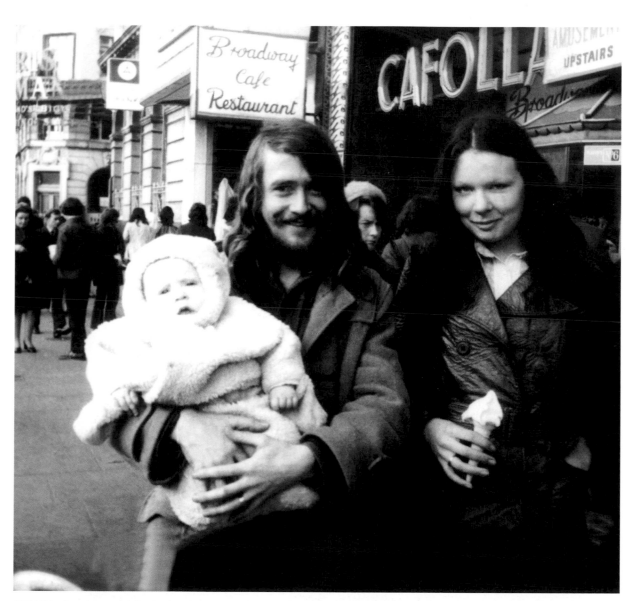

1973 'My sister Lorna with her husband Johnny O'Donohoe and their first-born, Daragh. Daragh went on to become a jockey and work for the Godolphin racing stable in Dubai.' *Honra Walsh*

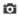

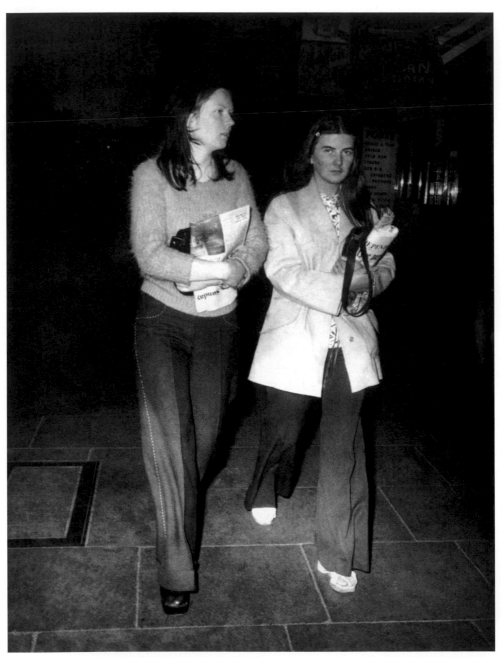

1973 'Carol O'Sullivan (left) and me, carrying our Sunday newspapers, before returning to "Flatland" in Rathmines. We were both working in the civil service at the time.' *Marian Hill*

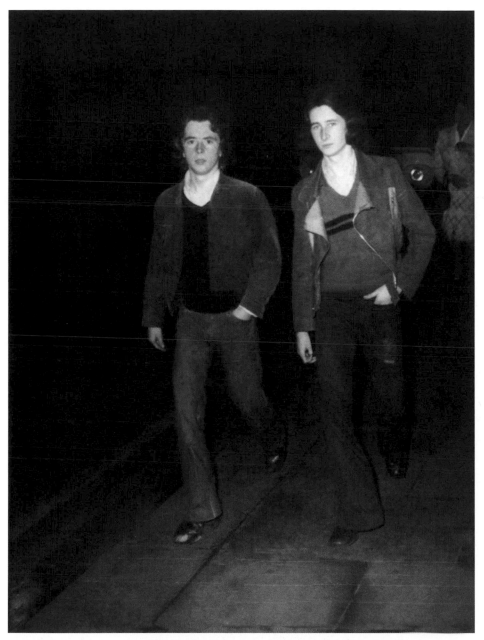

1974 '(L–r): Mark Dunne and my brother Stewart. On Stewart's left leg there is a patch with the word "Albion" for the West Bromwich football team, which he supported. Stewart passed away in March 1975.'
Hubert Donnelly

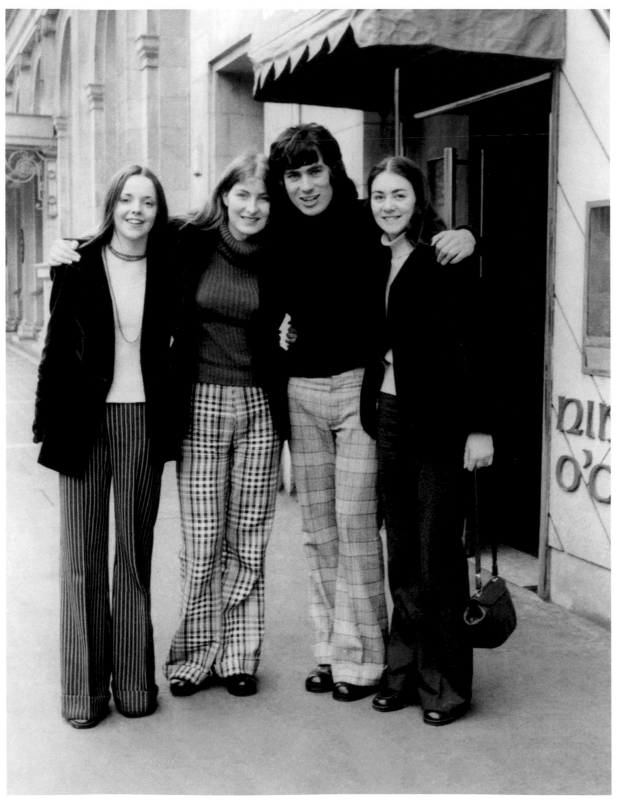

1974 'Meeting friends for a Saturday in town, all from Sligo. (L–r): Annie Getkins, Geraldine Scanlon, Padraic Quinn and me.'
Margaret McTiernan

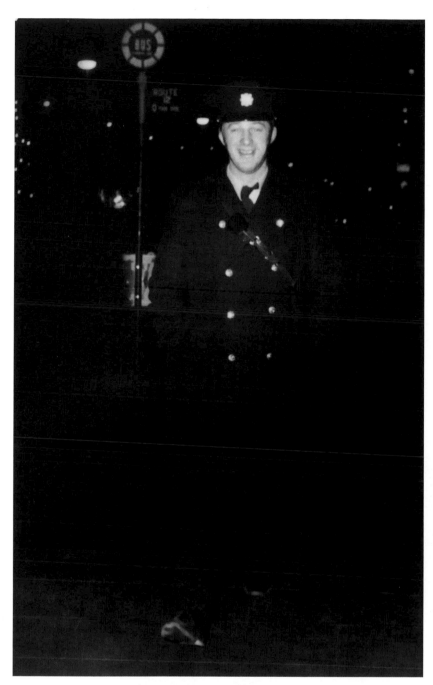

1974 'As a 22-year-old member of An Garda Síochána, I was stationed at Store Street Garda Station and was a regular on beat duty on O'Connell Street from 1974 to 1980. It was at the height of tensions in the North and I was on the "bomb beat". I walked from 8 p.m. to 2 a.m. up and down the street looking for suspicious devices. I had a very good relationship with all the characters on the street: newspaper vendors, shop owners and hotel staff. I had a special soft spot for "the man on the bridge", Arthur Fields. He was always very polite to me and would stay close by when I was on the beat. It gave him security from the drunks who would be messing with him and also credibility that he must be legitimate if the gardaí let him take the photos. The night he took this picture he said something to me to make me laugh. He gave me the ticket to collect. When I collected it, the photo was on the house.' *Hugh Coghlan*

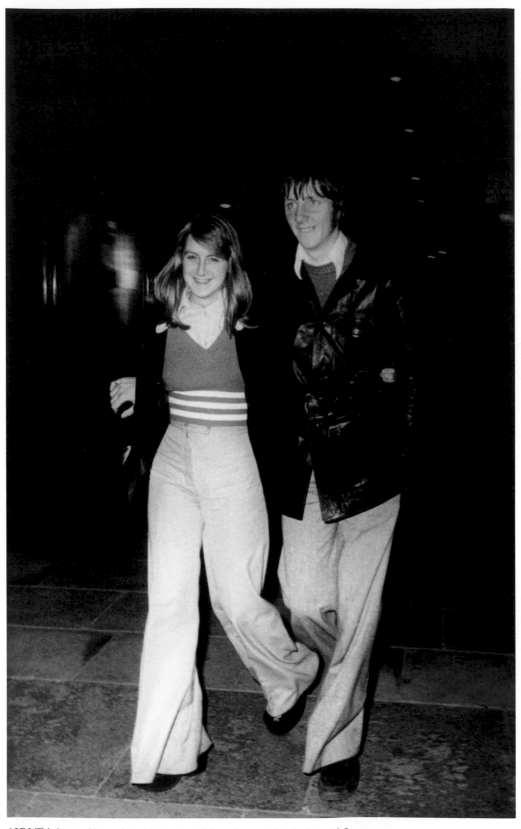

1974 'This is us – Rita and David Grant – still happily married today.' *David Grant*

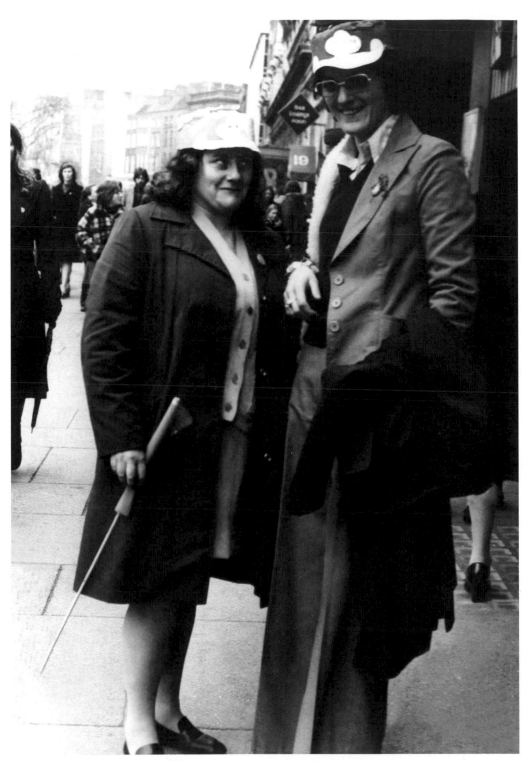

1974 '(L–r): My friend Catherine Markey and me, Marian Quinlan. Catherine is from Cavan and I am from Tipperary. We were on our way to a Railway Cup match in Croke Park on Saint Patrick's Day.' *Marian Quinlan Curtin*

1974 'Myself on the night before the 1974 bombing outside Clerys. Originally from Clare, I was working as a bus driver in Dublin. The buses were on strike so I was just killing time and had my photograph taken and the next day I collected my photograph on Talbot Street. I had just got back to my flat in Phibsborough when the window shuddered. I heard Mike Murphy on the radio saying there had been some disturbance in the city centre. When I look at the photo, it reminds me how lucky I was. I probably passed by the car that contained the bomb. Everyone tells me it was my lotto-ticket moment.'
Jimmy O'Friel

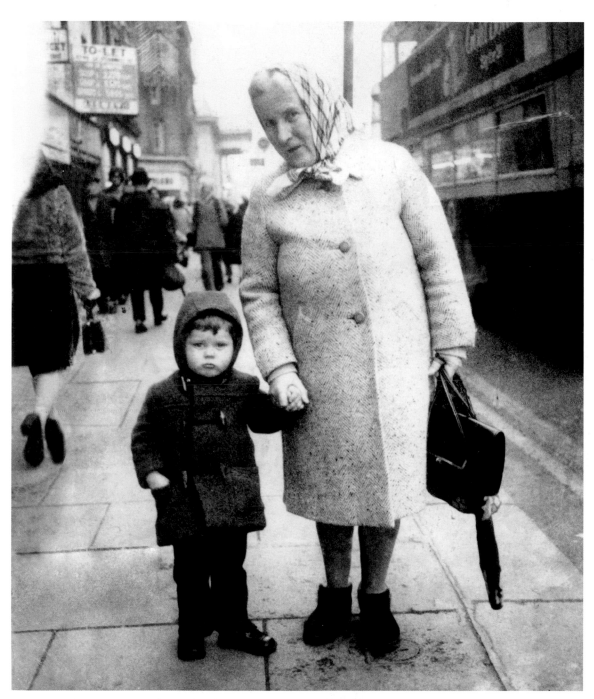

1975 'Me and my aunt Mary Maloney, who was up in Dublin for the day from Limerick.' *Pat Upton*

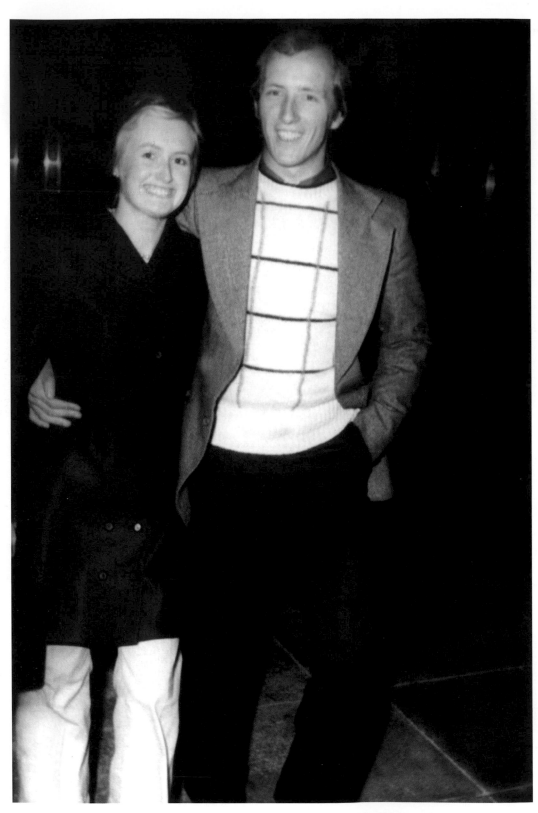

1975 'My parents, Martha Durham and Larry Hackett, coming out of the Savoy. They had been dating for two or three years at the time, and have now been husband and wife for over 30 years.' *Mark Hackett*

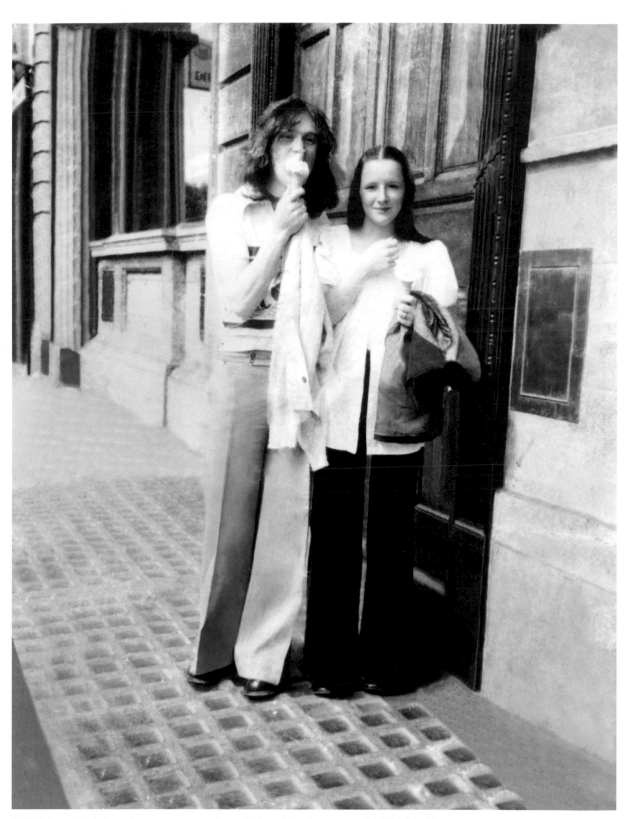

1975 'Me and Christina, when we were a newly married couple in the summer of 1975.' *John King*

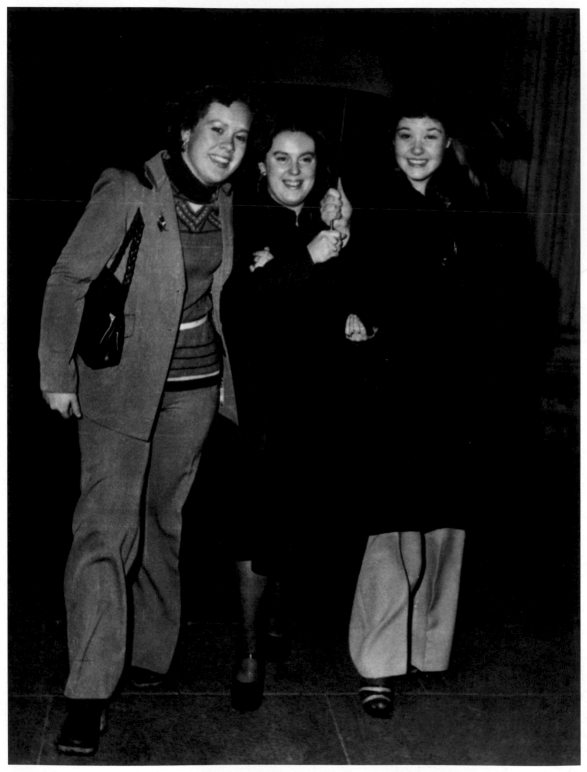

1975 '(L–r): Me (Breda Mullins), Margaret Keenan and Deirdre Dillon. Finished school, out in town smiling for Arthur.
Very happy times.' *Breda O'Hara*

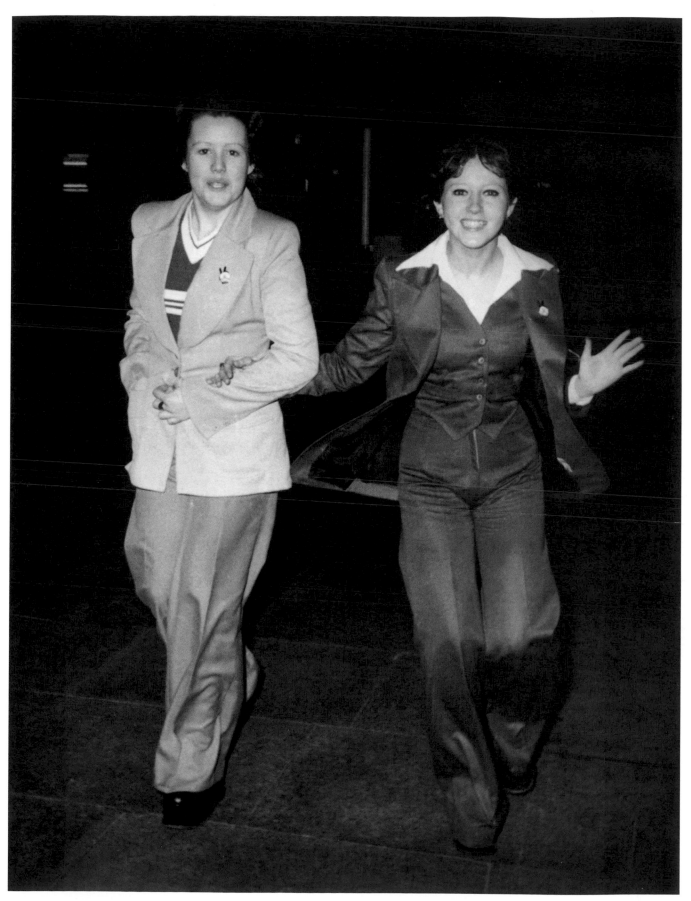

1975 '(L–r): That's me and Bernie Martin, on St Stephen's Day 1975, on the way into town to meet our fellas. We're still friends and enjoy a glass or two of wine together.' *Dolores Hand*

1975 '(L–r): Josephine Moran, Gerry Conroy, Elizabeth Keague, me and John O'Reilly. We were students at Coolmine Community School, Dublin 15. If memory serves me right, we were in town celebrating Liz's birthday. This was us heading back across O'Connell Bridge for the bus on Aston Quay, opposite McBirney's. The LP in the Golden Discs bag was *The Best of the Stylistics*.' *Vyra Hardy*

1975 'My children (l–r) Brian, Marie, Janet, George and Fergal, on a day out with their father, Sean.' *Carmel Colley*

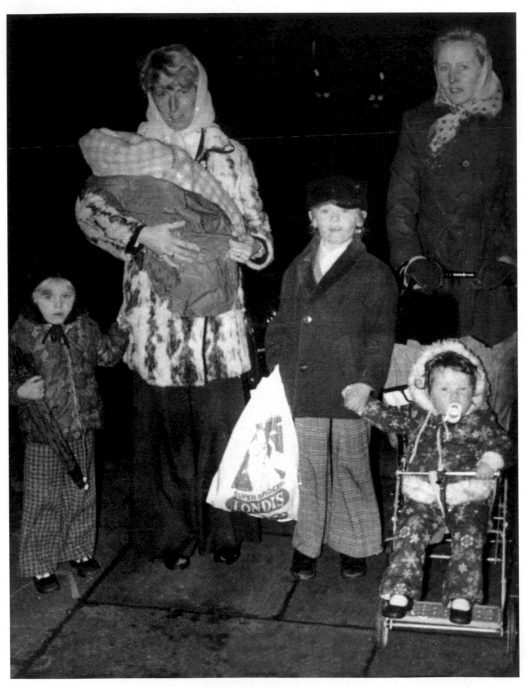

1975 'My wife, Joyce (holding baby Audrey) with her children Sharon and Anthony in town.' *Nicholas Earley*

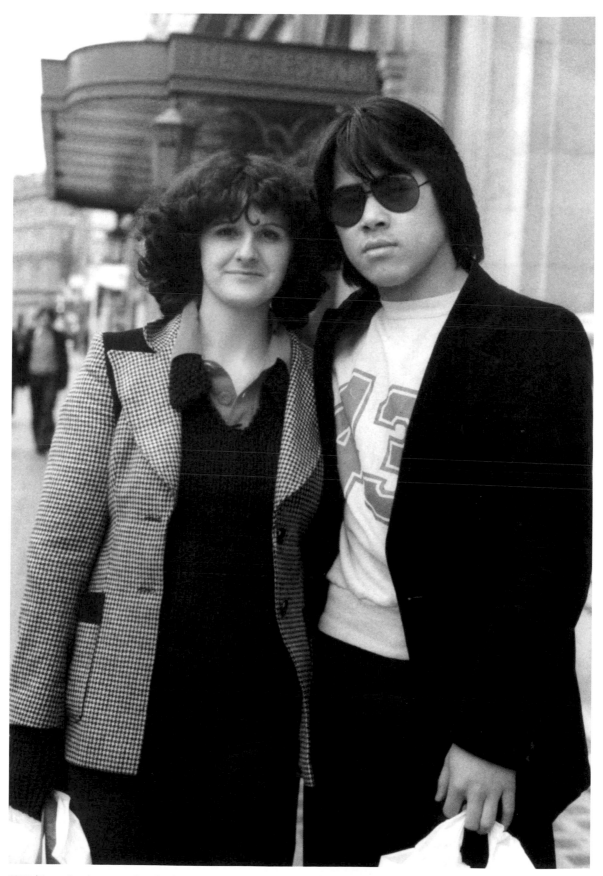

1975 'Easter Sunday: me and my boyfriend at the time, Martin Leung. We're still friends.' *Olivia Doyle*

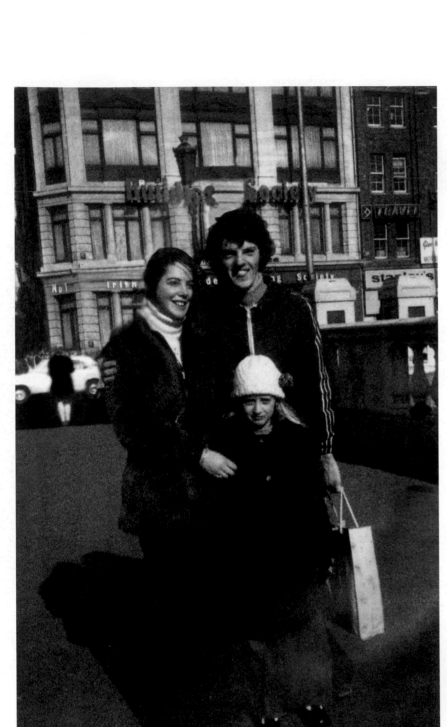

1976 'Me and my then girlfriend (now wife), Annette Byrne in town on a Saturday morning. With us is Annette's younger sister Noeleen.'
Tomas Hopper

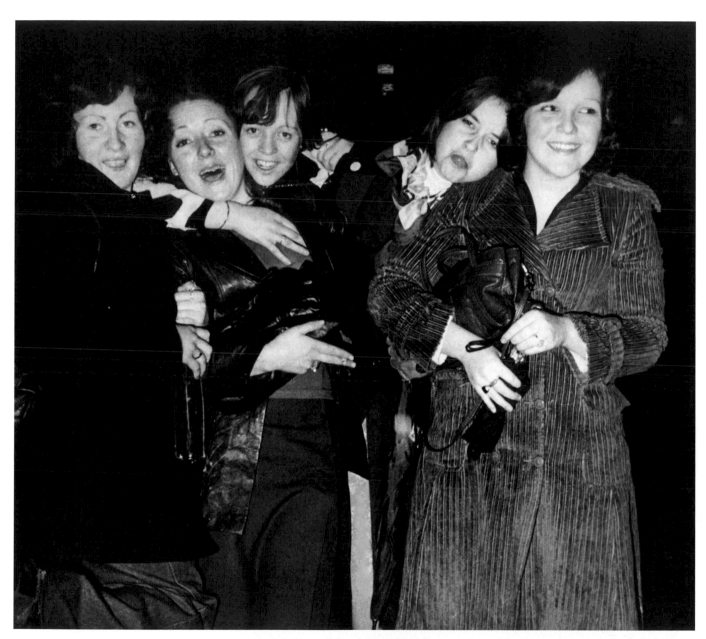

1976 'Myself and work pals from B+I Line, a shipping company. We all worked together on the boat to Liverpool. This is us on a night out, going to Rumours nightclub up by the Gresham Hotel.' *Christina Flynn*

1977 'Barbara Grogan, my girlfriend at the time, and me, coming from the cinema. It was the 70s and we were hippies. I was a musician and was inspired by the likes of Marc Bolan, T-Rex, The Incredible String Band. Punk hadn't yet hit Ireland so 1977 Dublin was more like 1967 London. Not many people dressed like this all the time, maybe for the weekend, but we were the real thing and felt very much part of a counter-culture.' *Martin Kelly*

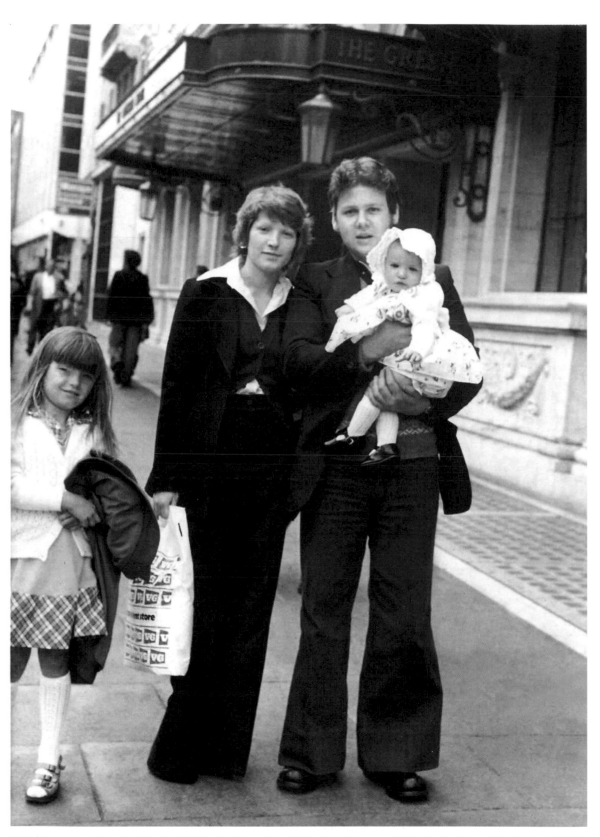

1978 'My brother-in-law Noel Royal with his wife, Margaret, and baby Lisa. The young child is Ursula, Margaret's sister.' *Andy Dalton*

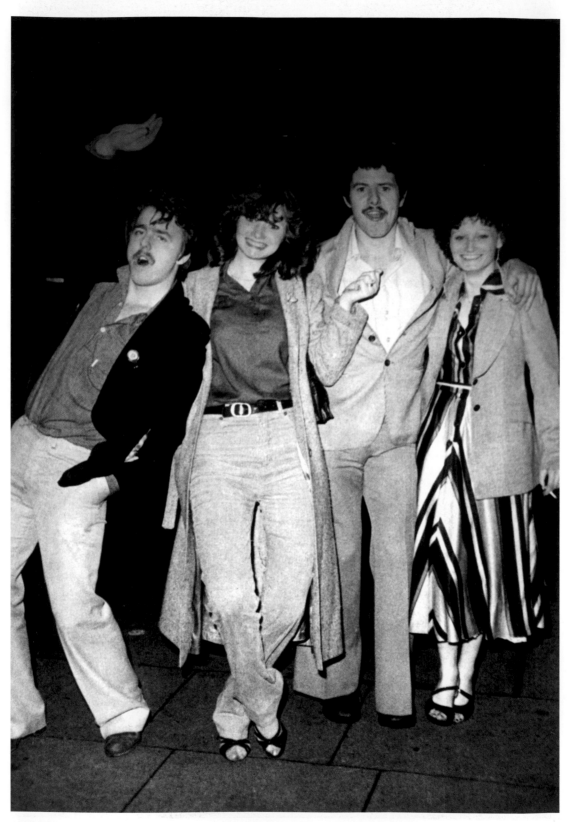

1979 'After a great night in the Tudor Rooms, (l–r) my husband Larry and me with our pals Christy and Rose Mahon. The Tudor Rooms was a cabaret in Barry's Hotel.' *Angela Jones*

1979 'This photograph was taken on O'Connell Street. Punk had exploded and the Dandelion Market was born. We were a gang of punk rockers and used to chat to Arthur. He loved taking our photo. That's me, Liz Kenny, in front and (l–r): Mary, Dave, Suzanne, Dustin and Sandra.' *Liz Kenny*

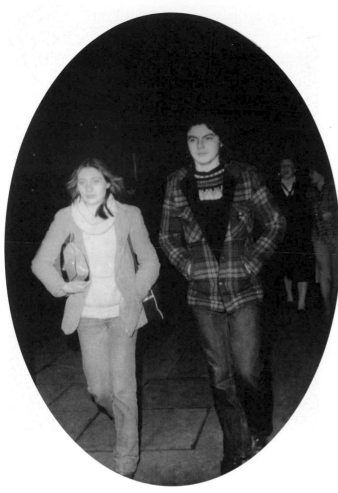

1979 'Me and my brother Paul McDonnell on O'Connell Street. Paul was killed in a car accident one month later. After Paul died, I found Arthur's ticket in my coat pocket from the night it was taken and collected the photo. It has been treasured ever since as it was the last photograph ever taken of Paul.' *Carol McDonnell*

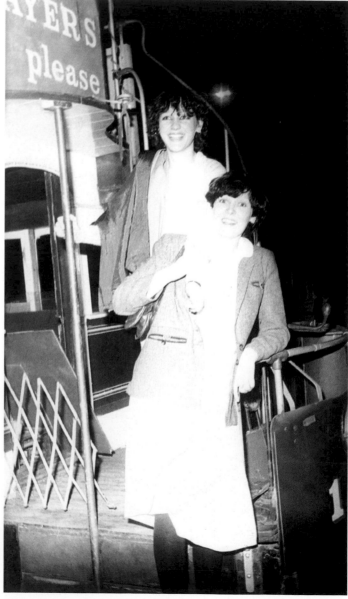

1980 'The two ladies in the pic are my future wife Sheila Hyland and Mary Coughlan and the tram was for the set of *Strumpet City* which was being made by RTÉ at the time.' *Joe Walsh*

1980 'My parents, Carmel McBride of Macken Street and Paul Byrne from Sheriff Street, walking past the GPO.' *Paul Byrne*

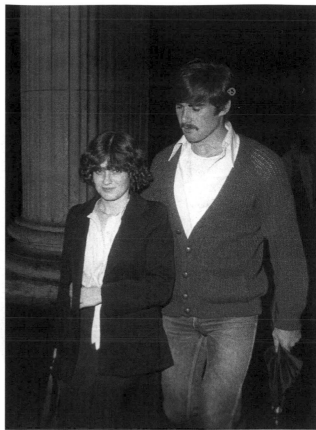

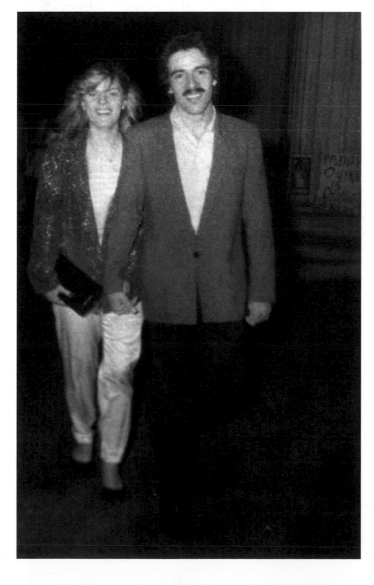

1981 '(L–r): Catherine Preston, who was later to become my wife, and me. We were heading to the Harp Bar on the other side of O'Connell Bridge. Note the banner in background for hunger striker Paddy Quinn.' *Christy Boyle*

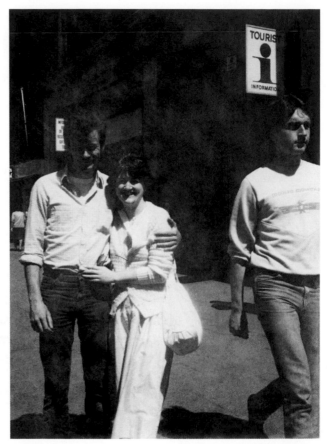

1982 'My husband Tony Marks and me. This picture taken after a visit to the cinema on a date. Eventually we got married and remain happily married today.' *Cathy Marks*

1985 'This was taken on 31 May 1985 on O'Connell Street on the day we got engaged, Barry McCormack from Finglas and me, Yvonne Sheridan from Naas, County Kildare. It was taken just after we picked up our rings in Lawrences on Henry Street. It was one of Arthur's last years working and he used a Polaroid instamatic camera. It has faded somewhat, as is the way with Polaroid photos. My father, Denis, also worked as a photographer on O'Connell Bridge but that was in his younger days, *c.* 1930, whilst he was unemployed and recovering from TB.' *Yvonne Sheridan*

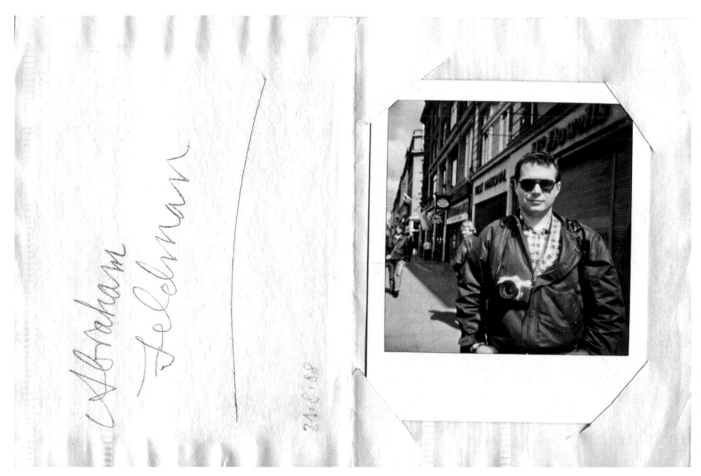

1988 One of the last photos taken by Arthur Fields, on 21 August 1988. The photo was emailed to Arthur's son David and captures an Italian tourist in Dublin. Arthur signed the photo but used his original Jewish name, Abraham Feldman. Shortly after taking this photo, Arthur retired altogether after over 50 years. When Arthur died on 11 April 1994, the headline on the front page of *The Irish Times* read 'Man on the Bridge fades from view'.

MAN ON THE BRIDGE TEAM

Ciarán Deeney, David Clarke, Rebecca Bermingham, Margaret Gibbons, Niall de Buitlear, Dave Bolger, Stephen Mangan, Karen Hanratty, J. J. Rolfe, David Byrne.

Special thanks to:

The family of Arthur Fields, Anne and John Deeney, Margaret and Brendan Clarke, Sarah Ryder, Angela Smith, Orla Fitzpatrick, Garry O'Neill, Niall McCormack, Martin Mooney, Brian Whelan, Brian Murphy, Trish Lambe, Tanya Kiang, Berminghams Cameras, Gunne Cameras, Deirdre Laird, Natalie Christie, Colm Quinn, Liam O'Cathasaigh, Eibhlin Roach, Hitone Books, Anne-Marie Kelly, David Davison, the Irish Professional Photographers Association, Lisa Deeney, Richard Deeney, Ruth Griffin, Trish Brennan, Deirdre Laird, FujiFilm, Jackie Farrell, Grehan Printers, Karen Ruddock, Sarah Dillon, Kevin Denny, David Denny, Ballymun Stevo, Laura Bergin, Ruarí O'Cuiv, Ray Yeates, Clerys, Angela Smith, Dave Leahy, Sybil Cope, Angela Scanlon, Chris O'Dowd, Ben Readman, Róise Goan, Cllr Christy Burke, Block-T Dark Room, Anthony McGuinness, John Curran, Mella Travers, Peter Kavanagh, Active Retirement Ireland, Ryan Tubridy, Elayne Devlin, Róisín O'Dea, *The Late Late Show*, Denise Dunphy, The Factory, In the Company of Huskies, Martin Busch, Scanners.ie, Epson Ireland, Derek Cullen, Colin Lawlor, Business To Arts, Andrew Hetherington, Designist, DIT Media Department.

First published in 2014 by
The Collins Press
West Link Park
Doughcloyne
Wilton
Cork

A CIP record for this book is available from the British Library.

ISBN: 978-1-84889-217-0

Design and typesetting by Glen McArdle
Typeset in Frutiger and Myriad Pro
Printed in Poland by Białostockie Zakłady Graficzne SA

Cover images
Front and spine: Arthur Fields with camera in 1941 on O'Connell Bridge. *Arthur Fields family collection*
Back (clockwise from top left): Eddie Browne and his fiancée, Evelyn Duffy, June 1970; Ignatius and Marie Martin, 1950; Wally Cassidy, 1961.